Susan Kahn

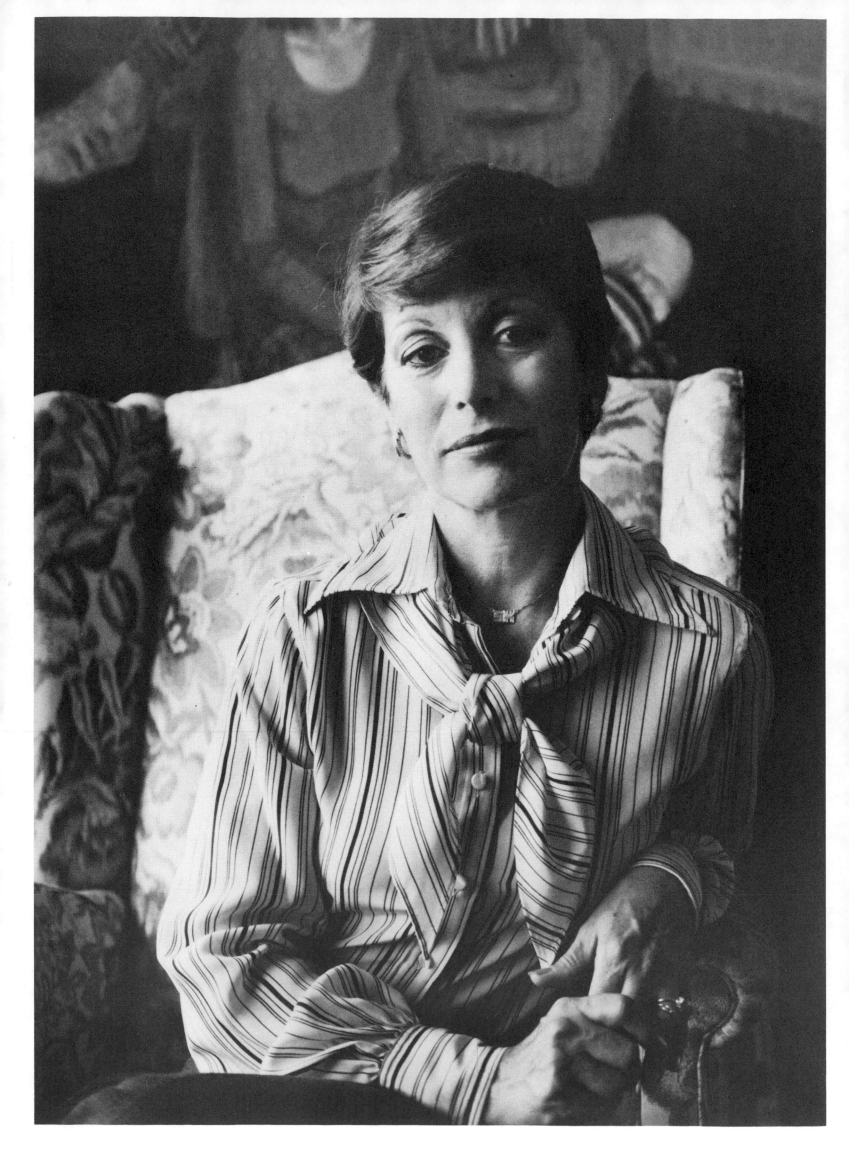

WITH A CRITICAL ESSAY BY

LINCOLN ROTHSCHILD

Philadelphia: THE ART ALLIANCE PRESS

London and Toronto: ASSOCIATED UNIVERSITY PRESSES

The Art Alliance Press
Cranbury, N. J. 08512

Associated University Presses
136–148 Tooley Street
London SE1 2TT, England

Associated University Presses
Toronto M5E 1A7, Canada

Library of Congress Cataloging in Publication Data
Kahn, Susan, 1924-
 Susan Kahn: with a critical essay.

 1. Kahn, Susan, 1924- I. Rothschild,
Lincoln, 1902-
ND237.K145A4 1980 759.13 80-16089
ISBN 0-87982-031-4

Color and Monochrome illustrations photographed by
Walter Rosenblum and Geoffrey Clements

The Photographs of Susan Kahn in the text are by Philip Hipwell

Printed and Manufactured in the United States of America

To the Beloved Memory of
JOSEPH KAHN
1916–1979

The heights by great men reached and kept
Were not attained by sudden flight,
But they, while their companions slept,
Were toiling upward in the night.

Contents

Susan Kahn

Susan Kahn: The Artist and the Woman

THE CASUAL VISITOR, ENTERING THE STUDIO OF SUSAN KAHN IN SEARCH OF THE ARTIST, finds a slim and youthful woman of incredible exuberance. She is not the intense and overpowering painter that has been conjured up by the sight of her paintings. As she paints in her canvas littered studio on the second floor of her duplex, thirty one stories above the East River, to the accompaniment of a concerto playing on her stereo, her art seems to weigh lightly upon her.

But this is a delusion. For Susan Kahn is a very serious artist. In a career as a painter that spans thirty years, she has reached the easy assurance that the maturity of her art has brought her. She is confident, she is secure, but she takes her art very seriously. Almost every day she is in her studio by eight o'clock. In the mornings she works with her models, and in the afternoons she goes over her work, filling in, adding the touches that bring her work to full life.

Susan Kahn is that *rara avis*, a native New Yorker. She is as much at home in her skyscraper apartment as is a rose in the garden. At 55, her art and her life style are in full bloom, fully formed. Perhaps the skyscraper is as necessary to her way of life and her painting as are the woods to the antelope. Perhaps out of New York she might wither and fade. These, at any rate, are the thoughts that flit through the visitor's mind as he watches a painting being magically formed on the canvas secured to the easel.

Susan Cohen was born in New York City on August 24, 1924. Her parents too were born in New York, first generation Americans whose parents had fled Russian Poland in one of the waves of immigration of the late nineteenth century. Her grandfather Samuel Cohen was a friend and follower of Henry George who had simplified George's complex philosophy of the single tax to suit his own theories of economic justice. As a child she heard the Georgian ideas of taxation much discussed and much applauded, but it left her with only an imperfect notion of its basics.

11

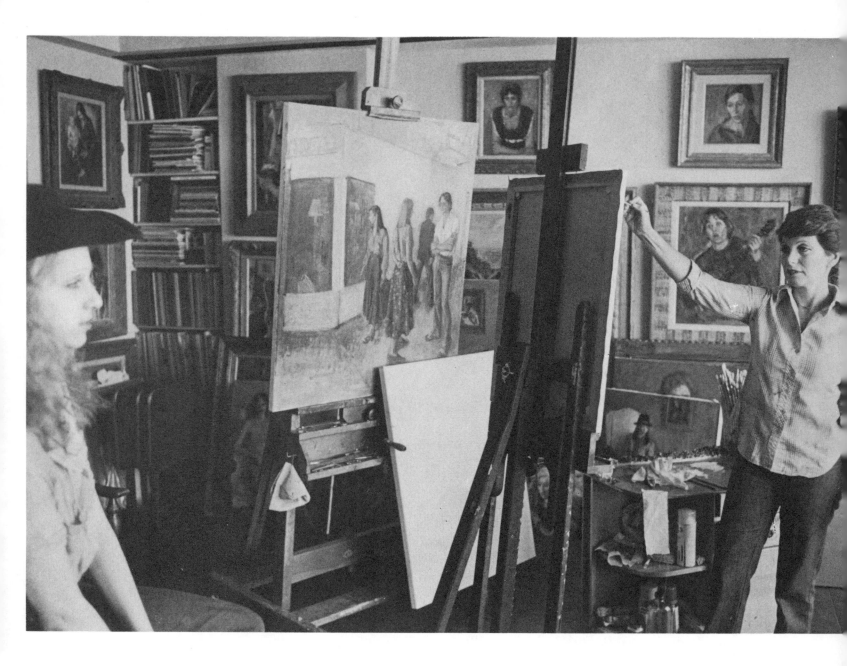

She remembers her childhood happily. "I grew up in a middle class atmosphere in New York," she has written. "In the winters I went to the public schools, my summers were spent in the mountains, and later, when we were old enough, my sister and I went to summer camp. I remember being very gregarious—I liked people and always had many friends. I was one of the few children who cried all the way back home from camp."

Even as a very young child she was fascinated by design. Her mother employed a dressmaker who came to their apartment and set up her sewing machine on the dining room table. She recalls that the table had a cover to protect it, green felt on the underside and an embossed design on the oilcloth surface—something akin to a paisley fabric. She would stare at the design, completely fascinated by it, and then try to duplicate it in a childish drawing.

Like most New Yorkers, she had many homes, five apartments in all, and each of them had their indelible impact upon her. As she was growing up, the impressions of those years were forming the future artist, for she lived with the idea of art for as long as she can remember. From the time she was old enough to hold a pencil, she was draw-

ing. Then later she experimented with her first watercolors, and tried her hand at forming figures out of clay. In school her ability was quickly recognized, and she was the one always called upon to make the posters for Open School Week, Cake Sales, Up and Down Staircases, and the other projects so dear to the hearts of school teachers. At camp too she worked on the "Yearbook," painted sets for the plays, and spent her free time painting. By the time she was eleven, she had her first set of oil paints.

The stage also fascinated her as a child. She participated in plays at school and camp, and even before that she would hang around the actors who came to the summer hotels in the mountains, taking any child's part she could get. Her crowning achievement of those years was a part as Sarah Bernhardt—as a child, of course. At Public School 9, at West End Avenue and 82nd Street, she and her best friend wrote and acted out plays for her class.

She went on to study at Julia Richman High School. She recalls one teacher from her public school days, a Miss Sullivan, a rather large and jolly lady who encouraged her in her art, and whom she adored. At that time, Parsons School of Design was located on two floors of a small office building on Broadway, near her home. She attended classes for children on Saturdays, and exhibited her work in the children's shows.

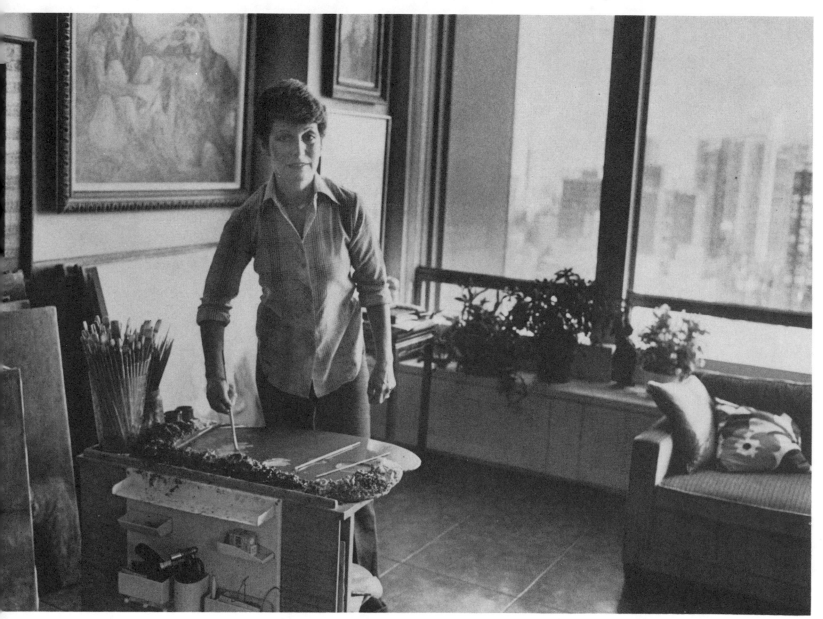

In the mid-thirties her doctor recommended to her parents that they take their asthmatic child to a warmer climate, and the family spent two winters in Miami Beach. Susan, her mother and sister went in early September, so that her schooling should not be interrupted, and her father would come down for a few days in each month.

Miami Beach in the mid-thirties was a wonderland for a child reared in the concrete and brownstone world of New York. The area north of Lincoln Road was largely an unspoiled stretch of natural beauty, without hotels, swimming pools, and shops. Even her school was a Spanish villa built around a courtyard with Moorish archways. The palm trees and brilliant sunsets particularly appealed to her teen-age fancy, and she tried putting this magic on canvas.

By the time she was 14 she was able to go back to New York winters. At Julia Richman High School she studied the usual subjects, but her interest, as always, was in art and drama. She was introduced into the world of abstract art, and as a class project, she was required to make some abstract paintings, starting either with an objective design or a simple pattern.

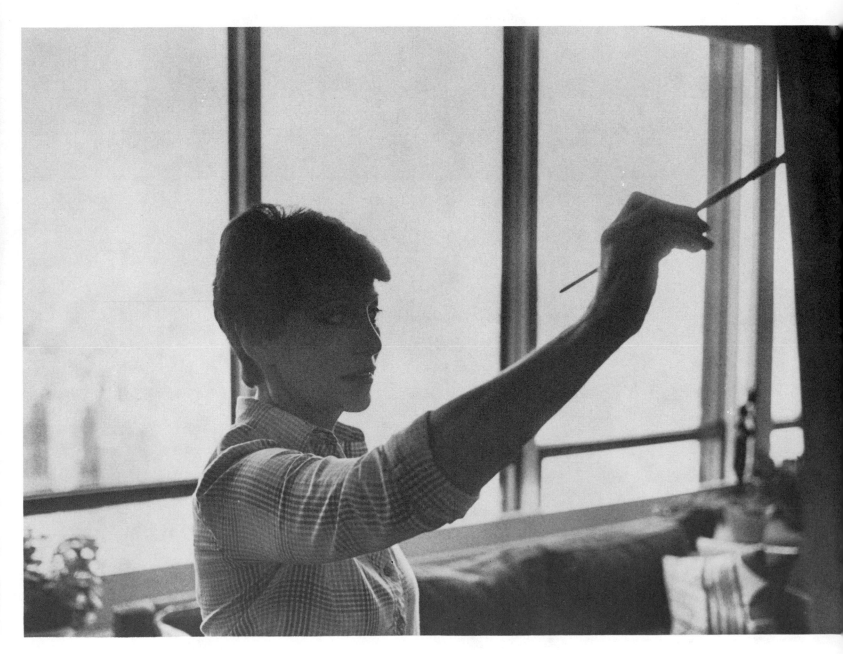

In drama classes she learned Shakespeare as theater, and she made her farewell appearance as a thespian playing Scrooge in a school production of *A Christmas Carol*.

On week ends and in vacation periods she went to museums and galleries, seeing a variety of styles and techniques. Her most vivid memories of this period was of her first sight of Salvator Dali and his fluid surrealistic world.

The Parsons School had moved to West 57th Street by the time she came out of high school, and she enrolled. She would have preferred the Art Students League or the National Academy, but she wanted to prepare herself to earn a living at her art. She studied advertising art, layout, poster art, magazine illustration, book jackets, container and fabric design, art history, and even furniture design. Even though she was disinterested and bored by much of this, she now feels that all of this contributed greatly to her development as an artist.

After finishing her courses, she started to work for a fabric manufacturer, designing fabrics for men's ties and robes. She was sharply limited in colors she could use, and after a few months she had had her fill of it.

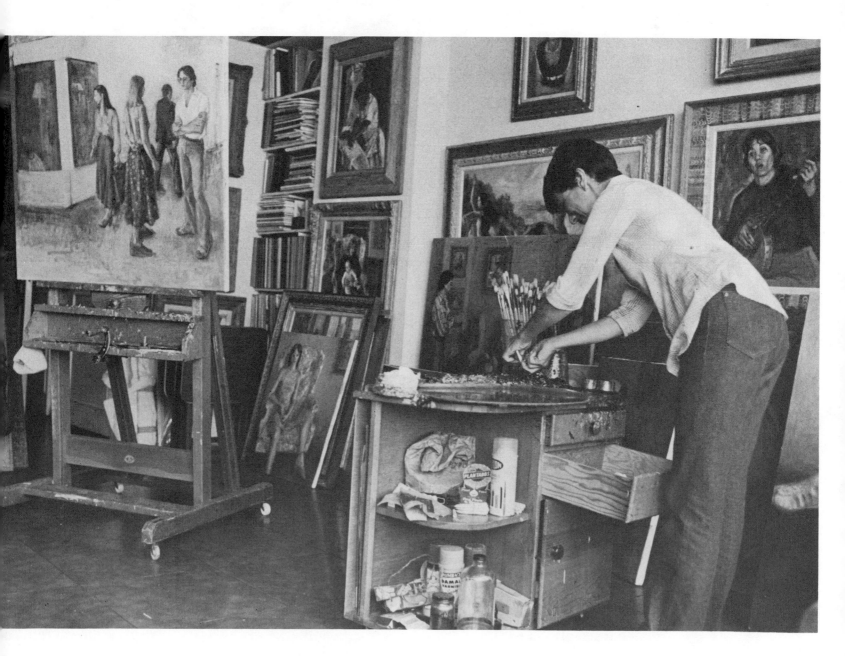

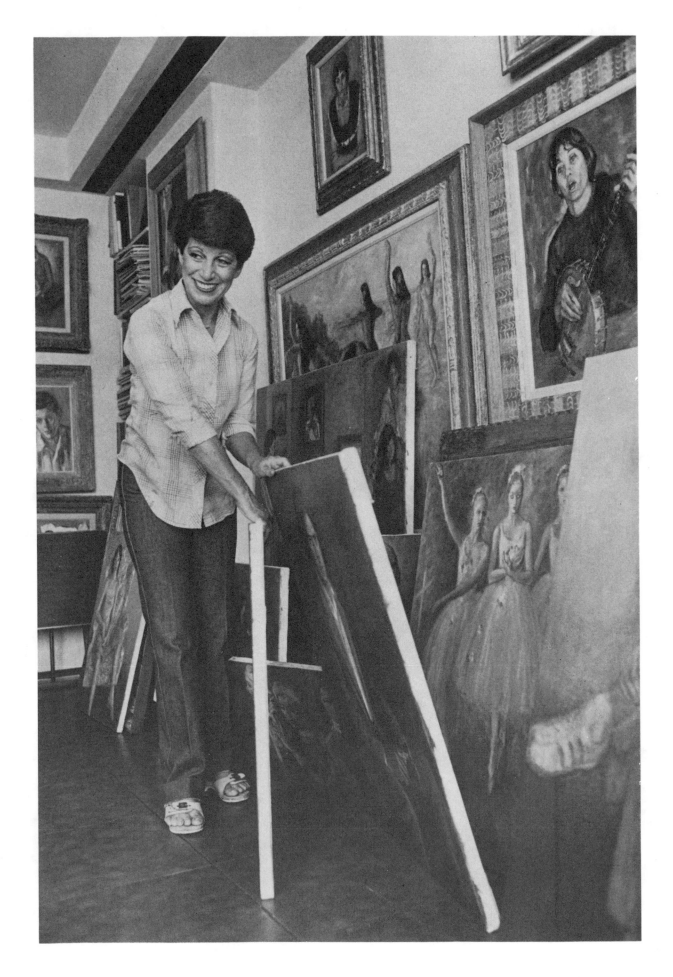

While she was in school and later at work, she spent much of her free time in the Metropolitan Museum. She found motifs for her designs in old Persian prints and sculptures.

Her eyes took in everything and translated what she saw into her own ideas of art. She loved Vermeer for his handling of light and fabrics. El Greco she felt had known how to capture character on canvas, and Degas' ballet paintings certainly influenced greatly her own future work.

It was in this period that she became acquainted with the work of the Americans—Winslow Homer, Sloan, Henri, Bellows, Moses and Raphael Soyer, Evergood, Gropper, Pascin, Zorach, and Chaim Gross.

The end of the Second World War brought joy and hope, but it also brought tragedy to Susan. Her father, after a long illness that sapped his strength but not his humor, his zest for living, or his loving spirit, died in January 1946, a young man of 49. For Susan it was a crushing blow.

Her art absorbed her interest completely, but a beautiful and vivacious girl of 21 was not likely to remain unattached very long. She met a young soldier, just out of the army, and fell in love. In September 1946, just after her twenty-second birthday, she married Joseph Kahn, who had emigrated from Russia seventeen years before, when he was 13 years old.

It seemed impossible to find an apartment in all of New York, and the young couple moved in and out of hotel rooms, and when they finally found a small apartment on Riverside Drive, it seemed like Paradise.

But there was the traditional serpent in Paradise. Susan started to paint, but it developed that Joe was allergic to the odors of paint and turpentine, and in the tiny apartment, painting became impossible.

It was at this time that a friend introduced her to Moses Soyer, and this was the major turning point in her career as an artist. Moses became first a teacher, then a father image, and finally a focal point of her life. She has said that knowing Moses enriched her life, but perhaps not even she knows how much he influenced the direction of her art. Moses remained her mentor and her dear friend for 26 years, until his death in 1974.

She resolved the problem of a studio. With two other artists, she rented a studio on the top floor of a loft building on 14th Street.

Now began a very fruitful period for Susan. She was absorbing everything that Moses could give her, and at first her paintings were faithful copies of her master's art—in color, in composition, in philosophy. But as her art matured, she began to strike out in her own directions. The dutiful daughter became the rebellious daughter. If Moses told her that a painting with five subjects was too cluttered, she immediately peopled her next painting with six figures. If Moses said she could not use purple as a dominant color, her next painting showed bright splotches of purple. Thus, with imitation, with groping, with rebellion, she was finding her own style.

During this period, two paintings were accepted for distinguished juried shows—the Knickerbocker Group and the National Academy. Three paintings were included in a group show at the Lynn Kottler Gallery, and she made her first sale. She then started showing her work in a new gallery on Madison Avenue, Richard Kollmar's Little Studio.

In 1953 she discovered Europe. She went with her husband on business trips, and while he was occupied in his work, she was free to wander the streets, study the life of the cities—the architecture, the people. She spent hours in the famous museums. Out of the jumble of paintings old and new, academic and modern, began to emerge a pattern of the world of art and a vision of her own work in context.

17

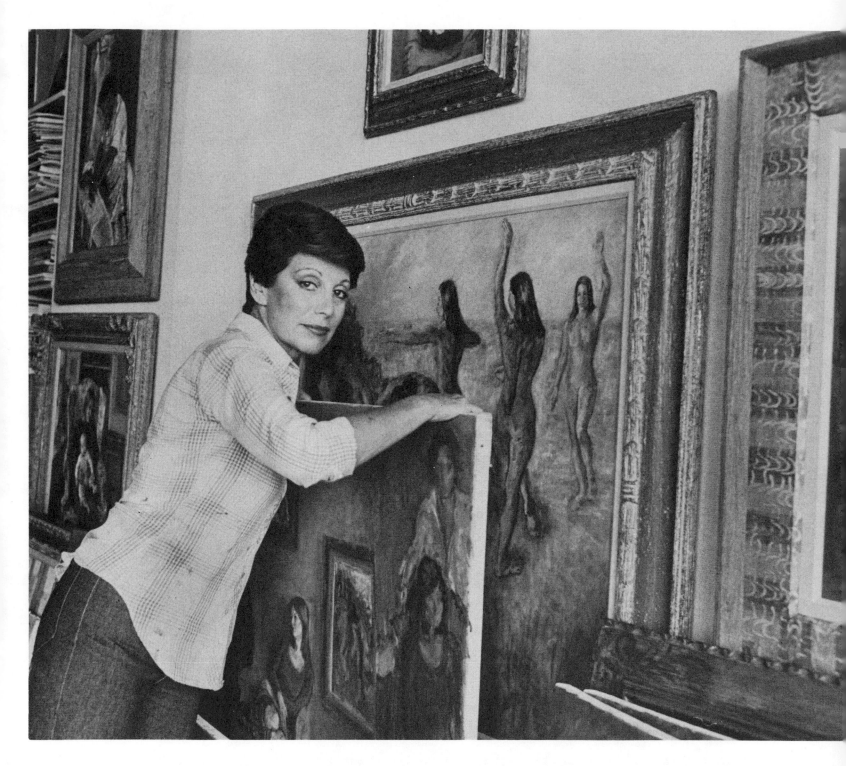

Paris delighted her. It was Toulouse-Lautrec come alive. In the museums—the Louvre, Jeu de Paume, Orangerie, the Rodin Museum—she saw the living art that she had known before only in books. She still recalls the art that left the deepest imprint on her. In Manet's *Le dejeuner sur l'herbe* she saw the influence of N. Diaz, the artist who had painted a small canvas she had bought. (Diaz was of the Barbizon School, and had in fact taught and influenced the Impressionists.) Other works she particularly admired included Corot's *Woman with a Pearl*, Degas' *Absinthe Drinkers*, Ghirlandou's *Old Man and Young Son*, and Delacroix's *Liberty Leading the People*. In the Orangerie she was fascinated by the circular gallery of Monet's *Water Lillies*.

In Amsterdam she saw Van Goghs in an overwhelming number, and like many other

viewers, she found herself especially drawn to the large somber canvas of *The Potato Eaters*. In Amsterdam also she saw the large collection of Rembrandts, and liked especially *The Night Watch*.

In 1956 Susan and Joe moved into a new apartment. This was on East 81st Street, and with five rooms, she could now have a studio at home. So she gave up the 14th Street studio, and started painting at home.

The following year she painted *Backstage*, using one of her neighbors as a model for the "dandy" with walking stick, bowler hat, ruffled shirt, red bow tie, and yellow gloves. She felt she had succeeded with this canvas, and her confidence was bolstered when the work was selected by the jury for the Art U.S.A. show of 1958, at Madison Square Garden.

At about this time Susan faced a painful fact that was to have a profound influence on the body of her work. After a long series of tests and doctors' strictures, it became clear that she would never have a child. When she was able to accept this, she became a vicarious mother in her work. In 1957 she painted *Pregnant Girl*, and the following year she started an entire series of "Mother and Child" paintings, depicting children from babyhood to teen-age. The first of this group was shown in a new talent show sponsored by the ACA Gallery.

It was in 1958 also that she won her greatest recognition up to that time, when she was given the Edith Lehman Award in the show of the National Association of Women Artists, for her painting *Despondent Girl*.

By 1959 she felt she had enough good work for a solo exhibition. So she began the weary rounds of interviews at the major galleries. Time after time she was told that the art minded public was not interested in her kind of work—what was wanted was abstract and non-objective work.

Her first opportunity came by a quirk of fate. The Sagittarius Gallery was to show Cecil Beaton's designs for the production of *Saratoga Trunk*. When the musical comedy folded, the Beaton show was cancelled and, with only two month's notice, Susan was invited to mount a show. She was able to show 20 works, and the exhibition ran from March 28 to April 9, 1960. It was very successful, and many of the paintings were sold, including the first *Mother and Child*.

Her experiences with the galleries at this time were discouraging. Few critics spoke up in defense of realistic representational art. But she was heartened by an article by John Canaday for *The New York Times*, regretting the current attitude. The visible world, he argued, still furnished ample scope for "realistic imagery interpretively employed." For 20 years she has kept the article, and often referred to it, as a valid statement of her own art.

In 1960 she began to get wide recognition. The Johns Hopkins Graduate School of International Studies acquired a painting which she called *People*. The next year the National Association of Women Artists gave her the Simmons Award for her painting *Masako*, and shortly after, the Syracuse University Museum acquired *The Library*.

In 1962, with Moses Soyer's help, she began an association with the ACA Galleries which has lasted for nearly two decades. Now, for the first time, she felt she was in the hands of people who could appreciate both her art and her commercial value.

A trip to Rio de Janiero at Carnival time brought her into a world of frenzied madness that both shocked and fascinated her. The result was her painting *Copacabana Carnival*. In that same year she painted her first *Street Scene*, which was acquired by the Montclair Museum of Fine Arts.

Also in that year she moved her work into a fine new studio, over the penthouse of

an apartment building near her own apartment. She now had a fine North light and ideal conditions for working. Joe bought her a miniature French poodle—for protection. One of the first paintings to come out of her new environment was appropriately *View from the Studio*, now in the collection of the Sheldon Swope Art Gallery.

Three times, in 1965, 1966, and 1969 *The New York Times* reproduced her paintings in its annual Christmas appeals.

In the meantime, she was represented in several group shows, and by 1964 she had enough new work to mount a second one woman show, this time at the ACA Galleries, which was now her home base. A dominant feature of the show was a series of Mother and Child paintings.

Another major award came her way—the Medal of Honor from the Knickerbocker Group for *Boy and Girl*—as well as several lesser awards. And by 1968 she was ready for a third show of her work at the ACA Galleries. One of the paintings from this show, *Conversation*, was acquired by New York's famous Palace Theater.

By this time her work had been reproduced in many publications, and in 1967 she won the National Arts Club award.

In 1969 Susan and Joe moved once again, into a spacious apartment on East 49th Street, high above the East River. Her studio, on the top floor of the duplex, has a wide expanse of windows providing a fine north light, with a magnificent view of the city. There she still lives and works.

She set herself a grueling pace, and by 1971 she was ready for her third ACA show. Many institutions acquired paintings out of this show, among them Fairleigh Dickinson University (*Artist and Model*),Cedar Rapids Art Center (*Double Image*), Joslyn Art Museum of Omaha (*Musical Gathering*), New York Cultural Center (*Pregnant Girl*), and St. Lawrence University (*Cynthia*).

Many other museums were beginning to acquire her work. *Reflection* went to Tyler Museum of Art and *Red Nightgown* was acquired by the Albrecht Gallery Museum of Art, St. Joseph, Missouri.

The ACA Galleries had moved uptown, from 57th to 73rd Street, and was now under the direction of Sidney L. Bergen, who was very enthusiastic about Susan's work, and it was he who arranged her most ambitious and successful show. This was a traveling show, seen in several museums around the country, from October 1973 to May 1974. It was shown in the Charles B. Goddard Art Center, Ardmore, Oklahoma; the Albrecht Gallery Museum of Art, St. Joseph, Missouri; and the New York Cultural Center.

On Labor Day 1974, her friend and teacher, Moses Soyer died. He died as he surely would have wished—in his studio, at his easel, painting.

Moses' death was a testing experience for Susan. Moses had been a part of her life for two decades. Through his tutelage she had developed her art and much of her outlook on life. Through him she had formed her associations in the art world. He helped her over the rough spots in her growth as an artist, soothing her wounded vanity when it needed soothing, praising her when praise was what she required.

When Moses died he was at work on a painting of Phoebe Neville, and it was she who telephoned Susan with the sad message. It is significant that Susan felt compelled to paint a portrait of Phoebe Neville—almost as though she could not bear to leave a work by Moses unfinished.

In 1976 she completed *Homage to Moses Soyer*. Inspired certainly by Raphael Soyer's *Homage to Thomas Eakins*, the painting depicts Moses in the right middleground of the canvas, surrounded by young people—his models and friends—each wrapped in his

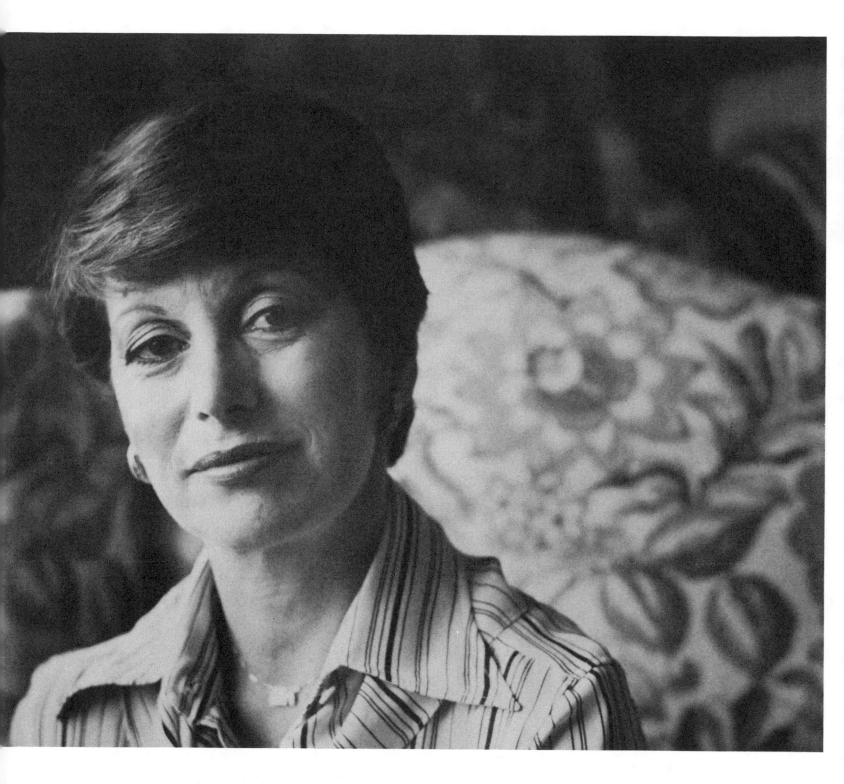

own thoughts. A half-finished painting sits on an antique easel. (The stool Moses sits on and the easel were given to Susan by Moses' son David.)

This painting was finished in time to become the cover of the catalogue for a new show of Susan's work at the ACA in 1976. Out of this show the University of Wyoming Art Museum acquired the painting *Song*.

In 1978 St. Peter's College mounted a program called Women in the Arts, and Susan opened the program with a show of her work in the O'Toole Library Gallery. Sidney Bergen, who had been associated with Susan for 16 years, wrote the Foreword for the catalogue.

In December 1979, as this book was being prepared for press, Joseph Kahn, who had been for 33 years so much a part of Susan's life and had the greatest faith in her art, died suddenly. As this is written she has not yet been able to gather up the unravelled threads of her life and resume painting. She feels alone and adrift and it may be long before she is back at her easel. But her reserves of strength and her own belief in her work may have the ability to heal this great wound and carry her over an awesome void.

What is ahead for Susan Kahn? Her art has developed and matured with a sureness of spirit that is almost a revelation. She has fulfilled in great measure the promise of her early years. Her subjects, now as always, are young people, and she has captured the spirit of the moment as perhaps no other artist ever has. Young people see themselves mirrored on her canvases, at work, at play, their lives made clear, and their thoughts laid open. Now in the fullness of her career, she is restless, seeking, awaiting each day with its new challenges.

She has adhered to her artistic principles, and not been wooed by the hope of material success. To those who see her art as "old fashioned," or "academic," or "photographic," she can reply that it is her art, it is no other's and it is *her* art by which she will be remembered.

The Art of Susan Kahn

To meet Susan Kahn either in person or in her painting is to recognize a spirit of immense vitality. She has vivid early recollections of being fascinated by designs on various domestic objects encountered in her childhood, of her awareness of the physical structure of her environment such as the layout of the homes occupied by her family as she was growing up, and her delight in creative materials made available to every child at the kindergarten stage. Whether or not they have had any direct relation to her eventual development into a professional artist, the energetic concern she displayed with all these aspects of her experience indicates a personality in search of constant activity and means of expression.

Actually, in her youth she seemed to show a greater interest in theatrical performance. When she finally selected the plastic arts as the medium for total concentration, her initial training and first employment were directed toward the field of commercial design since her occupation was expected to provide adequate financial support. However, as time went on the detached nature of such activity, devoting her entire creative effort in a potentially vivid medium to products that made so little direct reference to her life and those of her fellow human beings, caused her to turn in a short while to the making of pictures instead.

The vigorous images of reality achieved in Susan Kahn's painting throughout a lengthy career of intensely dedicated activity calls into question some of the notions about cultural progress in the arts that became increasingly accepted as the twentieth century progressed. Adequate evaluation of her work therefore requires some review of how the opposition to realistic representation came about and why it seemed to become the prevailing attitude when her professional development was taking place. Her resistance to aestheticizing tendencies toward the area of abstract design she had firmly rejected must

not be taken to indicate unawareness of current trends or an inability to master their presumed superiorities.

Whereas art historians had extensively noted how style in the long, continuous production of the plastic arts evolved through consistent, thoughtfully motivated modification of basic common aims and principles for their achievement, a scornful attitude toward such orderly gradualism arose in sophisticated European circles during the nineteenth century that insisted on eliminating the objective and the techniques of creating recognizable forms. Curiously it might be noted, however, that as each new wave of self-conscious ingenuity invented its peculiar oddity, they were all rationalized as being in some subtle or oblique way more real than any accurate optic image.

24

Impressionism was hailed at first as a break-away from academic authority, liberating the artist's vision from systematic practices of long standing that suppressed its true variability. Introduction of the precise study of natural illumination enabled artists to convey actual appearances at any given moment of the day or season of the year, with enhanced vibrancy attainable by means of the divided brushstroke and new scientific discoveries regarding the physiology of color vision.

When the novelty of these innovations as a triumph over the past wore off, questions were raised about the validity of imitating vision at all since painting could only create an "unreal" illusion of depth and volume on what was truly just a two-dimensional surface. Eventually *avant-gardism* demanded of the artist sweeping rejection of all the means and canons of established craftsmanship in order to demonstrate the free-

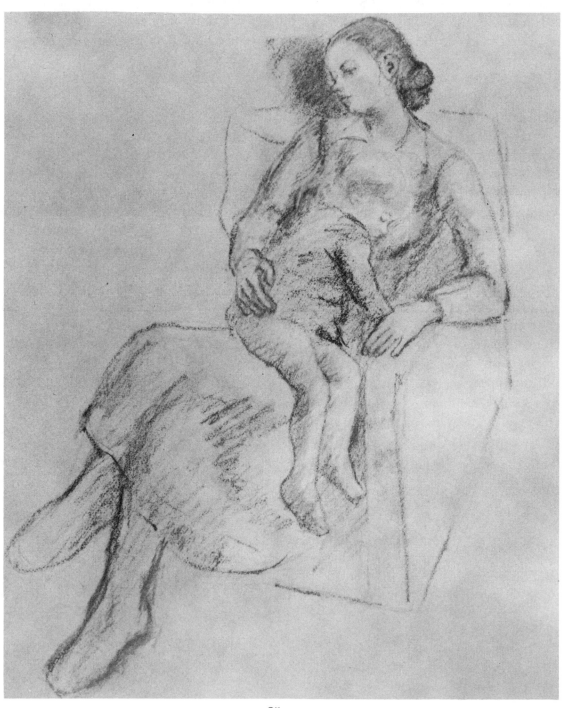

dom and ingenuity of the individual personality, which presumably became for its practitioners and their followers the only significant reality.

Evidences of need for drastic change in all phases of modern life seemed to be indicated by the dramatic advances of natural science, achieved in discarding early concepts of the nature of reality in favor of totally new approaches. In citing this precedent, however, the art world overlooked the basic rejection in laboratory practice of inspirational assumptions that could not be demonstrated by objective analysis and observation according to a set of clearly demonstrable principles of cause and effect accessible to any alert practical intelligence.

The strikingly new departures in such movements as Cubism's insistence on bulk as an aspect of reality and Futurism's attempt to discover means for conveying previously neglected sensations of movement were largely scorned by the American public when first exhibited in the Armory Show of 1913. It was not until later that they became more acceptable to the art world in the United States as part of a rising attachment to European cultural refinement brought about during the first World War and in the birth of transatlantic tourism thereafter.

However, a comprehensive view of the history of art shows clearly that negation of traditional views as advocated in the *avant-garde* movement could not have a basic validity paralleling the revolutionary overthrow of ineffectual notions from the past about natural science. Indeed, cultural aims similar to those of previous ages have been revived repeatedly in an almost cyclical pattern of stylistic evolution based on practical social change. Since about the seventeenth century diametrically opposed approaches have even prospered simultaneously as the structure of society became more complex. In Paris under the Bourbon aristocracy the modesty of Chardin's noted genre studies was accepted side by side with the Rococo flamboyance of Boucher and Fragonard.

Realism has survived several rejections previous to its apparent demise in the twentieth century. Skillfully realistic representations of animals of the hunt in the earliest cave paintings made during the paleolithic origins of human culture gave way to the totally abstract patterns of neolithic art, when they became appropriate for asserting by their rhythm and geometry the nascent power of disciplined human thought over natural environment. Growth of confidence in such procedures as their effectiveness increased through the ages inspired adoption of recognizable motifs, eventually elaborated to the production in ancient Greece of a new naturalism in which essential formal and canonical controls were used without disturbing the appearance of reality.

Abstraction reappeared a few centuries later in the hieratic symbolism of Byzantine style, conveying widespread emotional dependence on religious fantasies as an escape from the impoverishment and violence of human life that followed the decay of the Roman empire. After several centuries new conditions impelled artists to strive again for natural imagery. These familiar developments show that creation in the plastic mediums may resort in varying degrees to formal pattern or realistic description; but abstract rhythmical repetition of natural or geometrical motifs came to be considered serviceable simply for decoration, while unmodified representation was rated as performing only the function of illustration. Major works of art are generally expected to combine the two with cooperating force, though the degree of emphasis on either form or content will vary greatly according to attitudes felt by the individual or the society by and for which they are produced.

In the eventual reaction against the recent advocacy of totally abstract free or geometrical forms which make no precise allusion to human experience, paintings con-

taining any visually recognizable reference may be considered realistic. Thus the term blankets a wide range of variation in the emphasis either on the appearance of the objects represented or the aesthetic controls whereby the work is enabled to fulfill an artistic function, as well as in the degree of accuracy and detail with which the content is developed and the relatively objective or subjective, intellectual or emotional reaction to environment that motivates the artist's choice of material. A powerful personal presence is felt in the style of painting used by Susan Kahn, which qualifies as intensely realistic in respect to her immediate situation.

An example of highly personal realism in the art of the past may be seen in the unique style El Greco developed out of contact with the Renaissance as a journeyman in Venice. Though his painting of the human figure is often cited as unrealistic, careful ex-

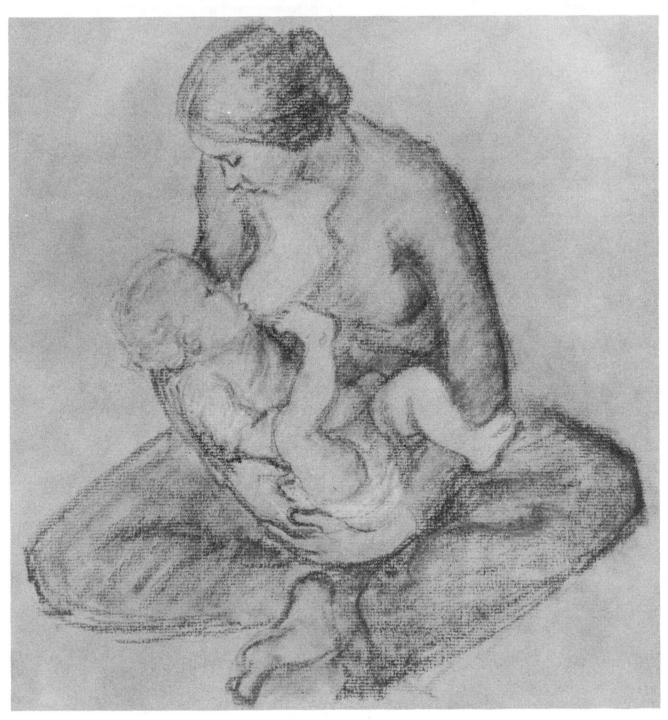

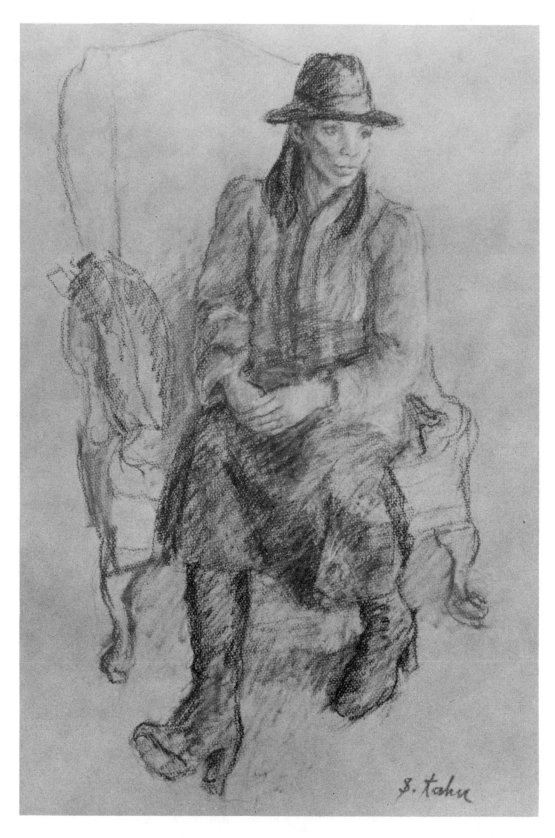

amination reveals that no anatomical distortion results from what was actually a sensitive departure in the direction of more dramatic tonality, though the proportions are somewhat elongated. Likewise the optically realistic approach of the Impressionists which they advanced as an application of new scientific discoveries regarding the physiology of vision, was nevertheless at first rejected by many as tactilely less realistic than earlier styles employing precise linear contours and smoother application of paint. Realism in the work

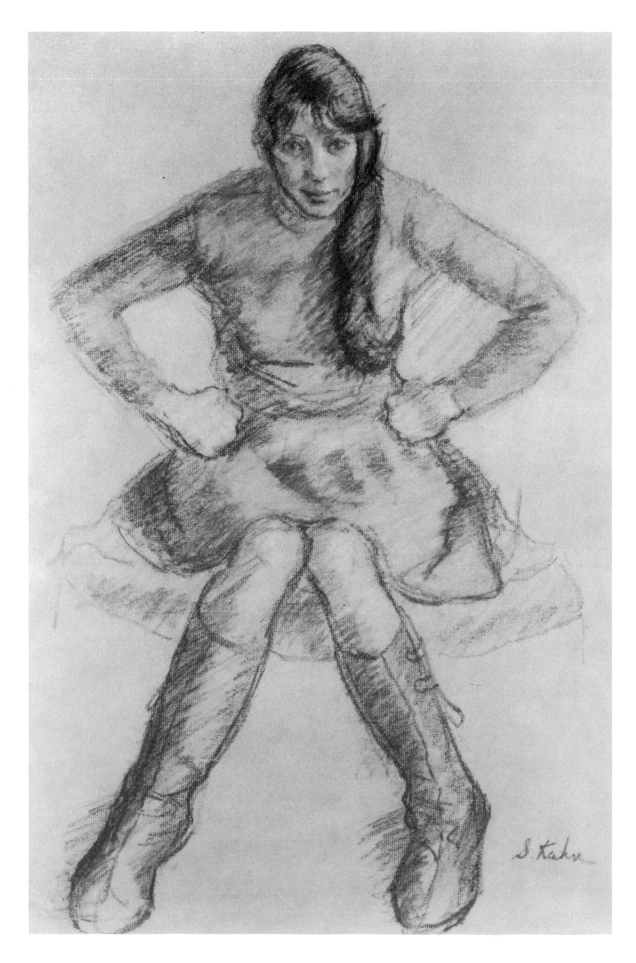

of Susan Kahn is aimed predominantly at describing aspects of her surroundings, although not carried to the point of sharply detailed delineation.

Respecting subject matter, twentieth century realism is qualified by the individualistic projection increasingly demanded of artists in the name of originality. Thus the degrees of emphasis on personal experience in the subjects they select may vary even to the point of depicting detached introspection which seems to absorb so many of Susan Kahn's characters. The latter-day approach contrasts with the highly objective description of peoples' lives or their joint activities in the community which was characteristic of the work of Amercan artists like Mount, Bingham and Eakins throughout the nineteenth century.

Though cultural change is often evolutionary, occasional sharp reversals have faced artists as craftsmen with the problem of reconstructing technical means for achieving the long neglected objectives they must revive. Early in the second Christian millennium, when material advances under a vigorous new market economy uprooted the prevalent disparagement of earthly existence that had comforted the hard-pressed majority during the feudal era, artists had to change such mystical, other-worldly emphases. The cumu-

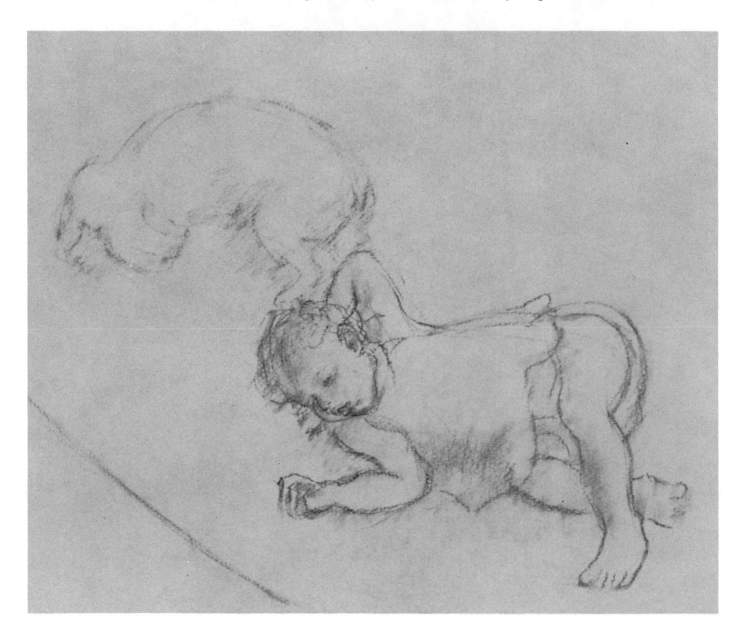

lative ingenuity of several generations of Gothic and proto-Renaissance artists was needed to adjust the symbolic Byzantine distortion of natural appearances and abandon the even more abstract patterns of manuscript illumination in northern Europe.

Giotto and his followers simply achieved a sense of three-dimensional bulk in their otherwise unnaturally stiff figures. Masaccio is cited for developing a grasp of anatomy and gesture, with perspective and chiaroscuro coming still later. Eventually a style paralleling the reality of late Roman illusionism was achieved, which was considered a rebirth of classical culture rather than something totally new.

Though many American artists of the early twentieth century embarked on a considerable change of style as well as content away from the vigorous representation of contemporary life that had played such a large part in previous production, abandonment of the aim to create recognizable imagery after World War I was never as universal as sometimes supposed. The work of Susan Kahn displays an approach coinciding with

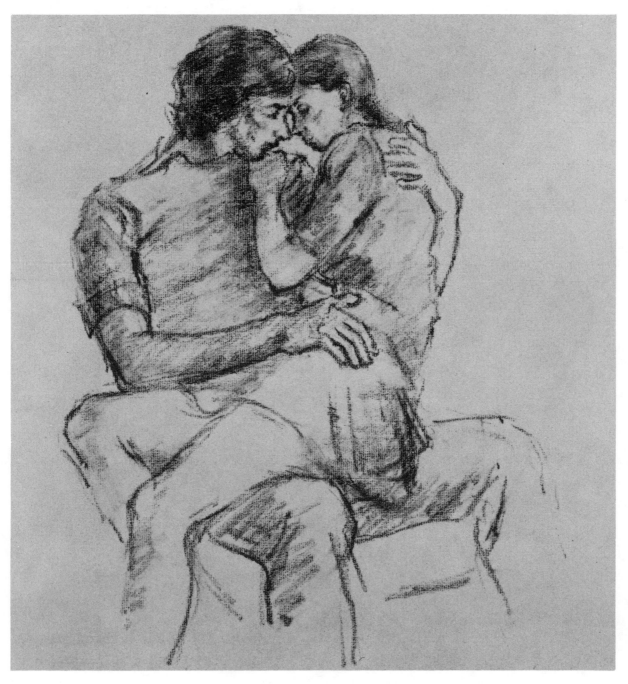

that of a considerable number of artists who did not allow the function of reflecting the nature of their physical or social environment to die out completely during the spell of critical admiration for subjective stylistic license. Their steadfastness eliminated the need for laborious reconstruction of the craft used to produce a reflection of natural appearances, as can be seen in the skillful reality she has been able to accomplish through her study with Moses Soyer, one of those who had never departed from the realistic tradition.

The fallacy that a totally non-objective mode became the universal concern of artists by mid-century was due simply to drastic imbalance in the offering of the commercial galleries, which was assumed by writers for the public press to represent a complete reversal of standards and taste. Their attitude, of course, is not as intellectually impartial as might be expected in a trained expert, since it must be influenced at some level of consciousness by the dependence of their employment on returns from the advertising columns.

Some justification for the extremes of *avant-gardism* was attempted by citing the pioneer element in the American cultural background as having made progress through experimentation and change. Those artists who interpreted this heritage differently and continued to produce work based on recognizable imagery achieved reasonable success but limited critical acclaim. Moreover, they set a clear example for those of the ris-

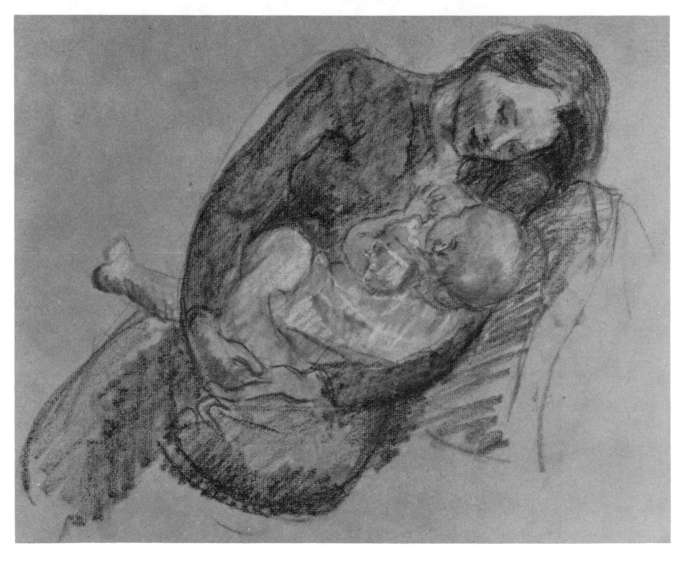

ing generation who shunned the *avant-garde* bandwagon, and several made themselves available to teach the techniques involved.

Notable among them were the brothers Raphael, Moses and Isaac Soyer. Early in her career Susan Kahn became a student of Moses Soyer, whose style of painting was similar to that of his somewhat more prominent brother Raphael. It is clearly reflected in paintings based entirely on literal representation of her surroundings, with emphasis on their personal rather than material aspects. Witness to the widespread survival of substantial public interest in art that reflects actual phases of contemporary life appears in the number of Mrs. Kahn's paintings that have been acquired for their permanent collections by museums in cities from coast to coast throughout the United States.

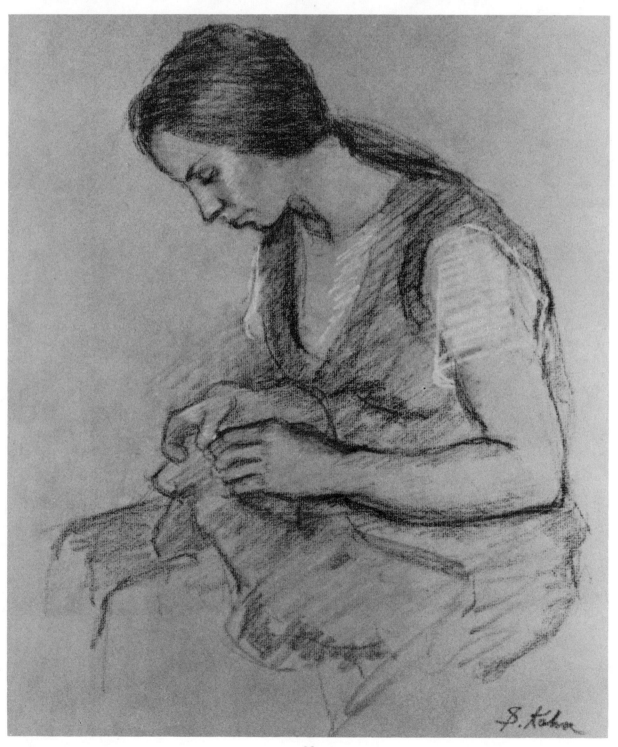

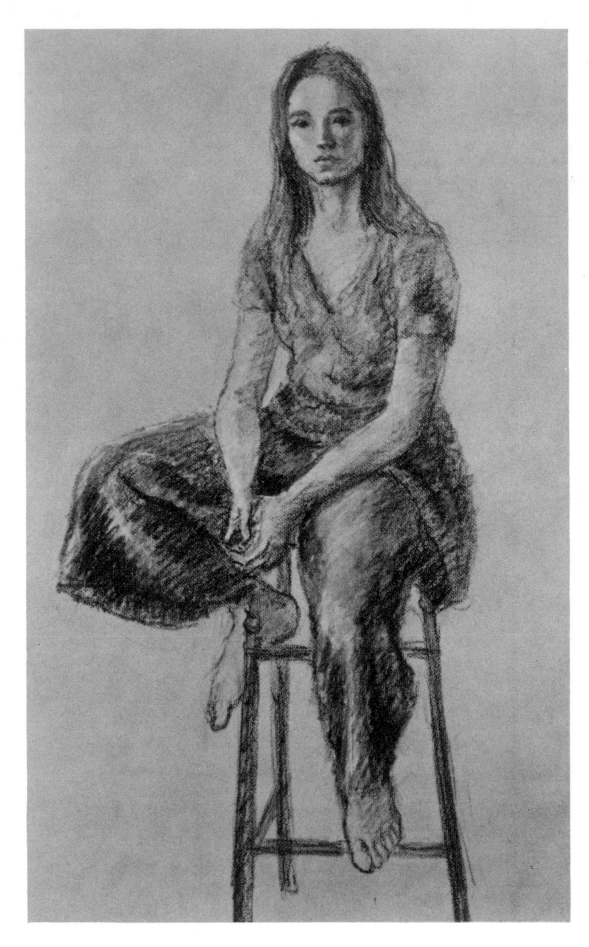

The scope of her subject matter is limited largely to the study of characters in her immediate social environment who convey a somewhat more lively sense of activity and involvement in personal interests than the more reflective individuals found in work by the Soyers. The youthful personnel of her paintings are often engaged in entertaining themselves or one another with carefree and exuberant performances of music and dance within the confines of the artist's studio rather than for a public audience. Basic or overriding relations between the sexes also receive almost constant attention.

Besides this enhanced sense of lively, light-hearted association, the spatial composition in Kahn's painting exhibits another marked difference from the calm roominess of the Soyer style. Her figures fill most of the area of the canvases without crowding but offering little implication of deep space surrounding them. However, vigorously recessional poses in virtually all the pictures of single figures or couples set up a strong sense of spatial volume with almost sculptural force. Larger groupings are spread out, moving back from the picture plane to create a volume of interior space but making little reference to details of the environment beyond the figures.

An apparent exception to this observation appears in some of the more elaborate compositions like *Studio Break* (1973, Fig. 65), but in this work the more profuse items of the setting are integrated with the figures rather than being used simply to create a background for them. Though the effect is quite open, all of the components are inter-related, whether animate or inanimate. The mirror at the back of the room bears the image of a painter who is in front of the picture plane. Thus an axis between the glass and what it reflects is projected forward, leap-frogging the crouched figure of the girl with a dog at the center and dramatically expanding the space represented within the frame. The picture plane is dissolved and the beholder becomes an additional occupant of the comprehensive sphere. The mirror and the image it reflects, along with the two other male figures, set up a dominant relationship of rhythmically spaced verticals echoed in details such as the musical instruments held by the man and woman at the left.

Kahn's casual handling of her brush seems to contradict the amount of care used to develop many of her compositions. The looseness of the brushwork adds to a soft tonality related to that of the Soyers, but not at all identical. Her paintings are enlivened with more sharply modeled detail at focal points. In single figures and couples the heads at least are always carefully done, and also the contours of limbs that move at an angle to the picture plane in order to enhance the construction of depth. Some later works such as the painting of *Cathy in a Scarf* (1977, Fig. 93) shows the whole figure quite carefully modeled and no attention is called to the artist's manual activity.

Unlike the work of many noted masters, the handling of paint in Susan Kahn's creations does not show a consistent evolution from firm to loose. It seems to vary rather in terms of her reaction to the particular subject at hand, except that contrariwise the heaviest impasto as in the *Mother and Child #3* of 1963 (Fig. 20) or the *Street Scene* of the same year (Fig. 19) owned by the Montclair Museum seems to phase out in the later work where more of the careful modeling is encountered.

To the extent that an evolutionary trend can be noted, the modeling becomes firmer rather than more loosely brushed as is usually the case. Thus the width of the strokes when they show in the later work seems to diminish and they are more carfully controlled. The change, however, is not entirely consistent and *Back Pack* (1974, Fig. 76) reverts to loose handling even in much of the central figure. Here it seems that the thoughtful manner in which the canvas is composed, with the striding figure of the mother emerging from the funnel-like space suggested by the curving path in the back-

ground, would have been clearer and more effective had the distant forms been more sharply realized.

Many artists of the recent past with a strong realistic commitment have felt they must make some concession to widely accepted insistence on bizarre gestures of individuality. This prevailing emphasis may account for Kahn's avoidance of more firmly clinching the forms though their bulk and structure obviously interest her more than the manner of their presentation.

The degree in which their art may be affected by basic and often subconscious aspects of their own lives can be seen in the work of artists with a strong spirit and emotional vitality such as dominate the creative impulses of Susan Kahn. One example is the repeated recurrence of certain subjects in her painting. She has herself commented that a tendency throughout her career to repeat groups of mother and child derives from her disappointment early in her marriage at the discovery of the physiological impossibility of bearing children herself.

The youthful crew that peoples much of her work corresponds roughly in age to what her own offspring might have been at the time, or they may reflect the age levels

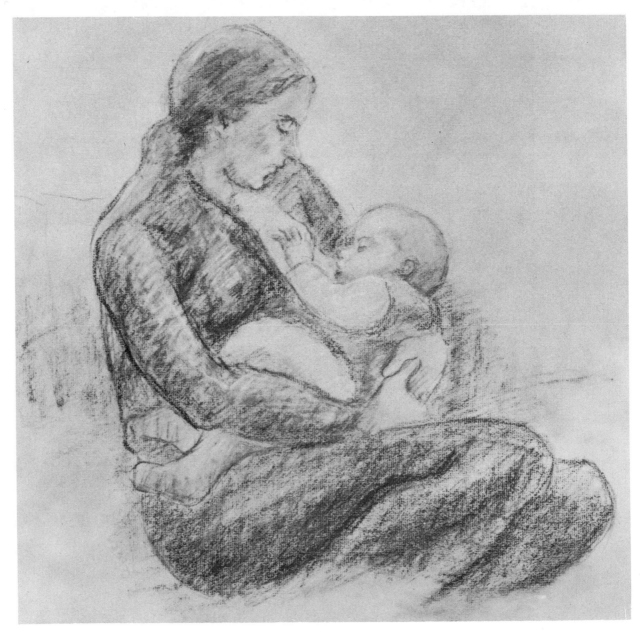

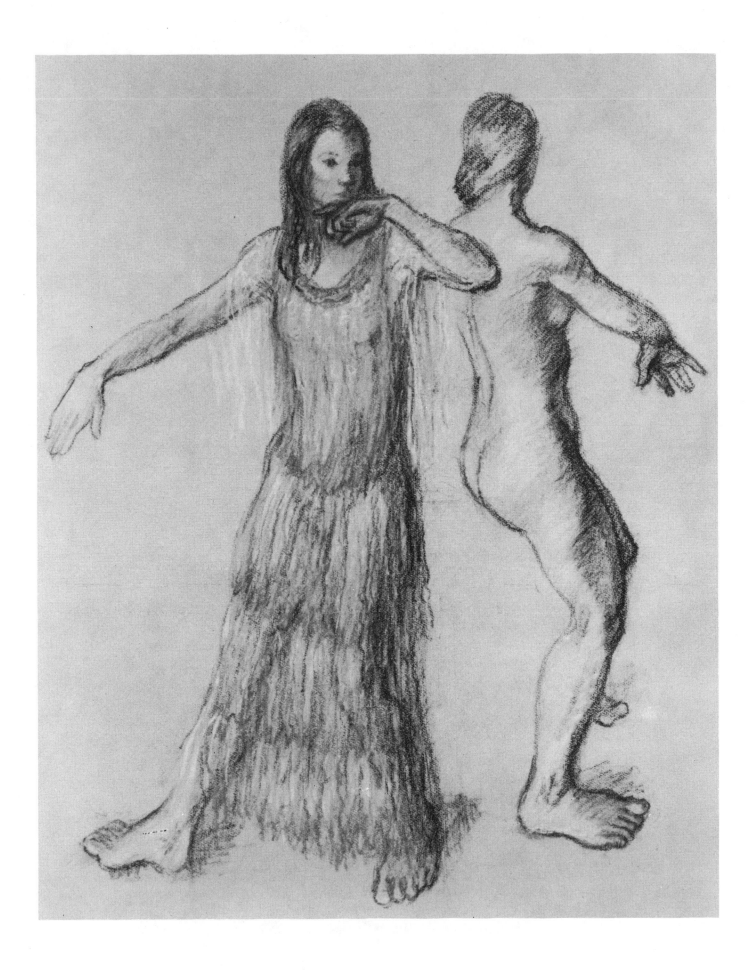

of those with whom she associated when her more gregarious early interest in the stage was paramount, a way of clinging to the aspect of that life she most regretted giving up. The implication of constantly prevalent emotional bonds between the sexes, especially in many paintings of young couples, may reflect some of the warm feeling generated in her own early and long-lasting marriage.

Despite, or perhaps to counteract, the relatively somber tonality that pervades many of Susan Kahn's paintings, she displays a frequent interest in using areas of bright color, often making drastic contrasts to achieve a stimulating effect. In the foreground of *Sale* (1974, Plate III) the three primary colors are lined up at the picture plane, but they nestle into the prevailing atmosphere without any disturbing tension. Echoes throughout the canvas help to organize the composition, and the rack of garments at the center ingeniously adds the secondary colors for a truly resounding orchestration.

In a work like *Studio Pause* (1979, Plate XII) the alternation of blue and red areas serves effectively to enhance the unity of the composition. Modifications of a prevailing red tonality contribute to the integration of *Jug Band* (1973, Plate II) with the contrasting blue shirt at the center firmly anchoring the surrounding circle of active performers.

Consistently throughout her voluminous production the artist's vital emotional awareness can be felt. Even the large number of canvases displaying only a single figure or a couple convey a predominantly reflective or even brooding air, which seems to contrast with Mrs. Kahn's own vivacity, but may echo a deeper strain in her personality.

Large groups are also frequent among her subjects as in the studio compositions of which the spatial construction has already been described. The standard trappings of an easel and pictures hanging on or leaning against the walls are integrated with the

figures so that space is felt more in terms of movement from one unit to another rather than as a surrounding volume that stretches on toward the horizon or infinity. Thus the implication is created of some sort of social relationship among people gathered in an enclosed space, as against the more usual feeling about volumes of emptiness as conveying dispersal and isolation.

An interesting extension of this feeling of liaison recurs in the repeated motif of a large mirror reflecting either a person immediately before it or someone across the room as in the painting *Studio Break* described above. In several paintings like *Standing Nude* (1977), *Double Image* (1968, Fig. 38) and *Reflection* (1970, Fig. 47) only a single figure is shown so the bond is more self-centered.

A corollary to the way in which this limited type of spatial axis reverses the feeling of relaxed, comradely intimacy of the studio interiors is shown in several paintings of a person regarding an extensive open vista, in almost every case the tightly built-up city,

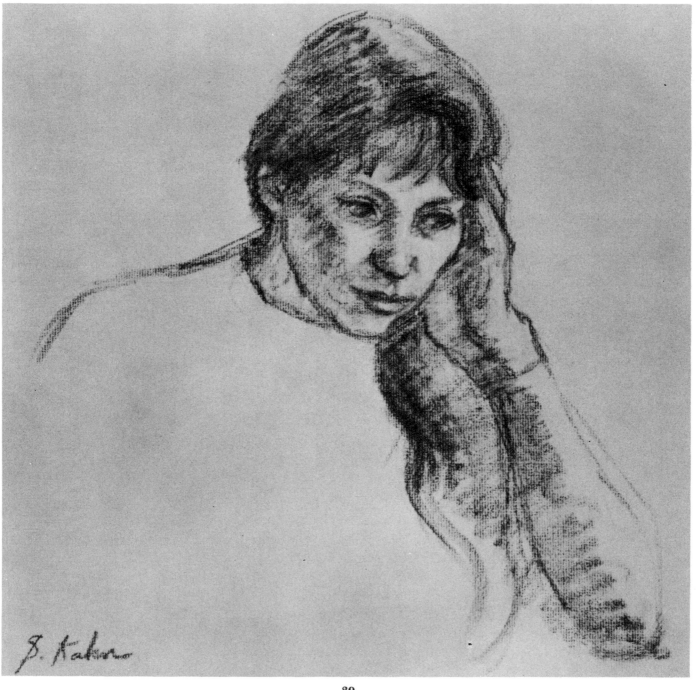

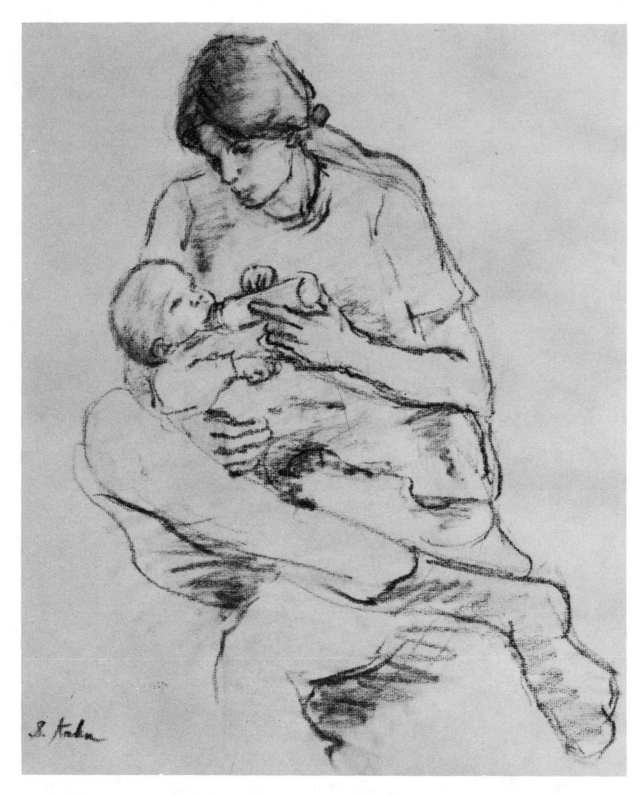

either from a roof top or studio window. The background is always quite distant with no representation of middle distance to relate the generally lone figure in the foreground with the buildings, streets and waterways so meticulously developed but too far away to reveal any human activity.

The presence in most of these distant views of bridges over the East River with their suspension spans looping between firm upright supports seems to convey more than the incidental circumstance that they happen to be visible from the elevated perch. The movement might suggest the life of the city pulsating within all the remote structures

and arteries, the circulation in and out of the populous boroughs and suburbs for which Manhattan Island serves as a focal core, or it might even add to these obvious possibilities a deeper, subconscious symbolism.

Besides presenting groups of figures in studio interiors, some of Susan Kahn's compositions show crowded city streets but with an opposite social implication. The center may be occupied by a person or couple presumably from the artist's circle who have ventured forth among the completely detached and less individualized passersby, or no focal personalities are developed at all, as in the canvas called simply *City Street* (Plate X). These pictures do not attempt to convey any sense of what the surrounding people might be about or the appearance of the city itself, but simply that a sea of strangers surges constantly along the public thoroughfares. The sign *Don't Walk* on the lamppost behind the strolling young friends in the painting of that name (1971, Fig. 54) seems to reflect a vague emotional caution about venturing forth among the unknown horde as well as the practical traffic precautions made necessary by so much activity.

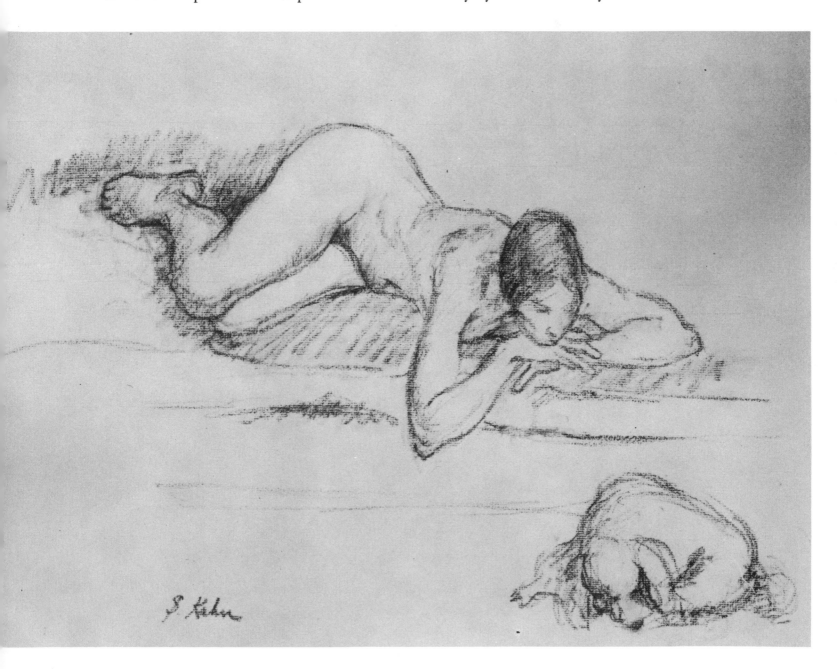

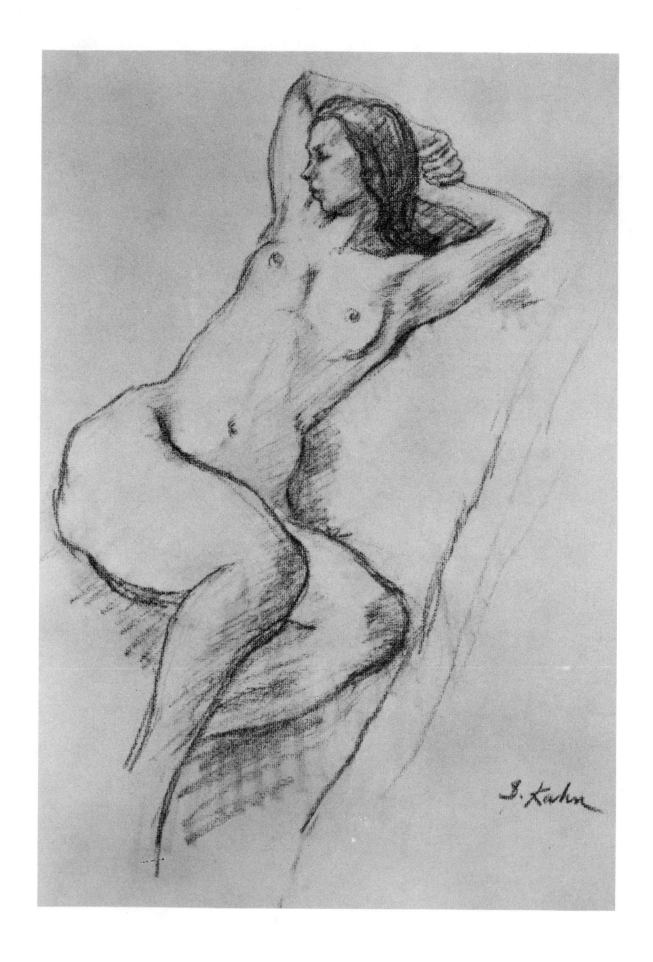

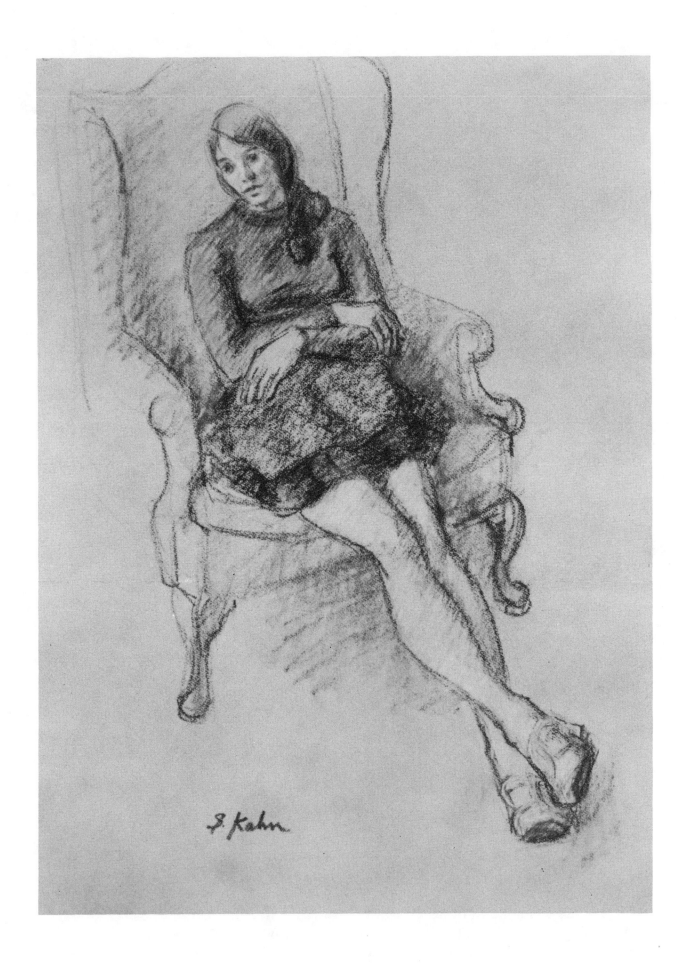

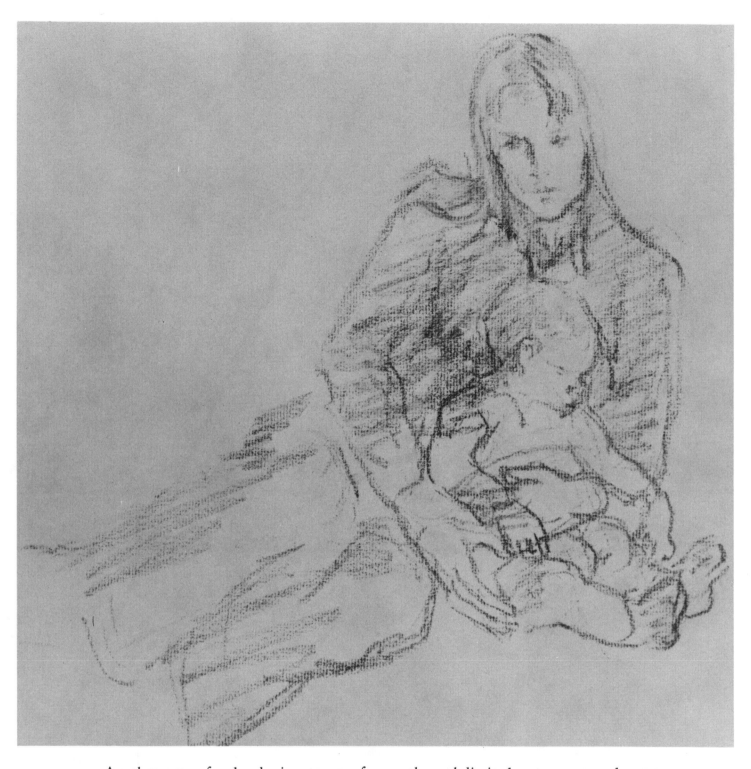

Another means for developing a sense of space through limited or concentrated movement is used by the artist in a series of pictures of the dance. All of them present the participants simply as bodies moving from some inner motivation without the usual theatrical setting or any implication of performing for an audience. Though several of the dance compositions depict figures in striking costumes as in *Monarch* (1978, Fig. 94) this added display can be taken as an extension of a desire for personal expression in the dancer's attempt to create a distinct role romanticizing her personality.

Shortly after the death of her beloved mentor, Mrs. Kahn painted *Homage to Moses Soyer* (1976, Plate VI) which she has described as follows: "His work usually showed people wrapped in their own thoughts so I painted young people around him in that

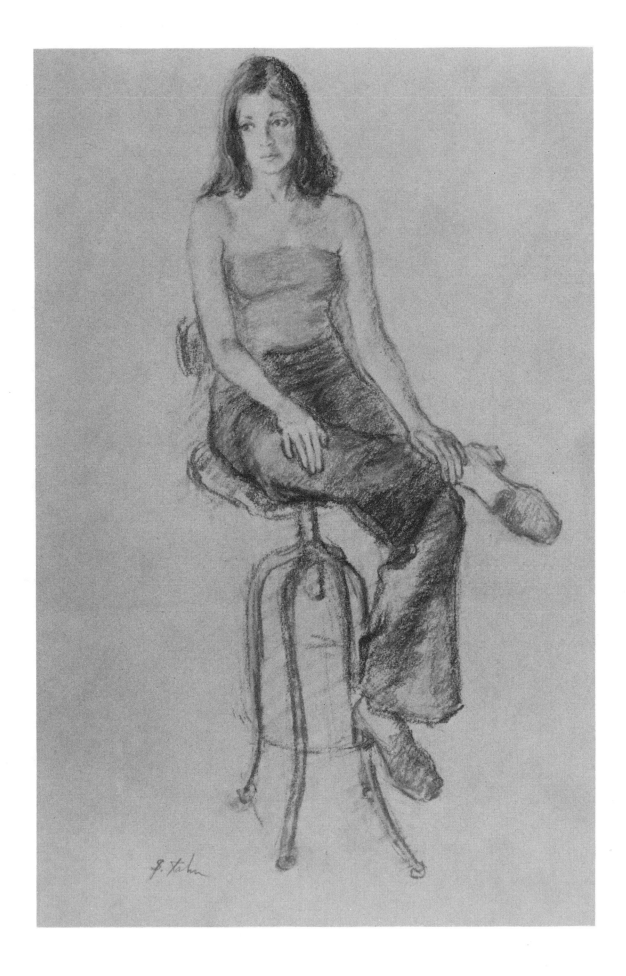

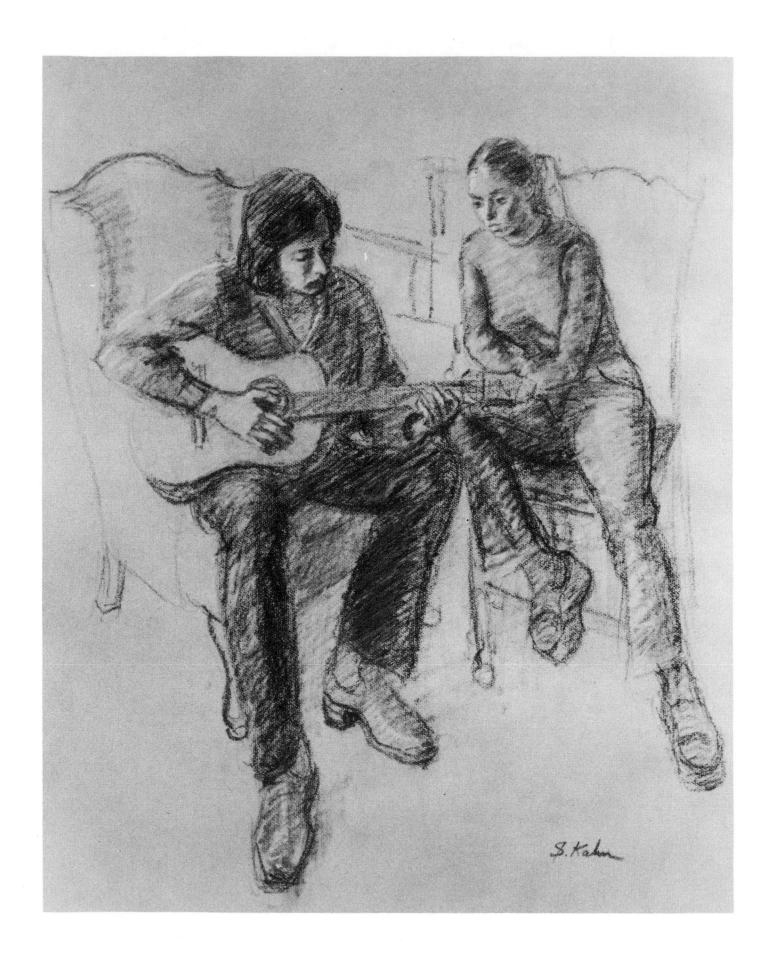

manner. Moses sits on a high stool on the right middle ground of the canvas, and behind him in the center is Cynthia who posed for him for about thirty years. She is playing the auto harp. Behind her one can see part of a Soyer painting that Cynthia posed for called *Intimate Concert*. In the foreground at the left is Phoebe Neville leaning on her hand, a pose Moses painted many times. In the far background is an antique easel with the start of a self-portrait of me on it."

This painting perhaps epitomizes the special avenue of realistic contemplation that Susan Kahn has adopted in her work. She depicts an immediate, intimate, detached sphere in which her emotions are intensely involved. Though a full scale revival of realism in the plastic arts must also eventually include artists who are willing and able to ignore the inhibitions about the complexities of the modern world and venture beyond the confines of their studios to encompass work-a-day activities and their settings, the more introspective approach of this artist represents a prevalent aspect of her contemporary world.

In view of the tendency of many people to concentrate on a particular line of activity, practical or otherwise in the "age of specialization," an important truth about life in the twentieth century is recognized by Kahn's exploration of the confined sphere of inner emotional impulses that may develop due to its limitations. Indeed, the problem of translating these intangibles into legible plastic expression, accomplished so successfully in the work of Susan Kahn, demands great sensitivity on the part of the artist, who thus renders a more profound understanding of the age.

This detachment from the practical world also reflects in a substantial way the opportunity afforded by the bounties of mass production in the twentieth century for widespread independence from material concerns, which has fostered great intellectual and creative successes. Other artists might present different aspects of the age as the result of their own special orientation to environment, for plastic art is one of the most comprehensive of media. The quiet intimacy of Vermeer as well as the teeming activity of Breughel have both been amply admired in their own times and by people in many subsequent ages, and reflections of either attitude continue to be legitimate forms of expression for realistic art in a socially more complex era.

Susan Kahn: The Background

EDUCATION:

Parsons School of Design
Studied with Moses Soyer

GROUP EXHIBITIONS:

Audubon Artists, New York
National Academy of Art, New York
Springfield Museum, Springfield, Massachusetts
New York City Center
ART USA
ACA Galleries, New York
National Arts Club
Butler Institute, Youngstown, Ohio

ONE MAN SHOWS:

Sagittarius Gallery, New York, 1960
ACA Galleries, New York, 1964, 1968, 1971, 1976, 1980
Charles B. Goddard Art Center, Ardmore, Oklahoma, 1973
Albrecht Gallery-Museum of Art, St. Joseph, Missouri, 1974
New York Cultural Center, 1974
St. Peter's College, Jersey City, New Jersey, 1978

MUSEUM COLLECTIONS:

Syracuse University Museum
Sheldon-Swope Gallery, Indiana
School of Advanced International Studies, Johns Hopkins University, Washington, D. C.
Montclair Museum of Fine Arts, Montclair, New Jersey
Butler Institute of American Art, Youngstown, Ohio
Reading Museum, Reading, Pennsylvania
Albrecht Gallery-Museum of Art, St. Joseph, Missouri
Cedar Rapids Art Center, Cedar Rapids, Iowa
Tyler Museum, Tyler, Texas
Joslyn Museum, Omaha, Nebraska
St. Lawrence University Museum, Canton, New York
Fairleigh Dickinson University, Rutherford, New Jersey
Ulrich Museum of Art, Wichita, Kansas
University of Wyoming, Laramie, Wyoming

AFFILIATIONS:

Artists' Equity
National Association of Women Artists
Knickerbocker Artists

Color Illustrations

(All color and monochrome illustrations are oil on canvas, unless otherwise noted. Sizes are given in inches, smaller dimensions first.)

Monochrome Illustrations

17. *Copacabana Carnival*, 1963. 30 x 36. Collection of Mr. and Mrs. Richard Weinstein.

18. *Aunt Jane*, 1963. 16 x 20. Collection of Mrs. Jane Neumann.

19. *Street Scene*, 1963. 20 x 24. Collection of Montclair Museum of Fine Arts, Montclair, N. J.

20. *Mother and Child #3* , 1963. 14 x 18. Collection of Mr. and Mrs. James Meade.

21. *Young Couple*, 1963. 12 x 16. Collection of Mr. and Mrs. Samuel Kahn.

22. *Two Girls*, 1963. 12 x 16. Collection of Mr. and Mrs. Howard Pack.

23. *Young Couple*, 1964. 20 x 24. Collection of The Butler Institute of American Art, Youngstown, Ohio.

24. *The Stocking*, 1964. 30 x 36. Collection of Mr. and Mrs. David Kahn.

25. *Masako*, 1964. 22 x 28. Collection of Mr. and Mrs. Charles Maybruck.

26. *Reading*, 1965. 24 x 30. Collection of Mrs. Denise Cohen.

27. *Jane*, 1965. 22 x 28. Collection of Mrs. Bernard Fabrikant.

28. *Friends—Joseph Kahn and Bernard Fabrikant*, 1965. 30 x 36. Collection of the Artist.

29. *Ellen*, 1966. 24 x 30. Collection of Mr. and Mrs. Philip Wise.

30. *Conversation*, 1966. 24 x 30. Collection of the Palace Theater.

31. *Boy and Girl II*, 1966. 16 x 20. Collection of Judge and Mrs. Richard Sydney Lane.

32. *Studio Interior*, 1966. 30 x 36. Collection of Meyer Feldman.

33. *Young Actress*, 1967. 24 x 30. Collection of Mr. and Mrs. Theodore Locker.

34. *Studio*, 1967. 30 x 36. Collection of Reading Museum, Reading, Pa.

35. *Artist and Model*, 1967. 30 x 36. Collection of Fairleigh Dickinson University.

36. *The Pink Robe*, 1967. 16 x 20. Collection of Mr. and Mrs. Irving Lobel.

37. *Mother and Child*, 1967. 16 x 20. Collection of Dr. and Mrs. Meyer H. Friedman.

38. *Double Image*, 1968. 24 x 30. Collection of Cedar Rapids Art Center, Cedar Rapids, Ia.

39. *Eve, Bartley, and Tiffany*, 1968. 16 x 20. Collection of Mr. and Mrs. Bart Chamberlain, Jr.

40. *Pregnant Girl*, 1969. 24 x 30. Collection of Fairleigh Dickinson University.

41. *Confidences*, 1969. 20 x 24. Collection of Raymond Burke.

42. *Feeding Time*, 1969. 14 x 18. Collection of Mr. and Mrs. James Meade.

43. *East End Studio*, 1969. 36 x 42. Collection of the Artist.

44. *Draped Nude*, 1969. 22 x 28. Collection of Mr. and Mrs. Francis Levien.

45. *Napping*, 1970. 14 x 18. Collection of Fretheim Chartering Company.

46. *Musical Gathering*, 1970. 36 x 42. Collection of Joslyn Art Museum, Omaha.

47. *Reflection*, 1970. 36 x 42. Collection of Tyler Art Museum, Tyler, Texas.

48. *The Kiss*, 1970. 12 x 16. Collection of Mr. and Mrs. Ewald Bartel.

49. *Reverence*, 1970. 24 x 30. Collection of Murray Gordon.

50. *River View*, 1970. 30 x 36. Collection of Mr. and Mrs. Maurice Weill.

51. *Seated Nude*, 1970. 14 x 18. Collection of Mrs. Louis Dulien.

52. *Victor and Adrienne*, 1971. 22 x 28. Private Collection.

53. *Seated Nude*, 1971. 24 x 30. Collection of the Artist.

54. *Don't Walk*, 1971. 30 x 36. Collection of the Artist.

55. *Red Nightgown*, 1971. 24 x 30. Collection of the Albrecht Gallery-Museum of Art, St. Joseph, Mo.

56. *Duet*, 1971. 22 x 28. Collection of the Artist.

57. *Street Scene II*, 1971. 24 x 30. Collection of Mrs. Denise Cohen.

58. *Reading*, 1971. 14 x 18. Collection of Mr. and Mrs. Edwin Altman.

59. *Cityscape*, 1972. 36 x 42. Collection of the Artist.

60. *Micki and Paul*, 1972. 30 x 36. Collection of the Artist.

61. *Banjo Pickin' Girl*, 1972. 20 x 24. Collection of the Artist.

62. *Filippa and Christoffer*, 1972. 16 x 20. Collection of Mr. and Mrs. Arne Naess.

63. *Reclining Nude*, 1972. 24 x 30. Collection of the Artist.

64. *Micki Dancing*, 1972. 24 x 30. Collection of Mr. and Mrs. Myron Saland.

65. *Studio Break*, 1973. 36 x 42. Collection of the Artist.

66. *Triple Exposure*, 1973. 24 x 30. Collection of Mr. and Mrs. Egon Rausnitz.

67. *Mother and Child*, 1973. 12 x 16. ACA Galleries.

68. *Young Mother*, 1973. 22 x 28. ACA Galleries.

69. *Modern Madonna*, 1973. 10 x 11. ACA Galleries.

70. *Young Sculptor*, 1973. 22 x 28. Collection of the Artist.

71. *Phoebe Dancing*, 1973. 20 x 24. Collection of Mr. and Mrs. Daniel Levy.

72. *Linda*, 1973. 30 x 36. Collection of the Artist.

73. *Memory*, 1974. 30 x 36. ACA Galleries.

74. *Confidences*, 1974. 24 x 30. Collection of the Artist.

75. *The Anton Family*, 1974. 24 x 30. ACA Galleries.

76. *Back Pack*, 1974. 16 x 20. ACA Galleries.

77. *Sleeping Baby*, 1974. 20 x 24. ACA Galleries.

78. *The Rausnitz Girls*, 1975. 30 x 36. Collection of Mr. and Mrs. Leonard Davis.

79. *Judy Arriving*, 1975. 24 x 30. ACA Galleries.

80. *The Park*, 1975. 30 x 36. ACA Galleries.

81. *Song*, 1975. 14 x 17. Collection of University of Wyoming.

82. *Jeffrey's View*, 1975. 30 x 36. ACA Galleries.

83. *Micki*, 1975. 24 x 30. Collection of Mr. and Mrs. Leonard Davis.

84. *Fantasy*, 1975. 24 x 30. Collection of Mr. and Mrs. Howard Pack.

85. *Young Couple*, 1976. 14 x 18. ACA Galleries.

86. *The Green Scarf*, 1976. 12 x 16. ACA Galleries.

87. *On Stage*, 1976. 36 x 42. ACA Galleries.

88. *Seated Nude*, 1976. 20 x 24. ACA Galleries.

89. *Reclining Nude*, 1977. 24 x 30. ACA Galleries.

90. *White Wine*, 1977. 20 x 24. ACA Galleries.

91. *The Blue Bike*, 1977. 16 x 20. ACA Galleries.

92. *Winter Walk*, 1977. 30 x 36. ACA Galleries.

93. *Cathy in a Scarf*, 1977. ACA Galleries.

94. *Monarch*, 1978. 30 x 36. ACA Galleries.

95. *Alter Ego*, 1979. 16 x 20. ACA Galleries.

96. *Lady Dance*, 1979. 24 x 30. ACA Galleries.

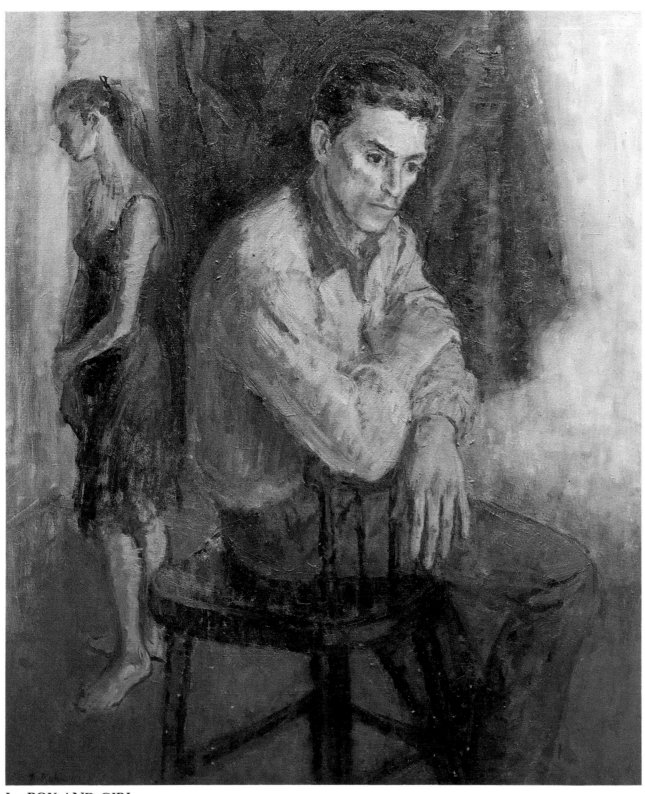

I. BOY AND GIRL

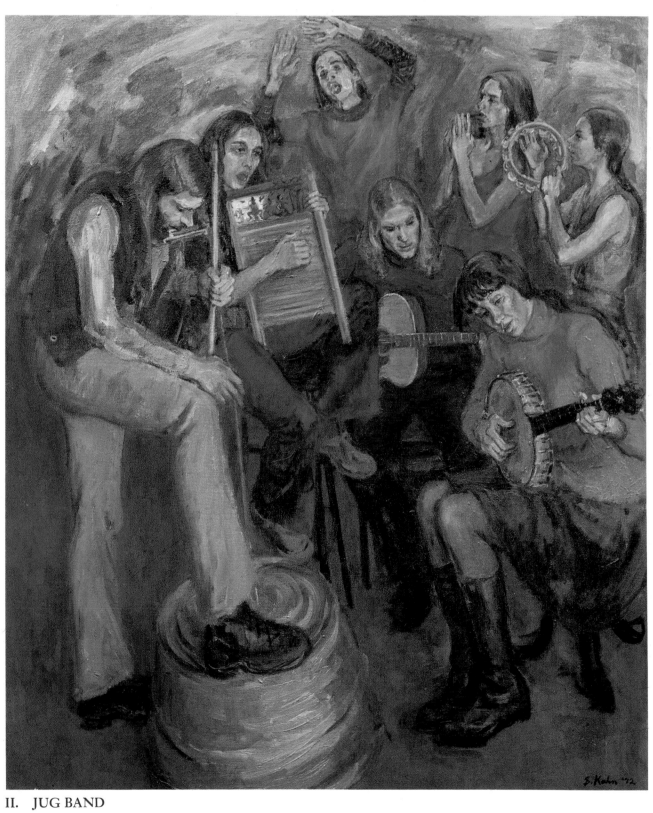

II. JUG BAND

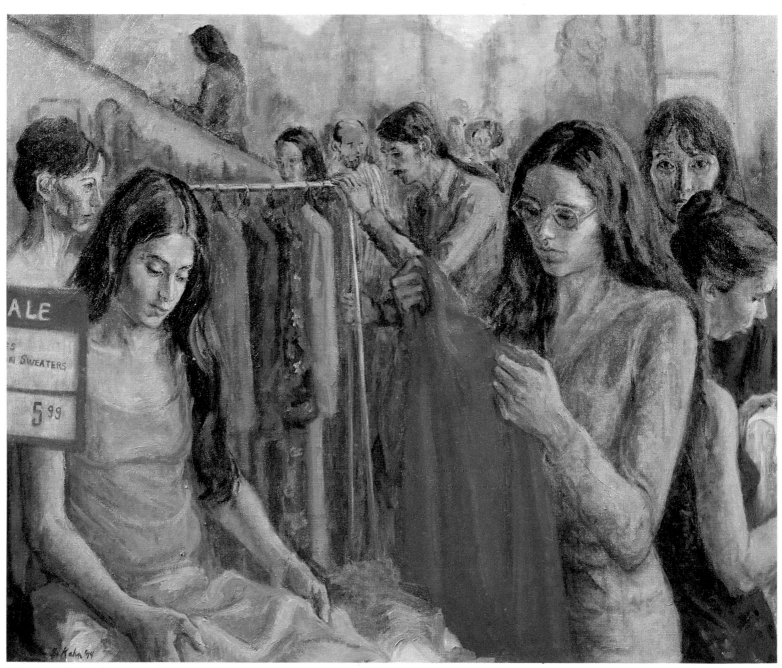

III. SALE

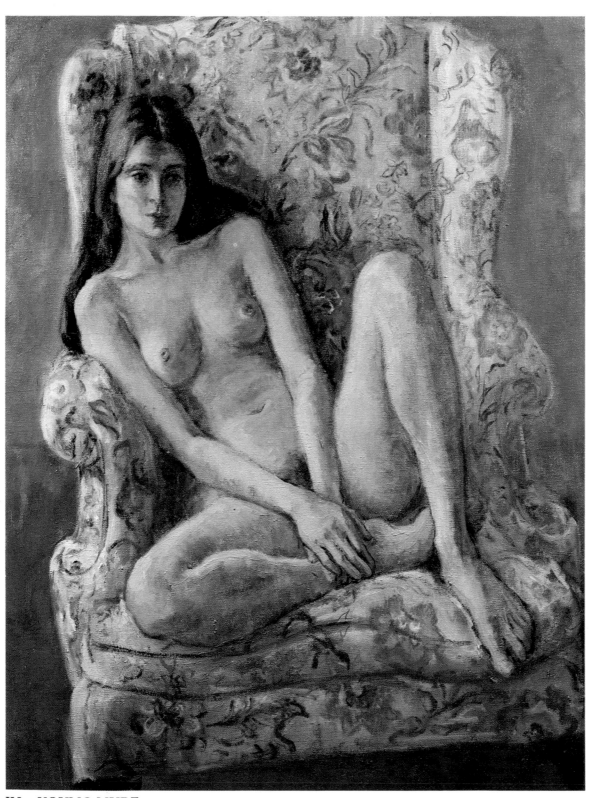

IV. YOUNG NUDE

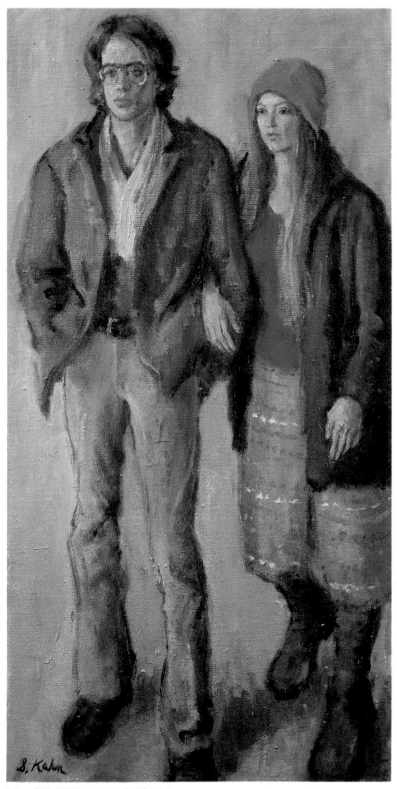

V. PETER AND SUSAN

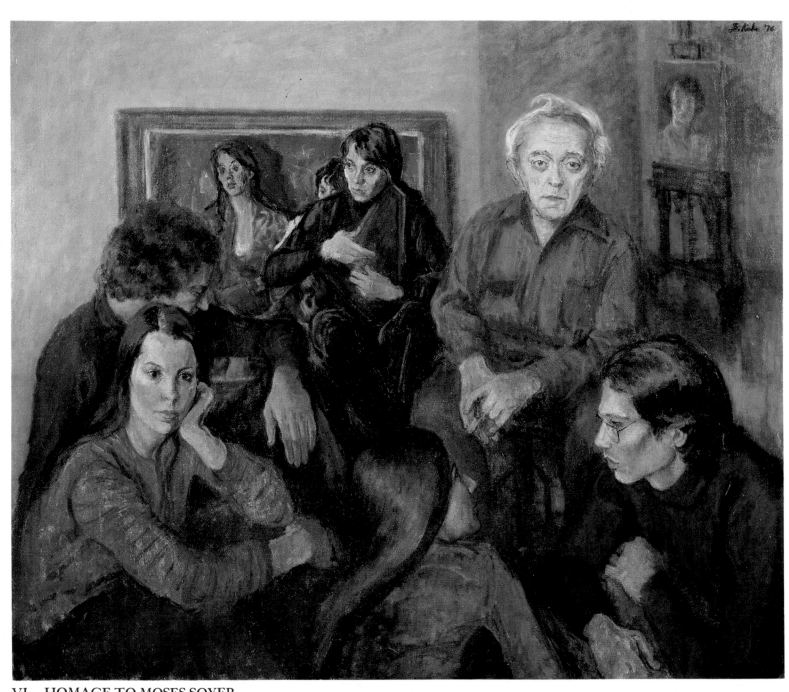

VI. HOMAGE TO MOSES SOYER

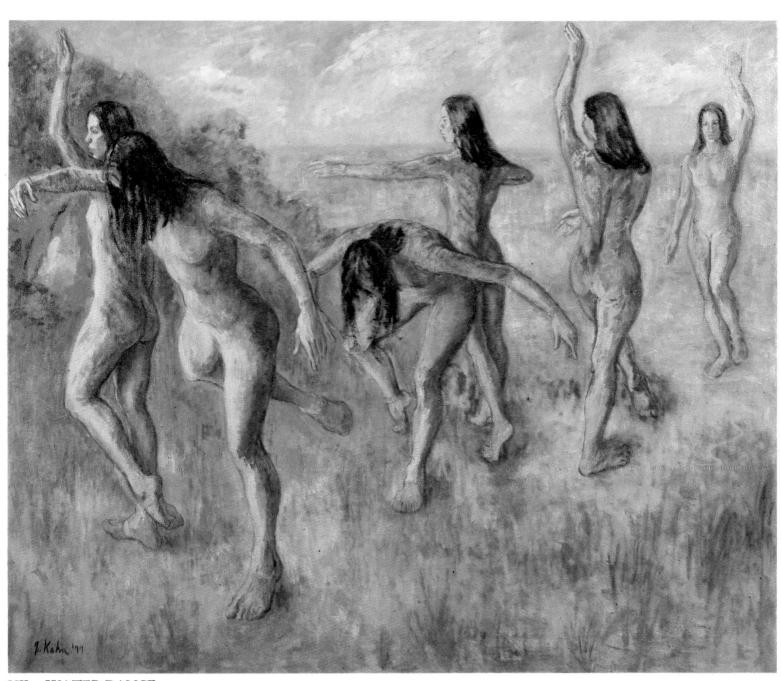

VII. WATER DANCE

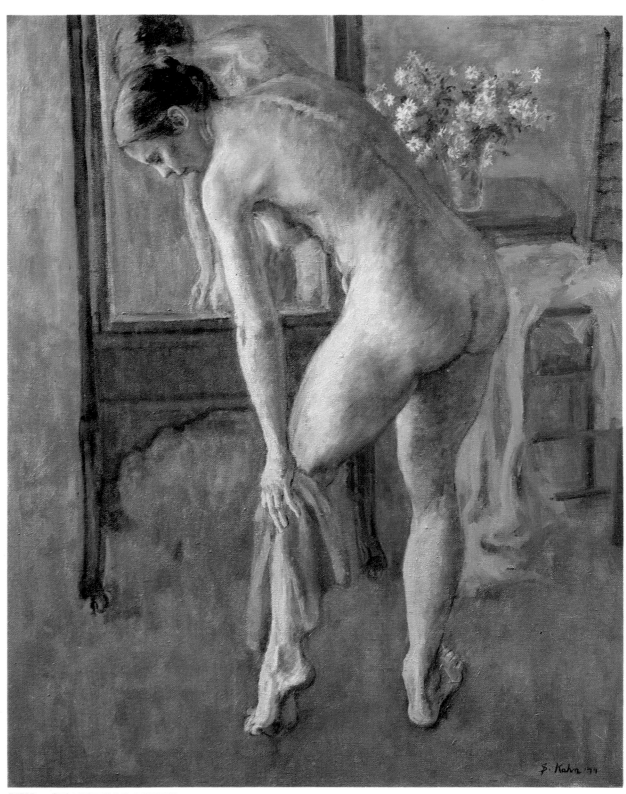

VIII. STANDING NUDE

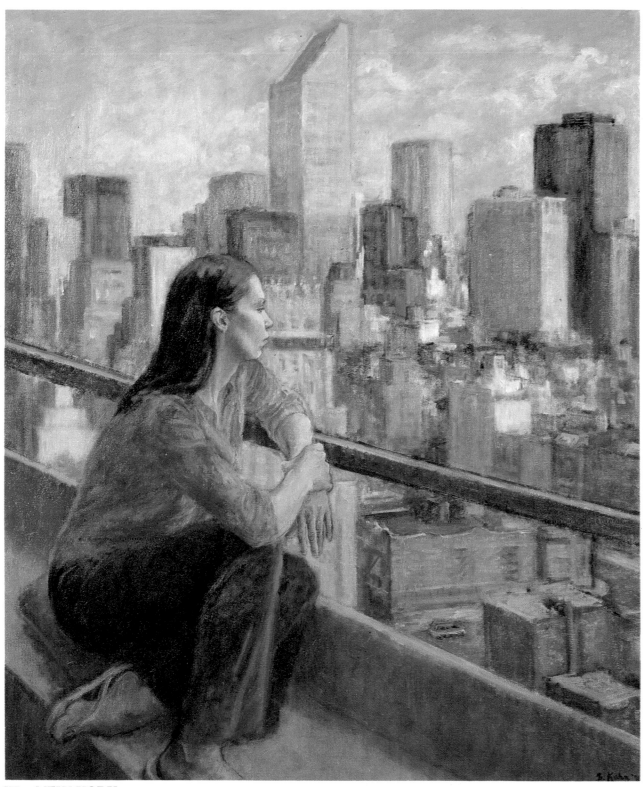

IX. NEW YORK

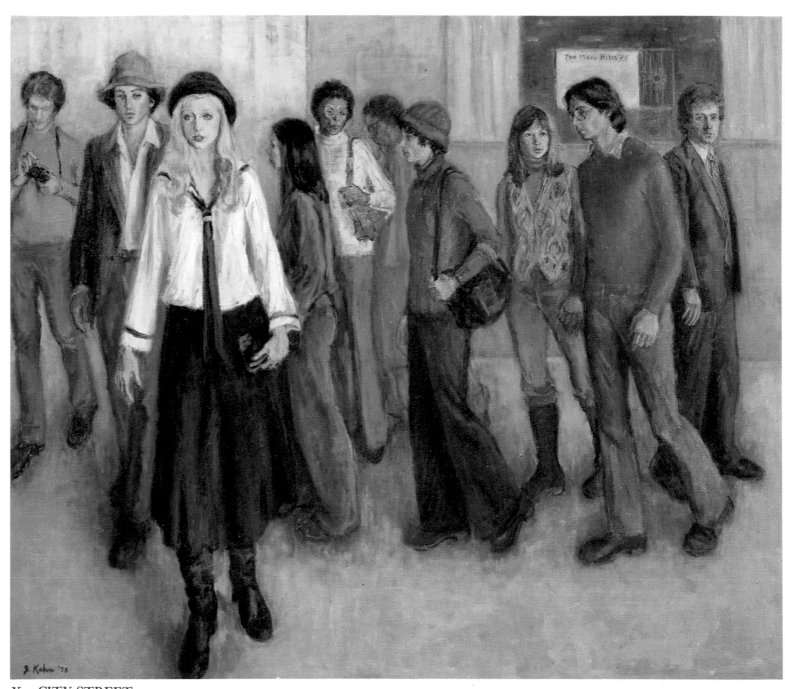

X. CITY STREET

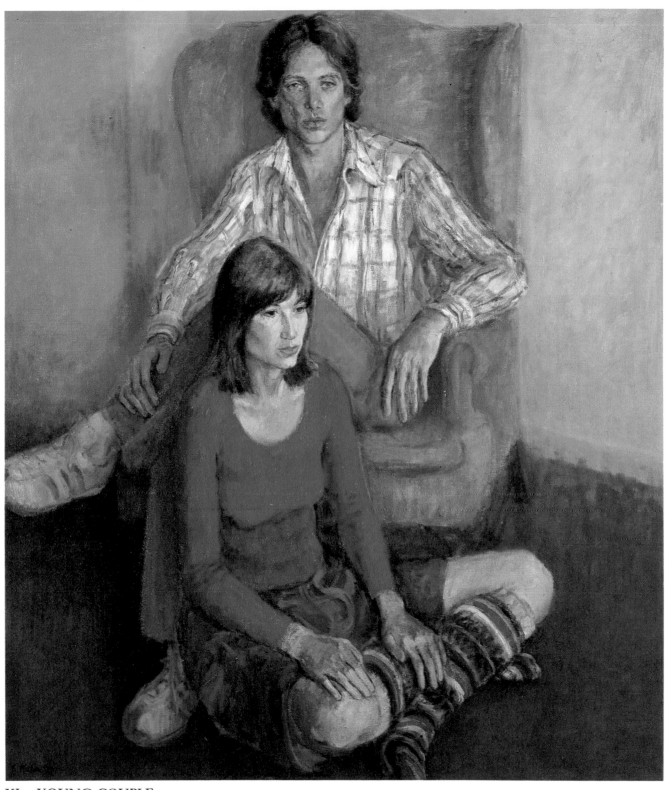

XI. YOUNG COUPLE

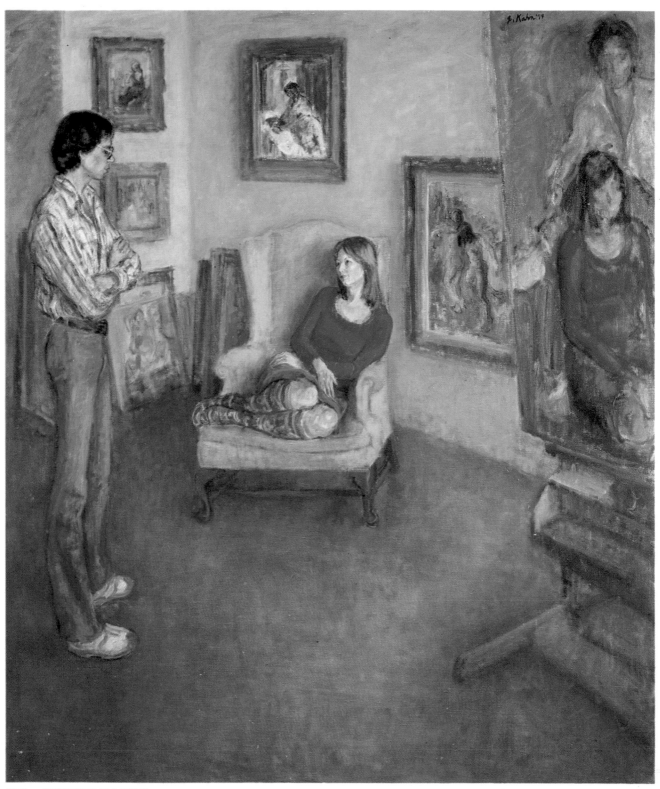

XII. STUDIO PAUSE

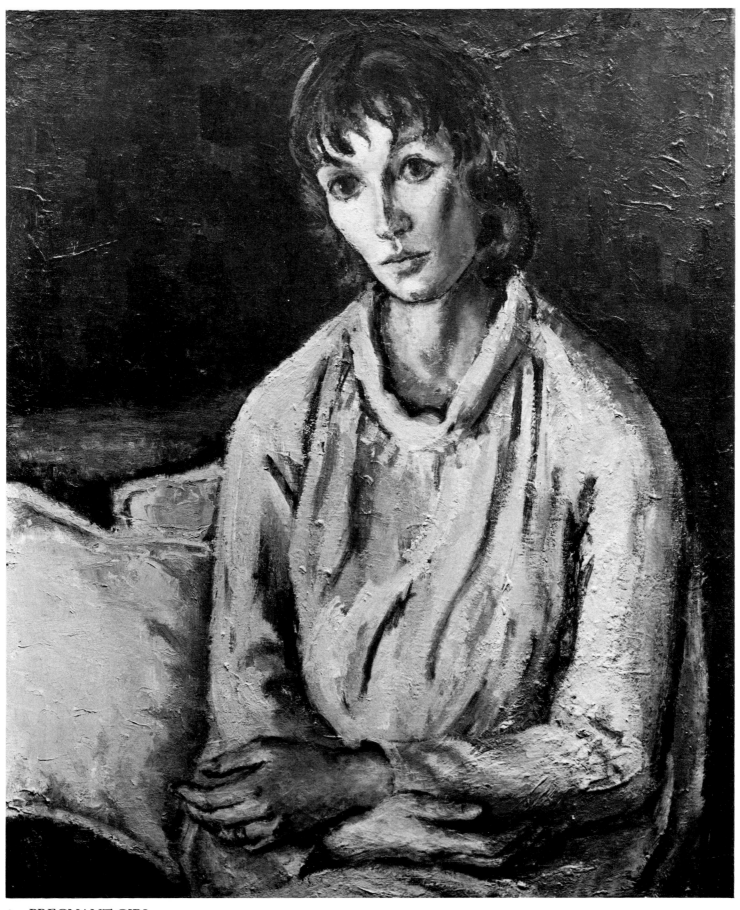

1. PREGNANT GIRL

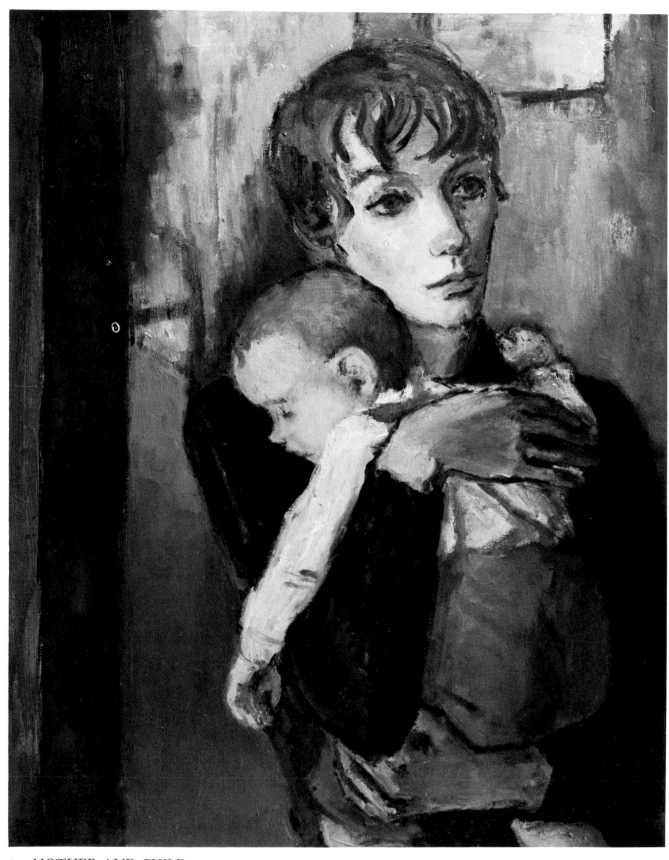

2. MOTHER AND CHILD

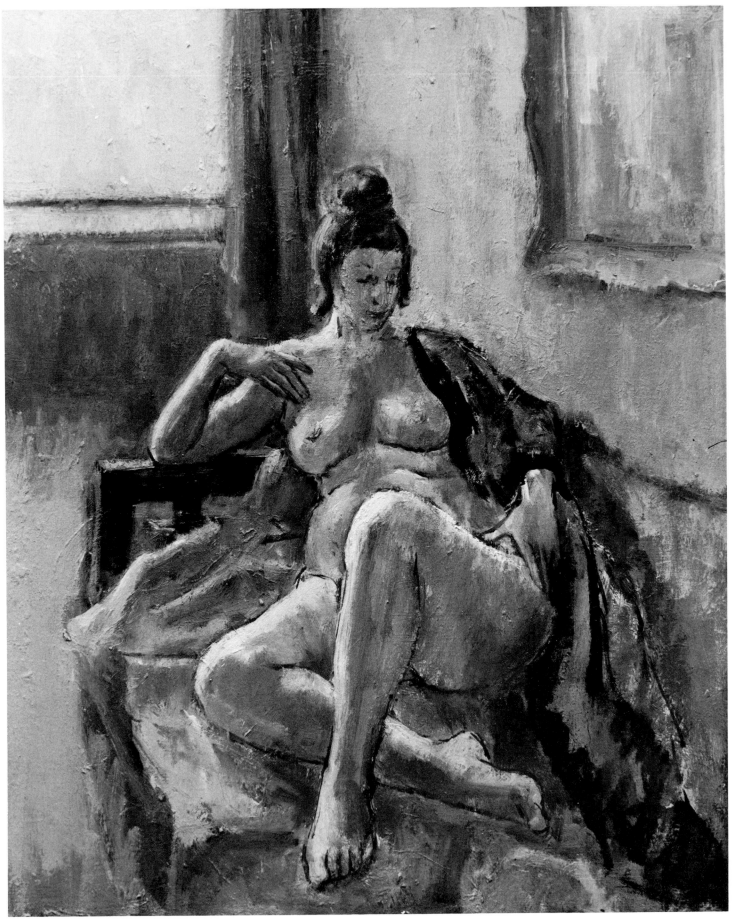

3. ADA

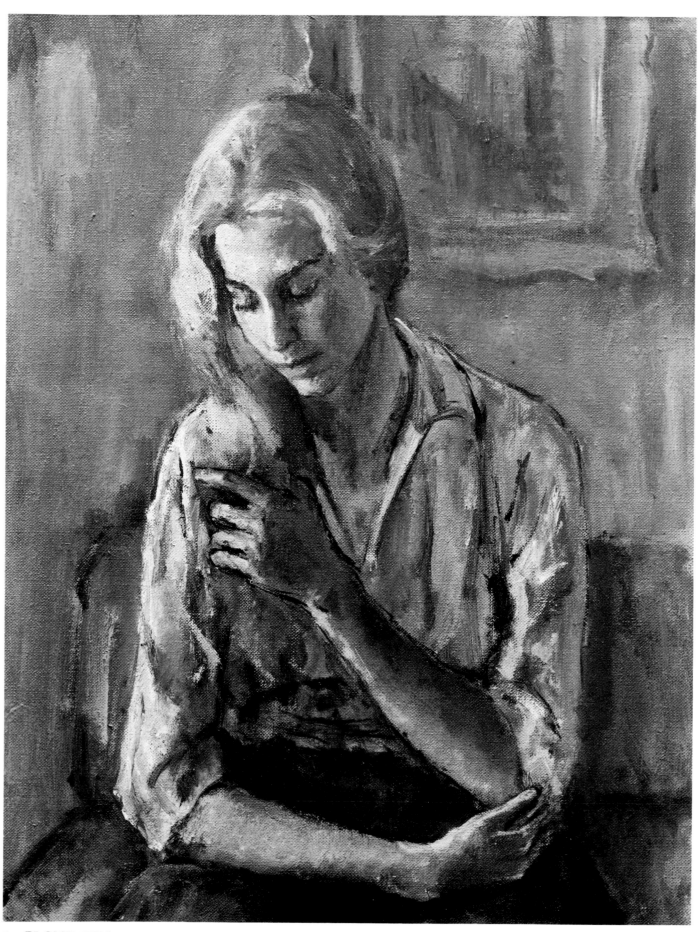

4. BLOND GIRL

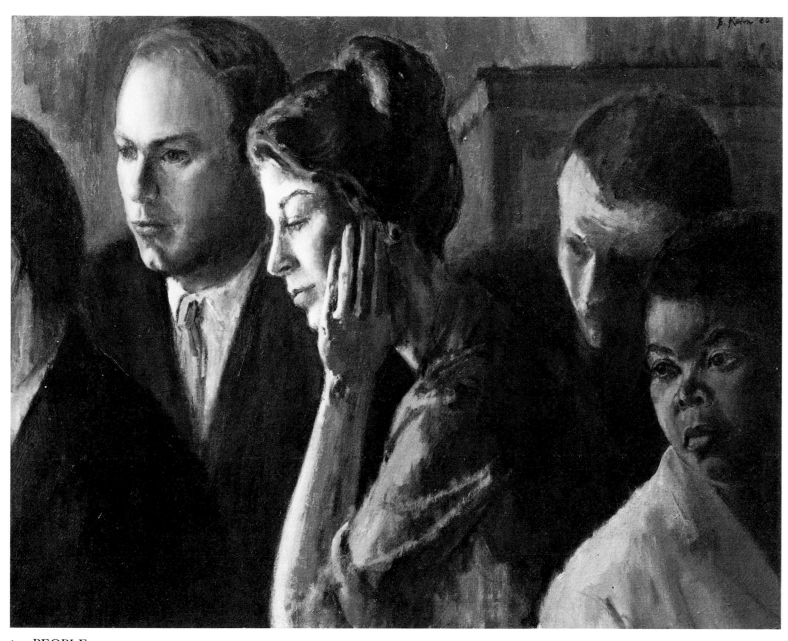

5. PEOPLE

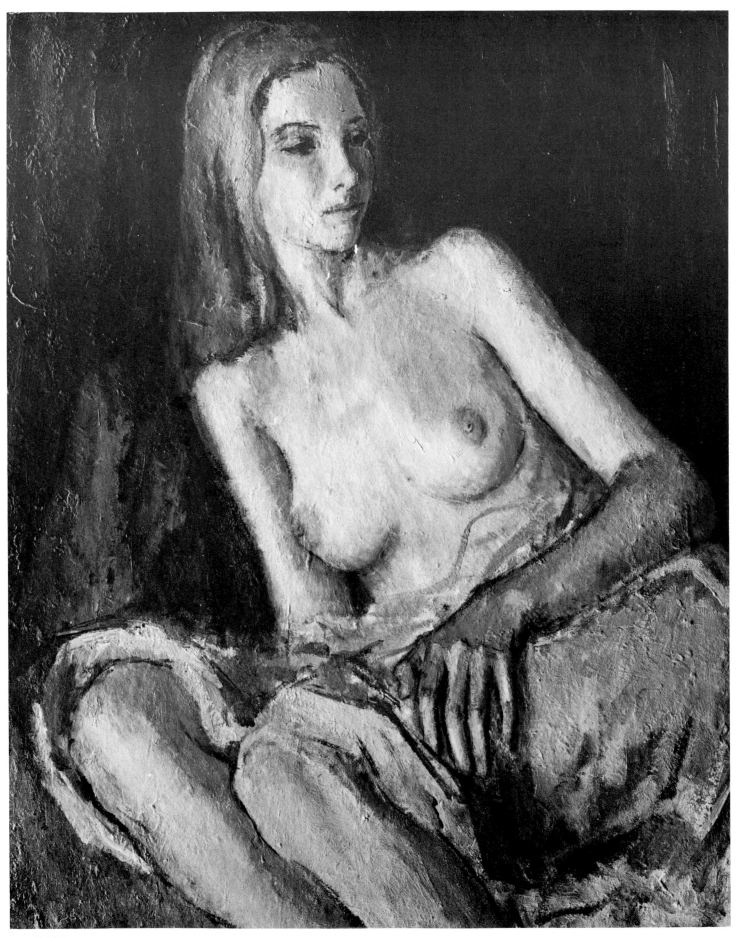

6. GAIL

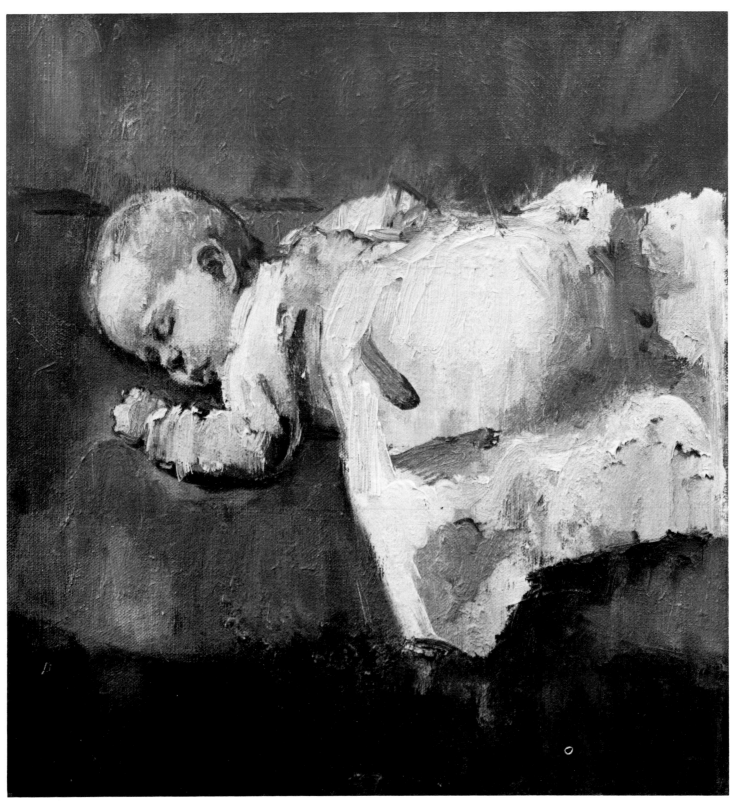

7. ASLEEP

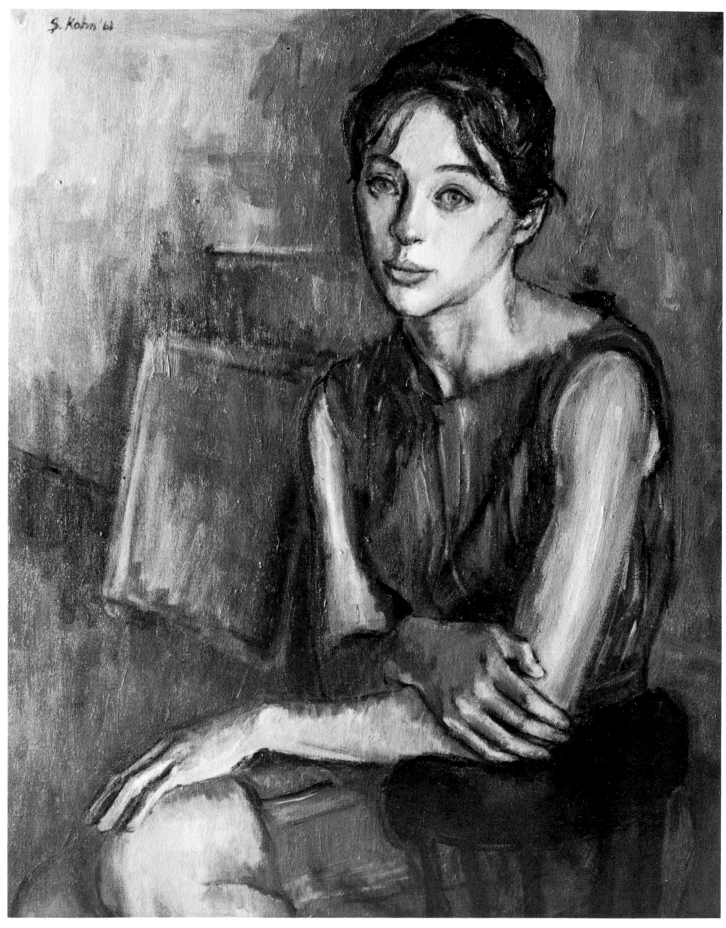

8. THE STRIPED DRESS

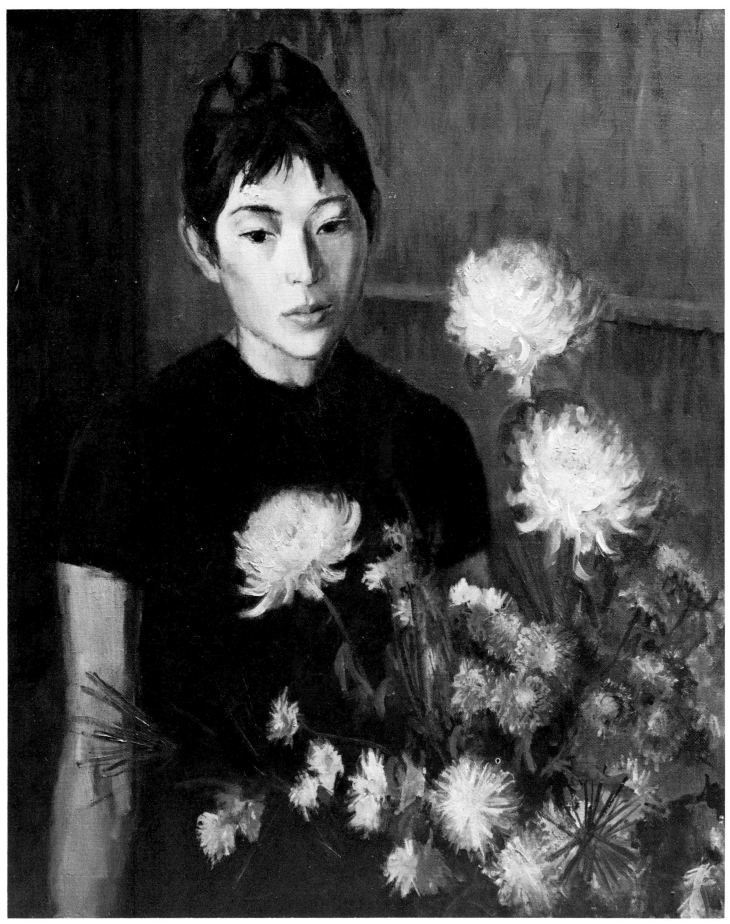

9. MASAKO

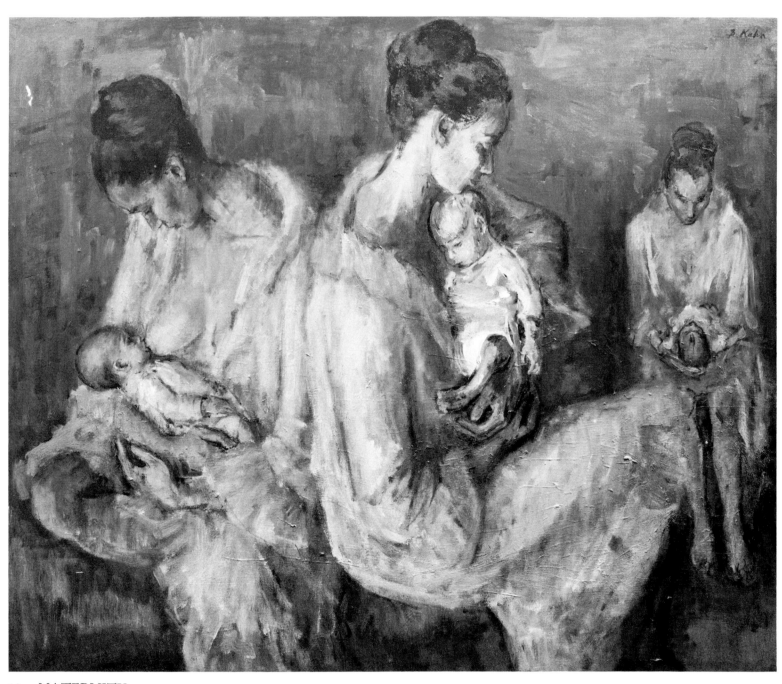

10. MATERNITY

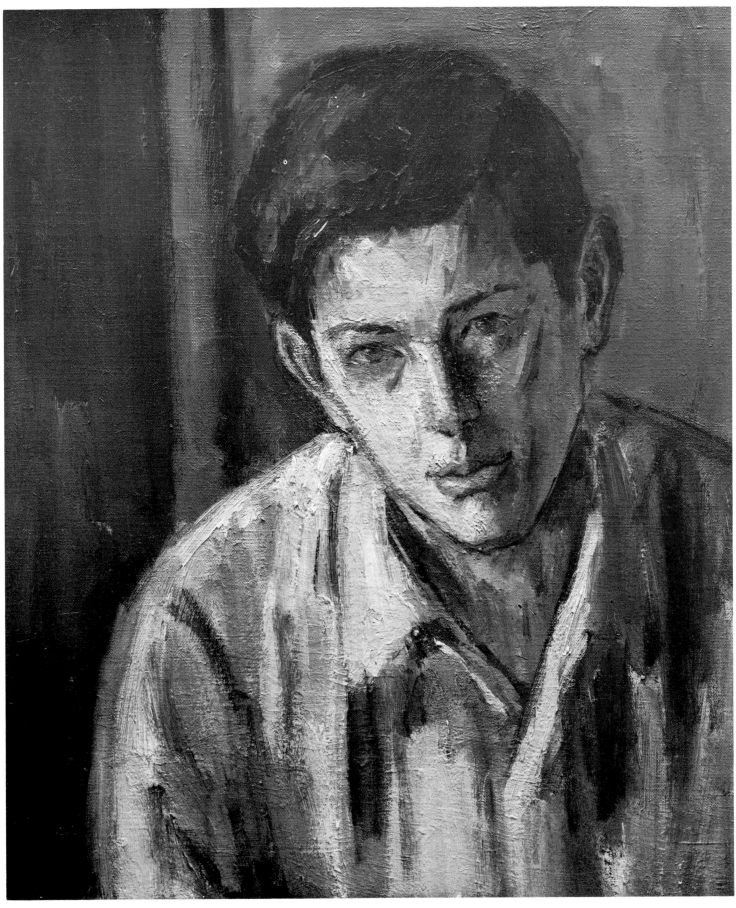

11. MARTY

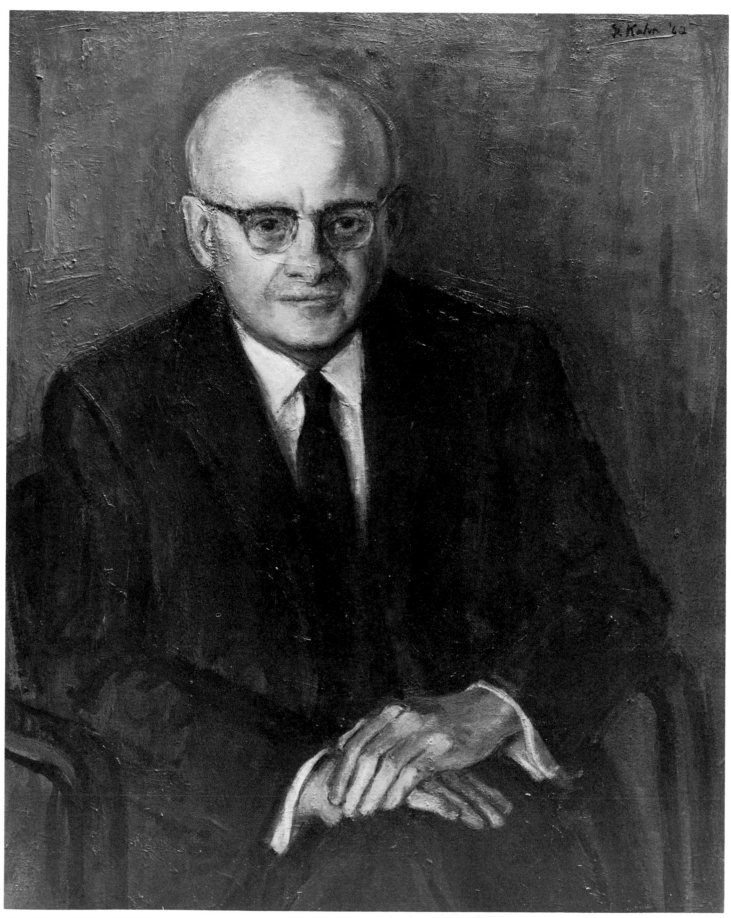

12. DR. MURRAY PESHKIN

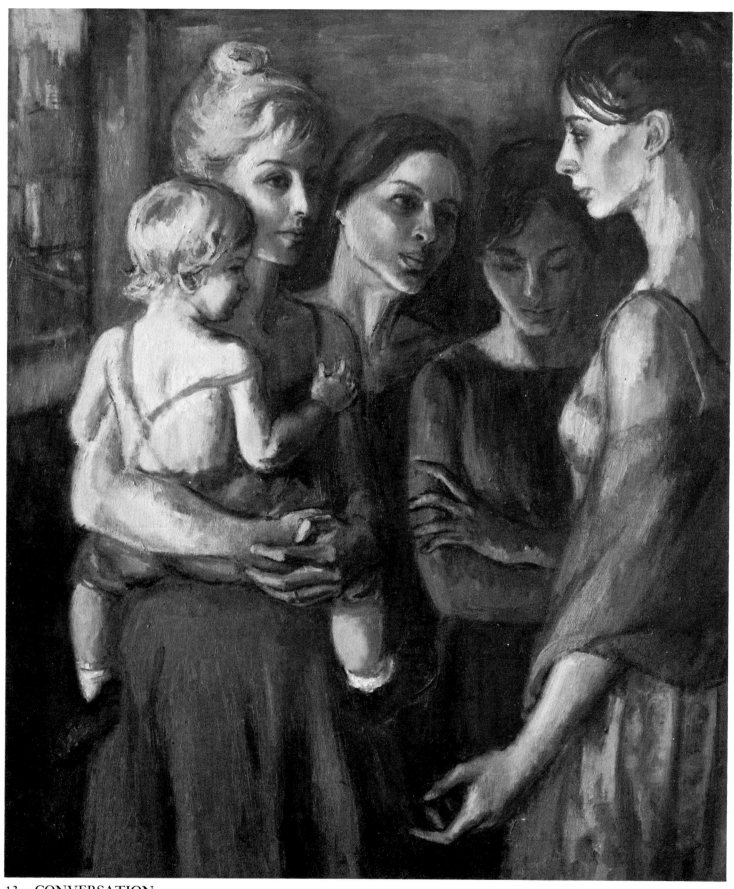

13. CONVERSATION

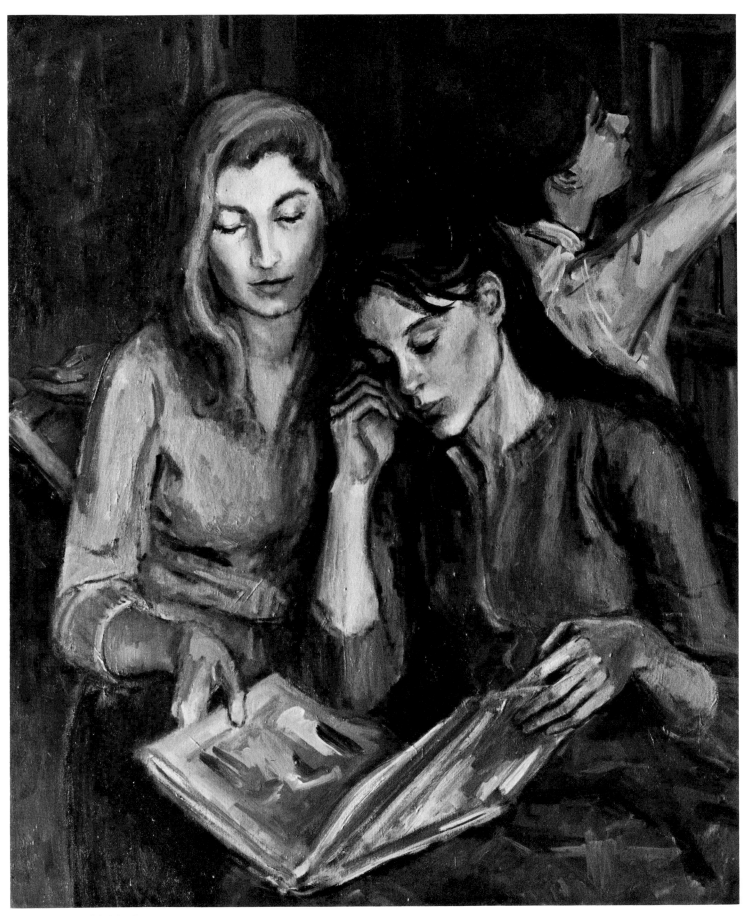

14. THE LIBRARY

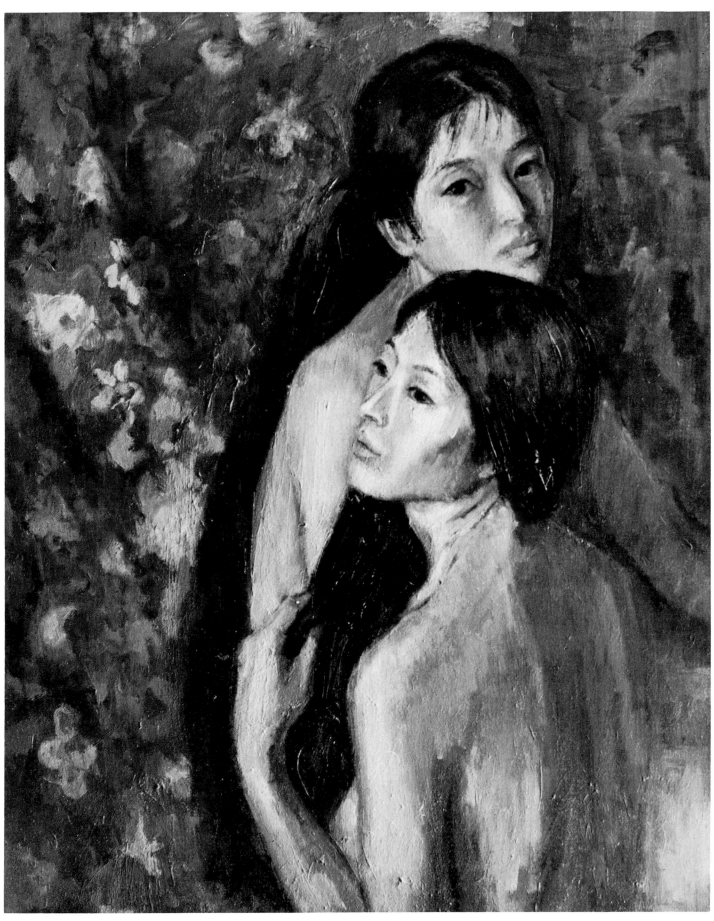

15. BACKSTAGE

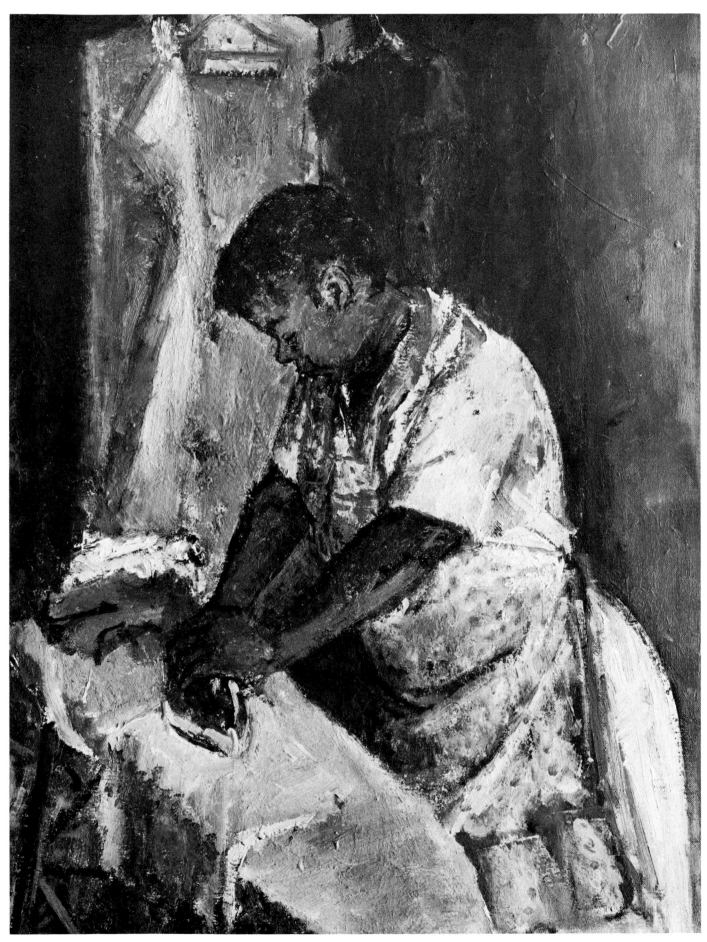

16. THE LAUNDRESS

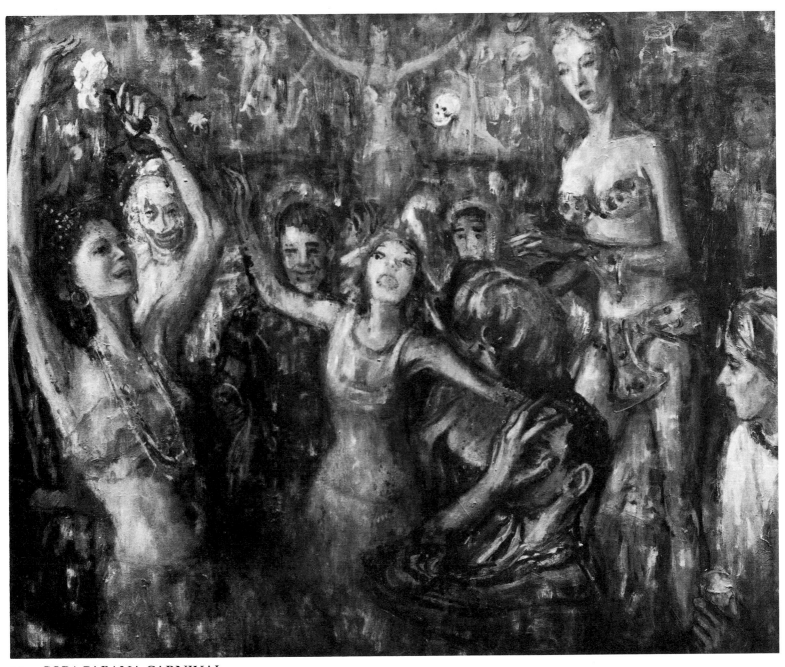

17. COPACABANA CARNIVAL

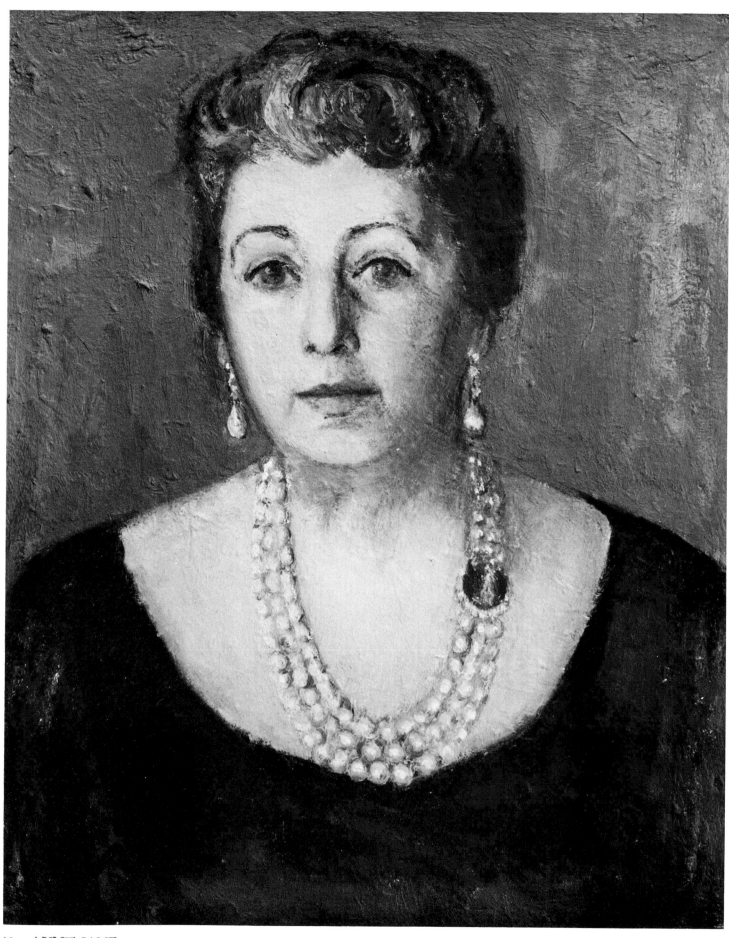

18. AUNT JANE

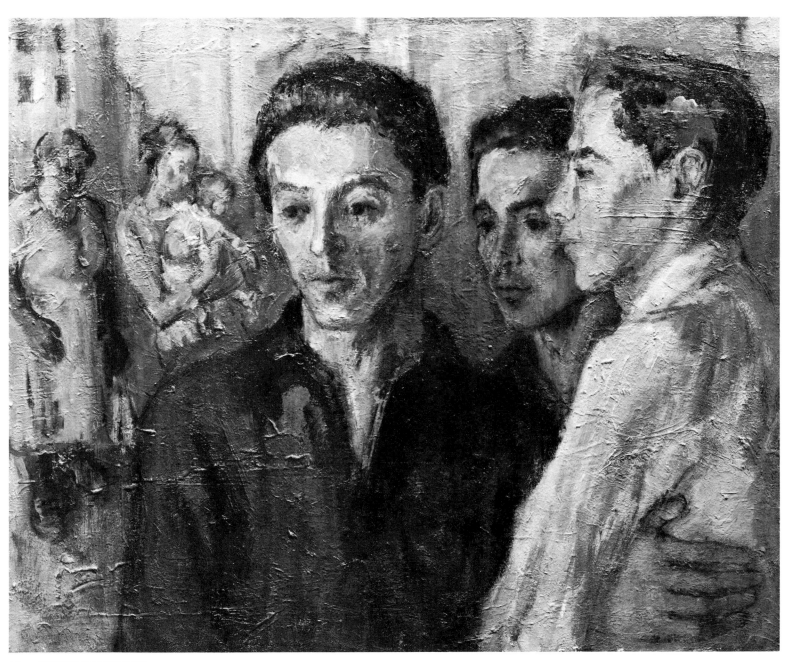

19. STREET SCENE

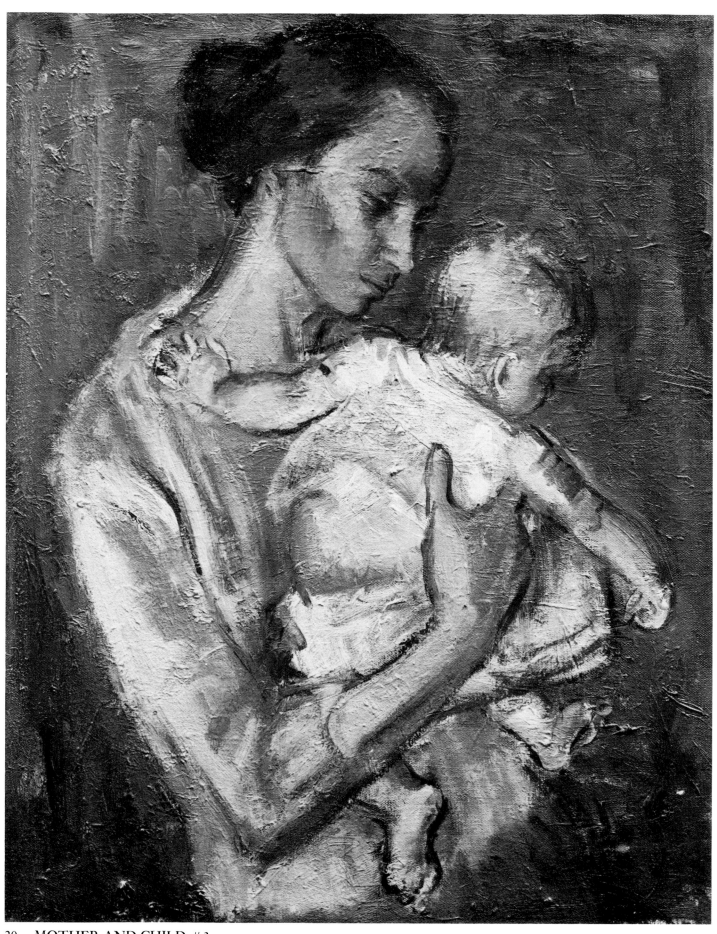

20. MOTHER AND CHILD #3

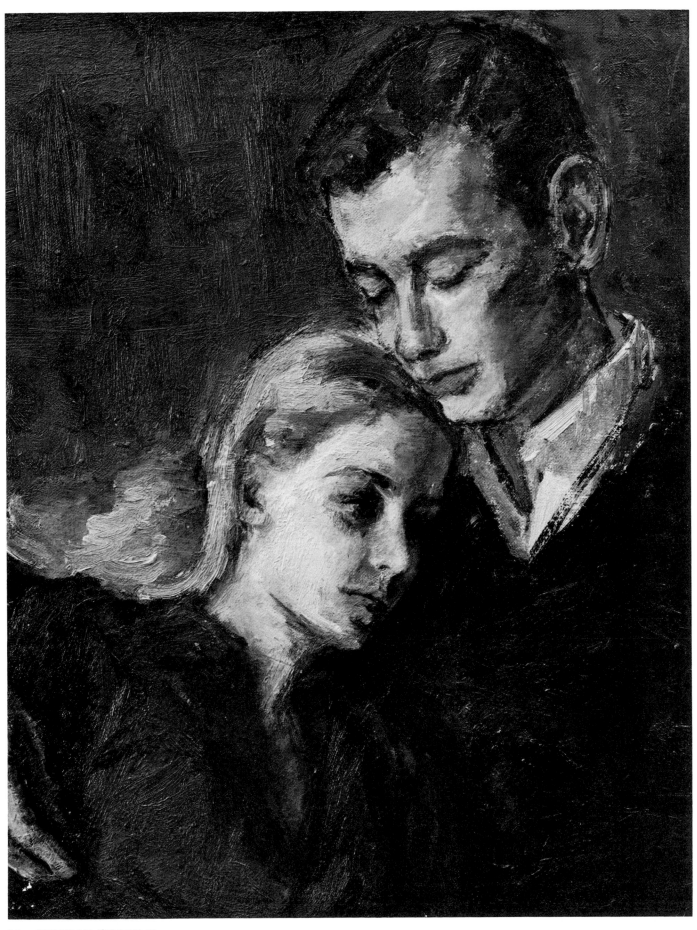

21. YOUNG COUPLE

22. TWO GIRLS

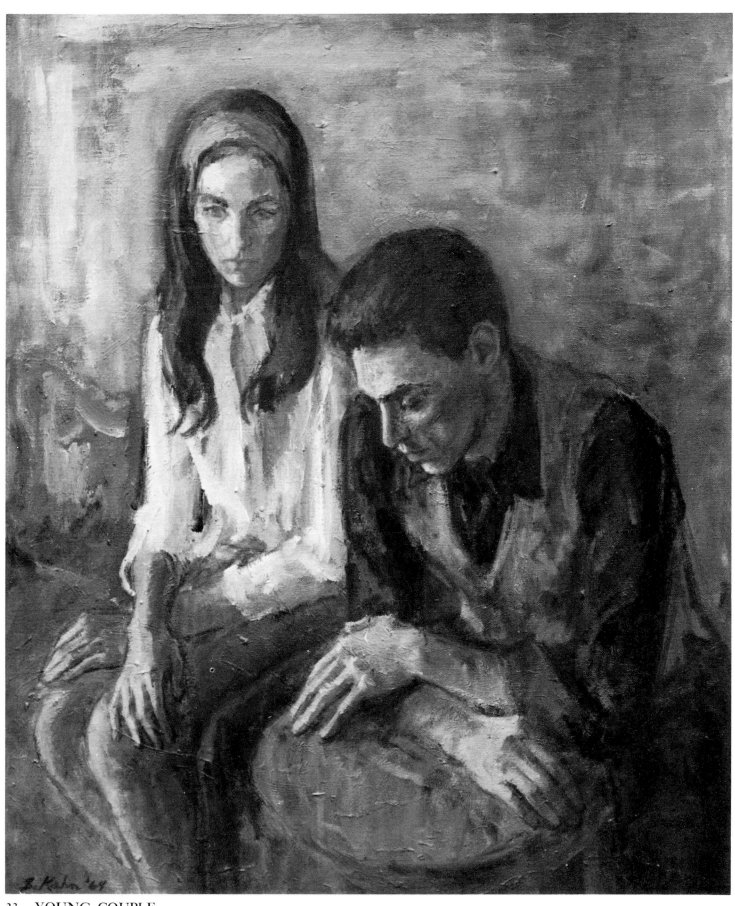

23. YOUNG COUPLE

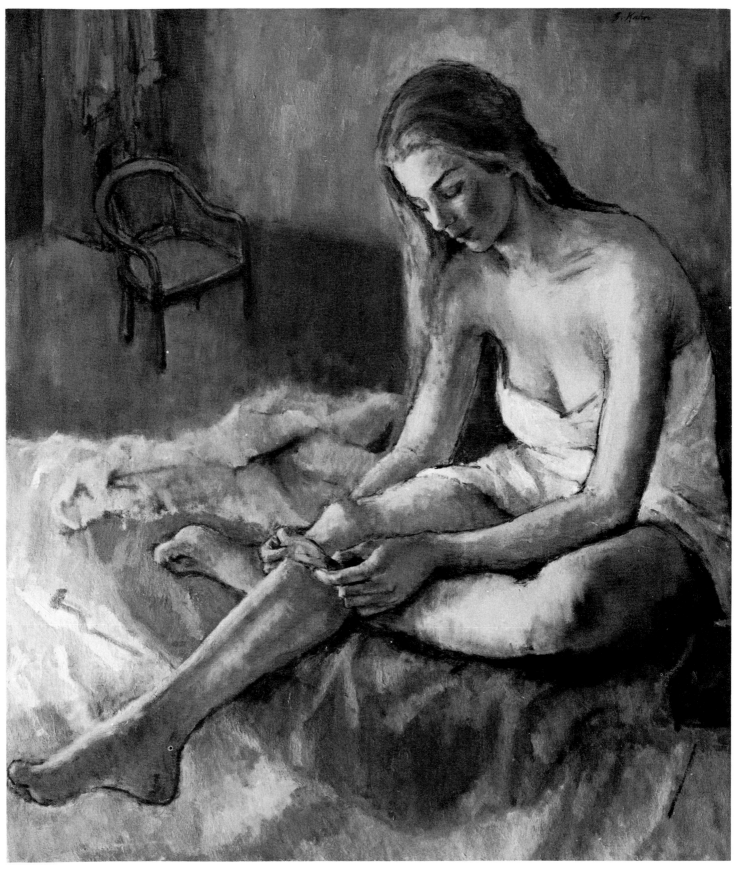

24. THE STOCKING

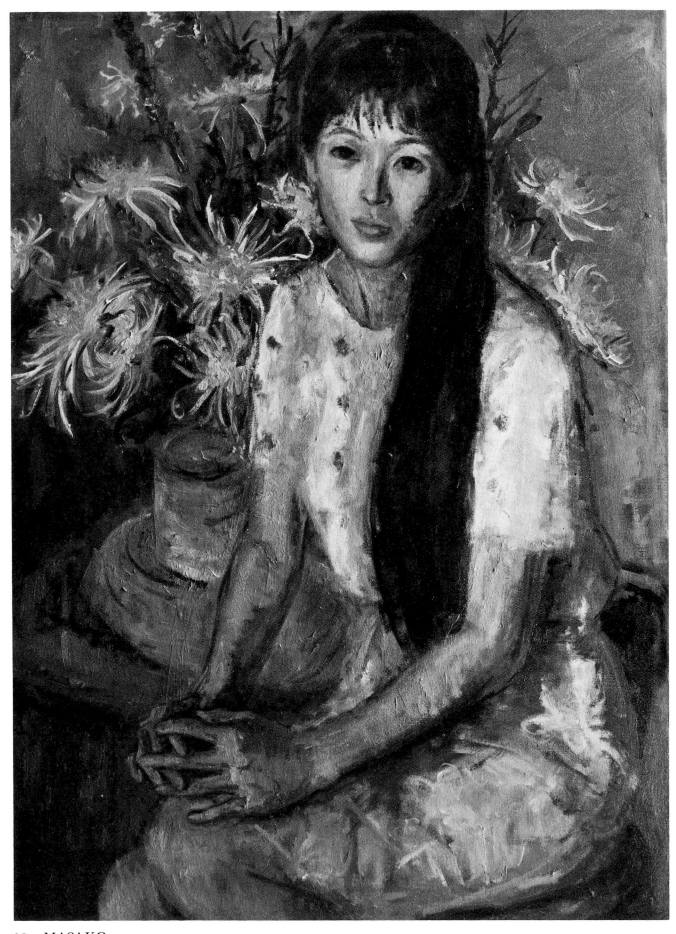

25. MASAKO

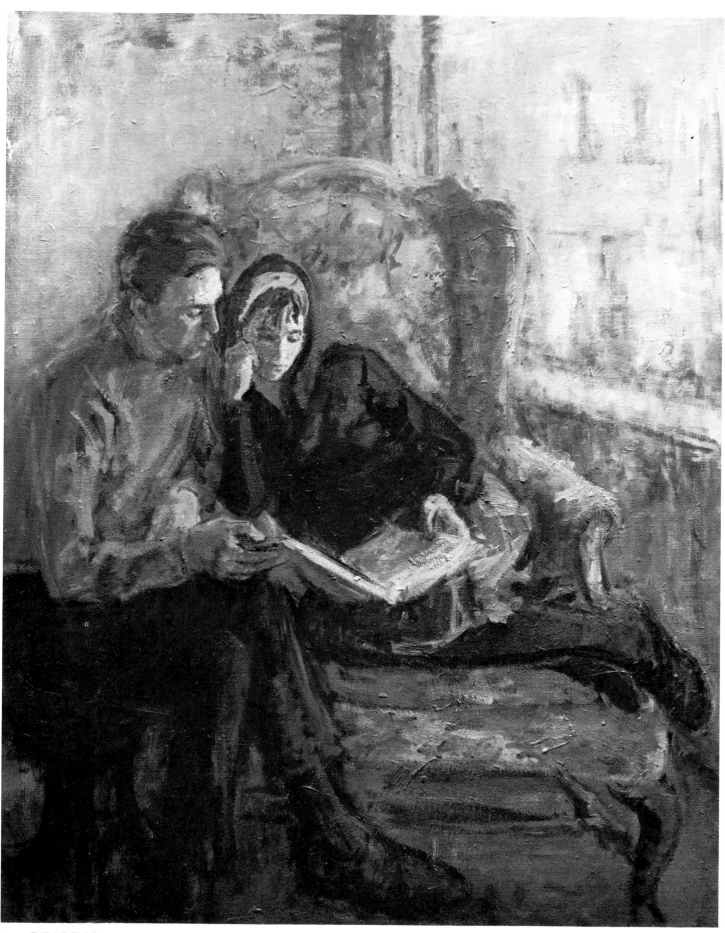

26. READING

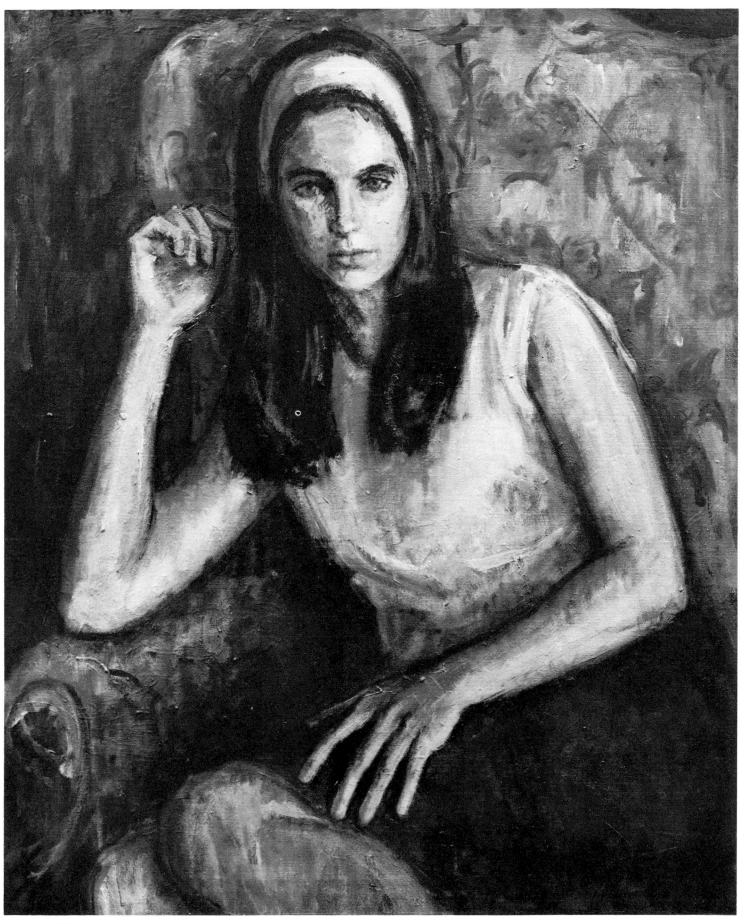

27. JANE

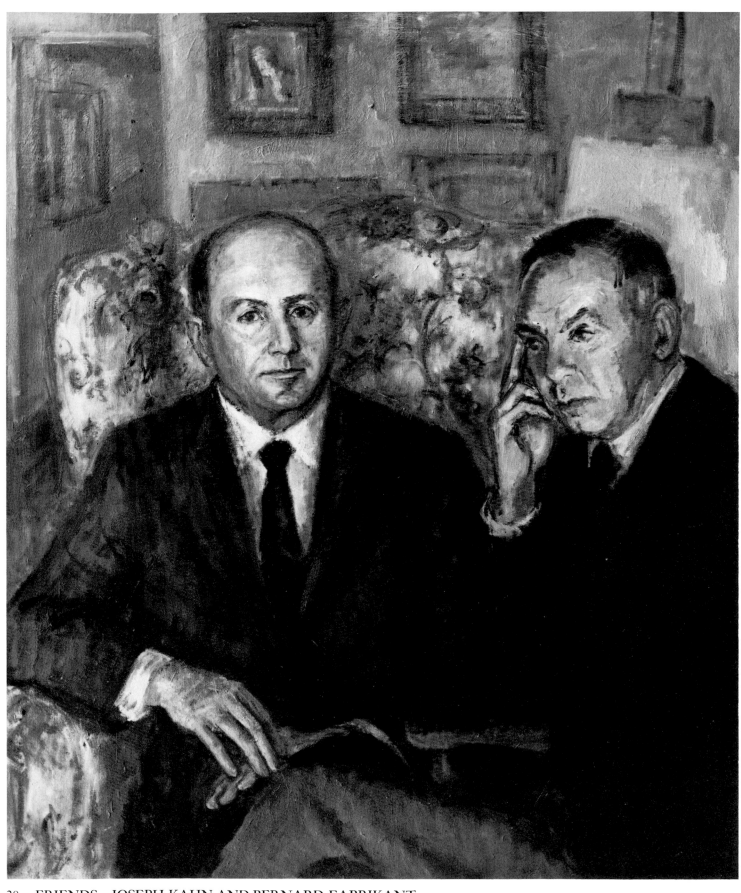

28. FRIENDS—JOSEPH KAHN AND BERNARD FABRIKANT

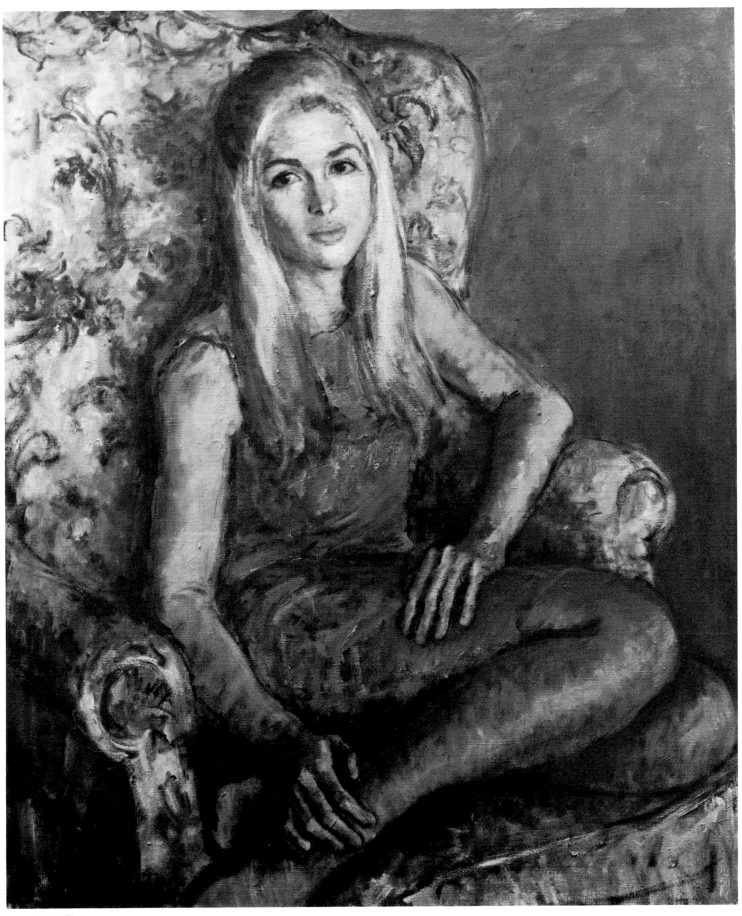

29. ELLEN

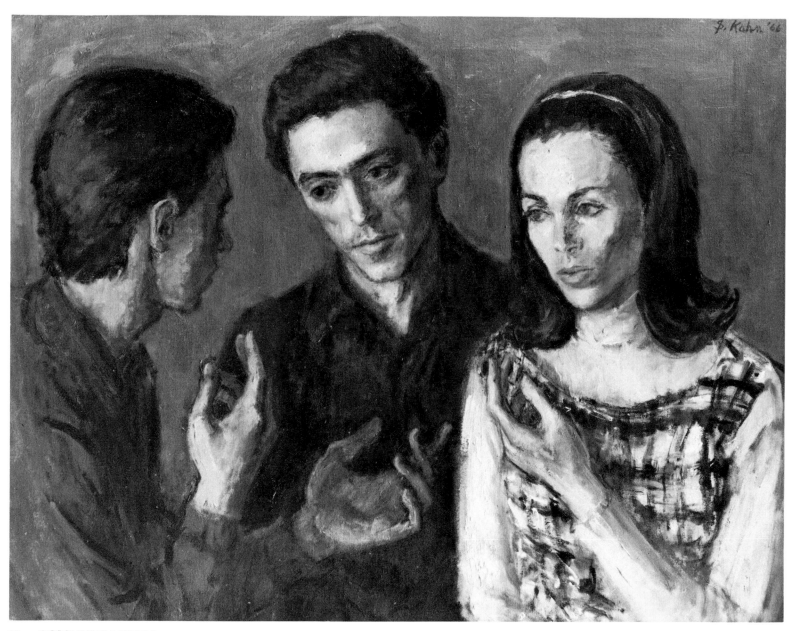

30. CONVERSATION

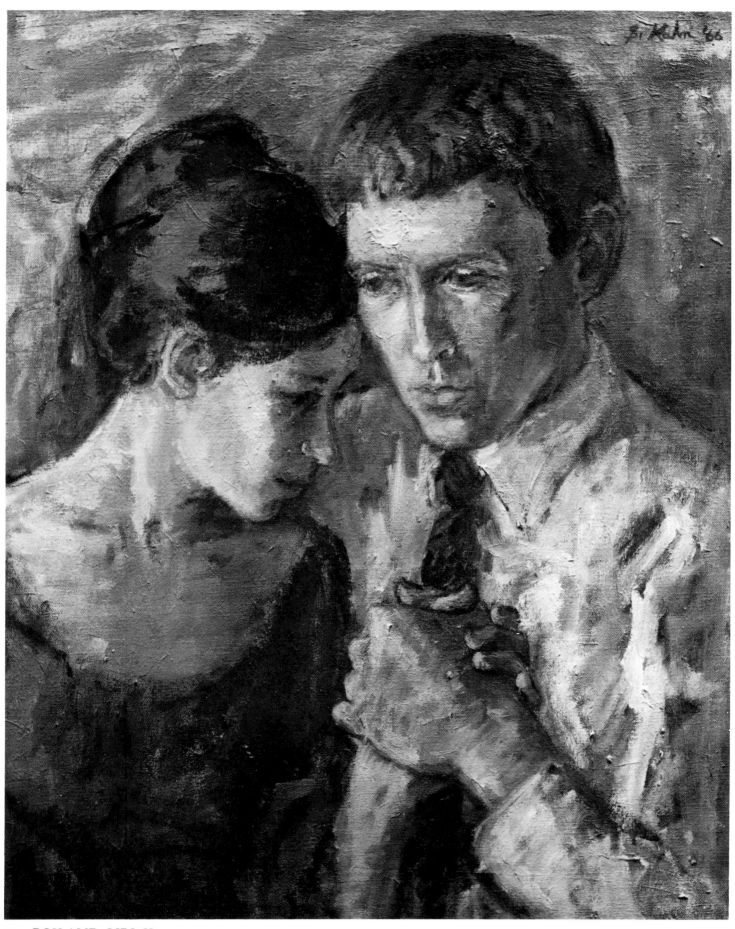

31. BOY AND GIRL II

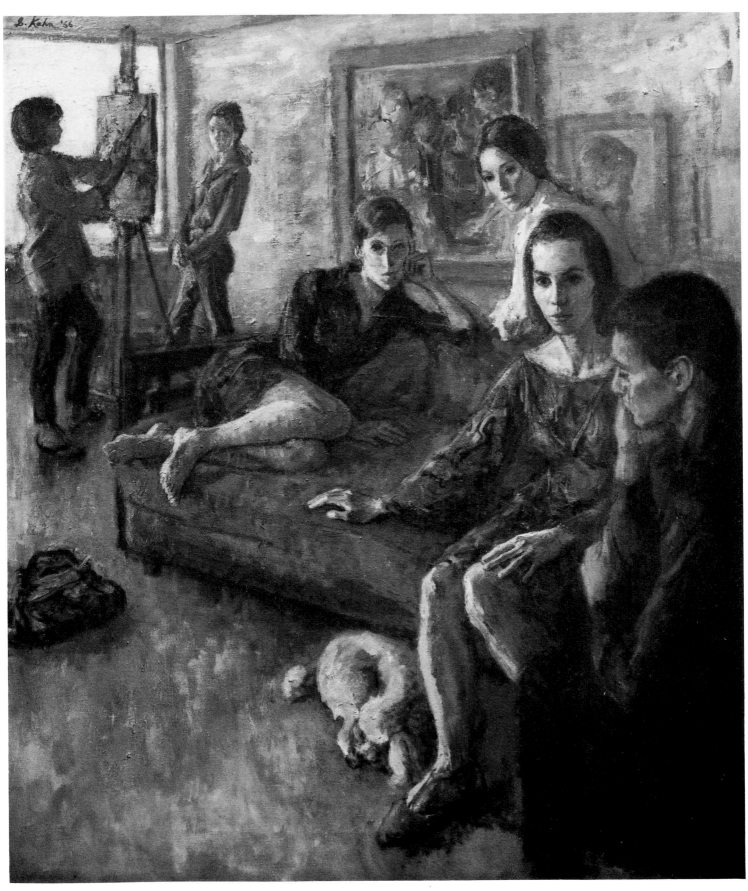

32. STUDIO INTERIOR

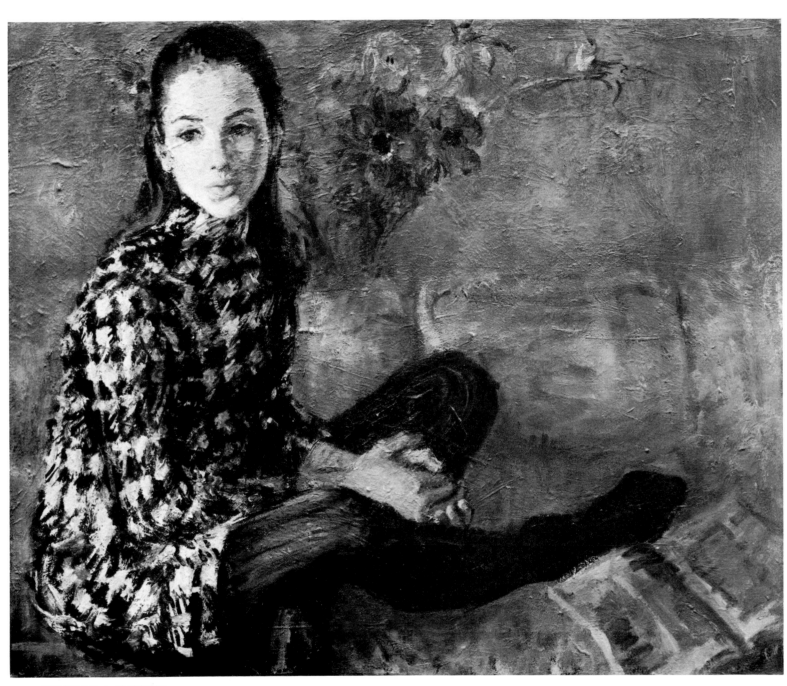

33. YOUNG ACTRESS

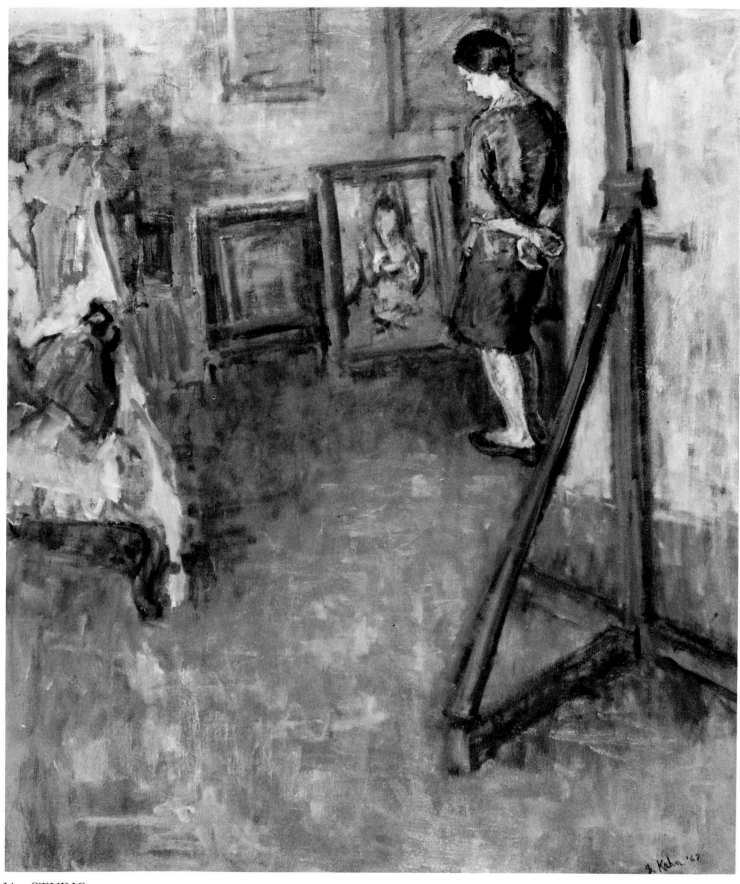

34. STUDIO

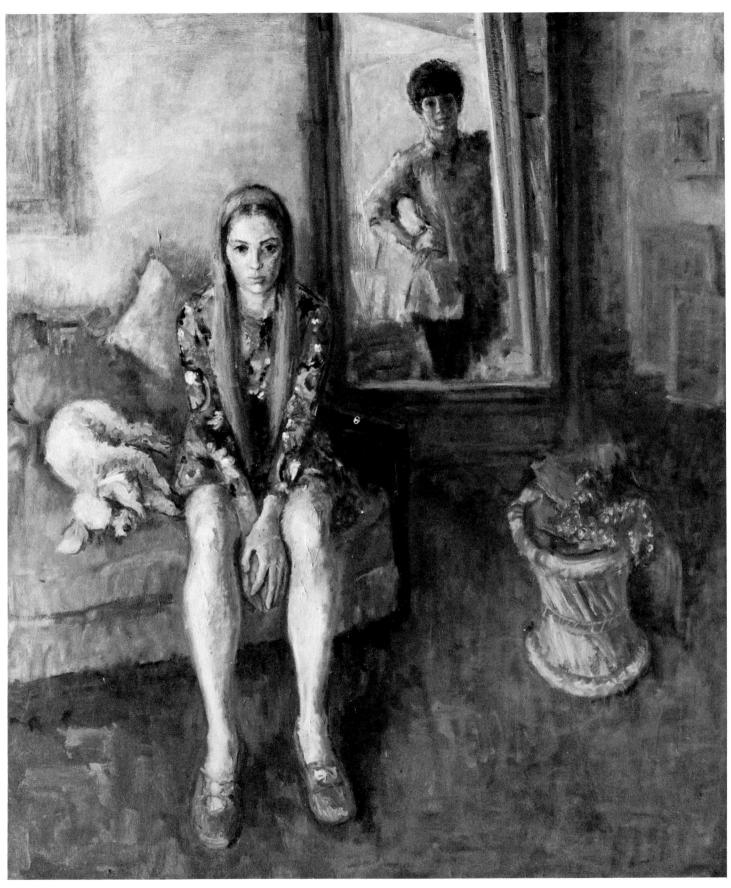

35. ARTIST AND MODEL

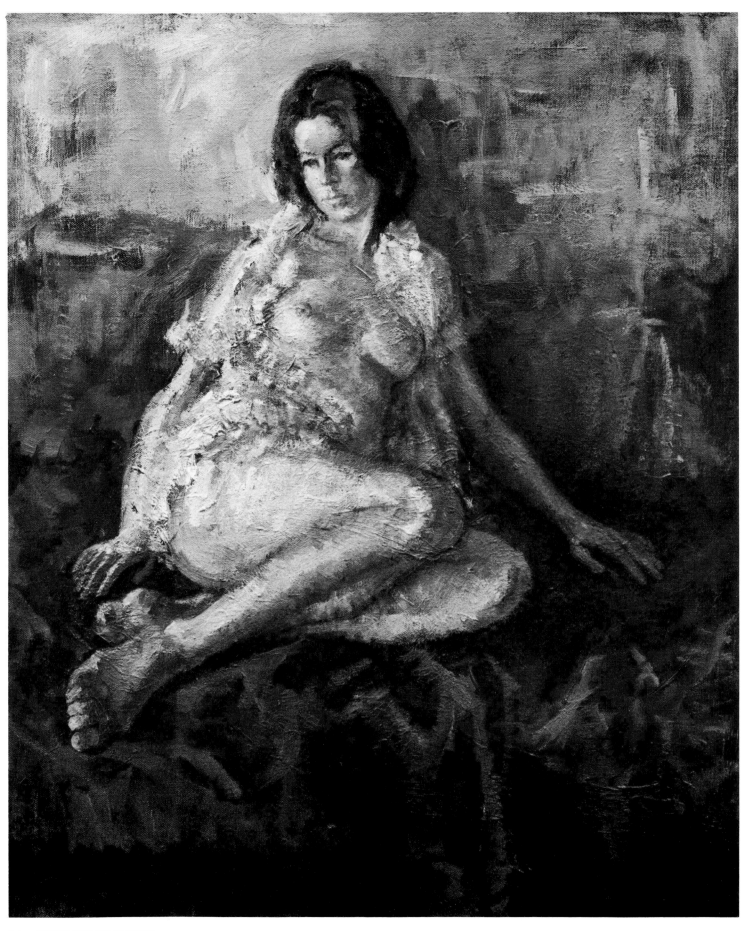

36. THE PINK ROBE

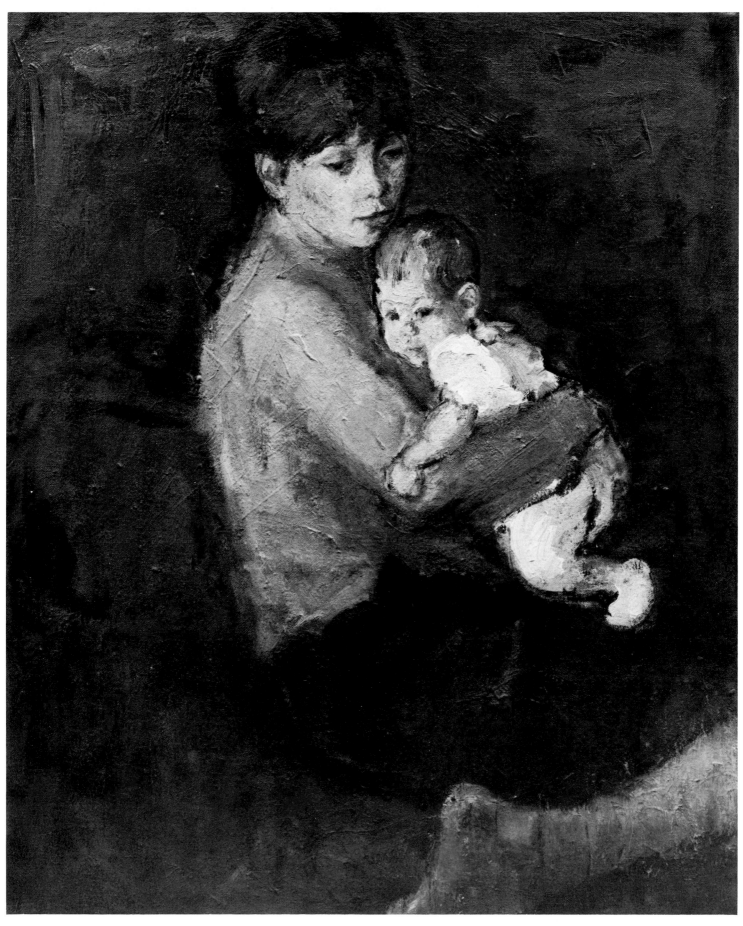

37. MOTHER AND CHILD

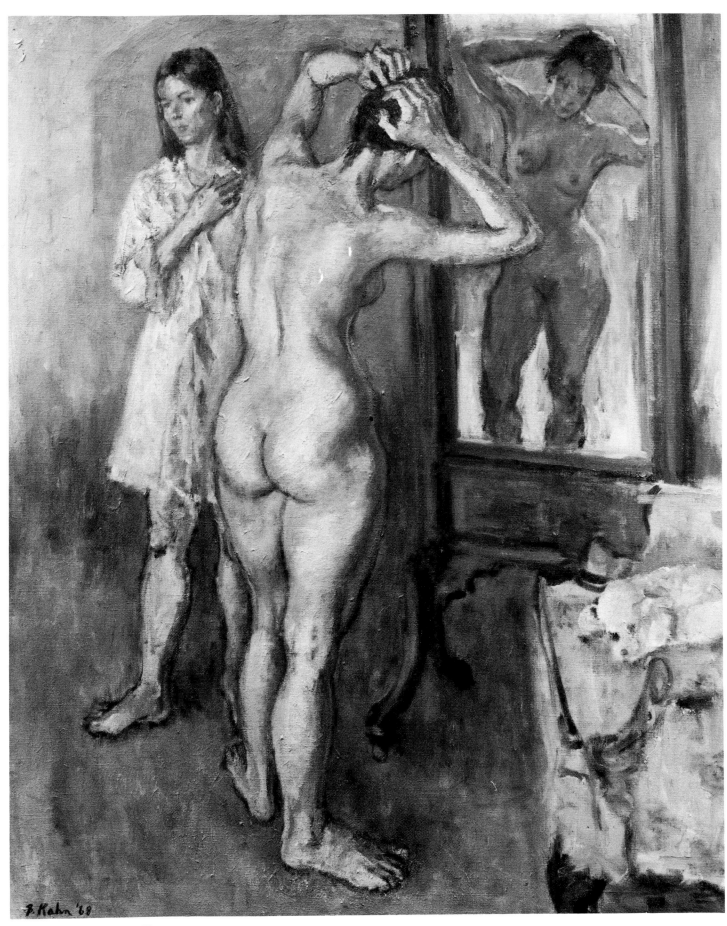

38. DOUBLE IMAGE

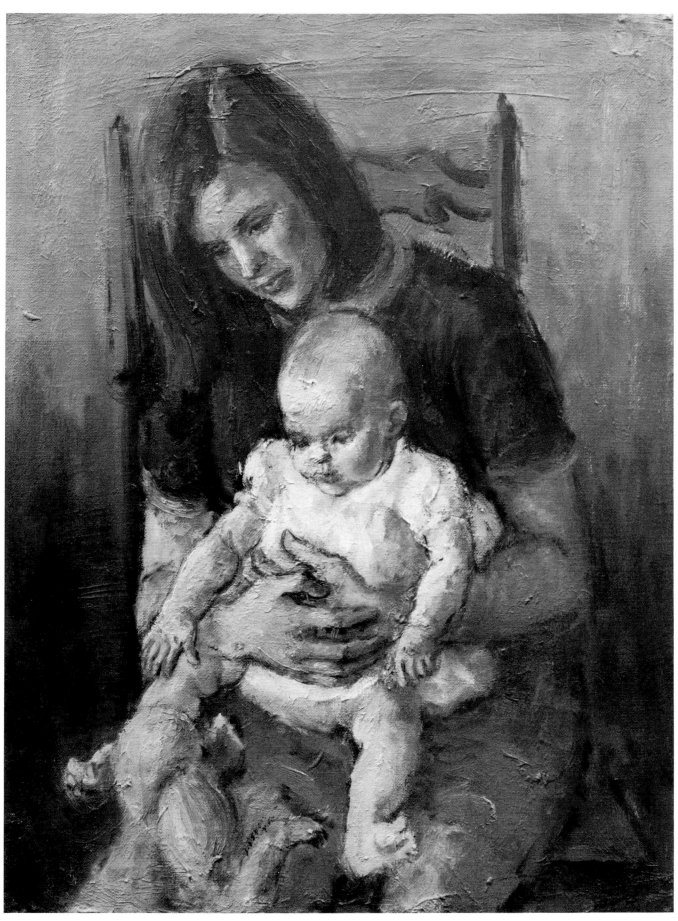

39. EVE, BARTLEY, AND TIFFANY

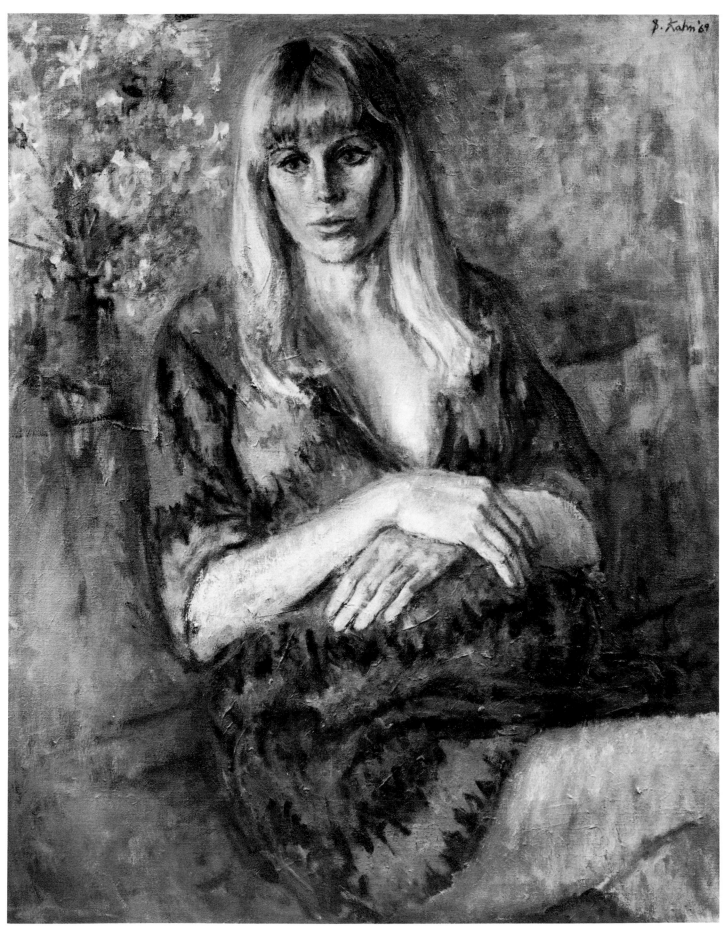

40. PREGNANT GIRL

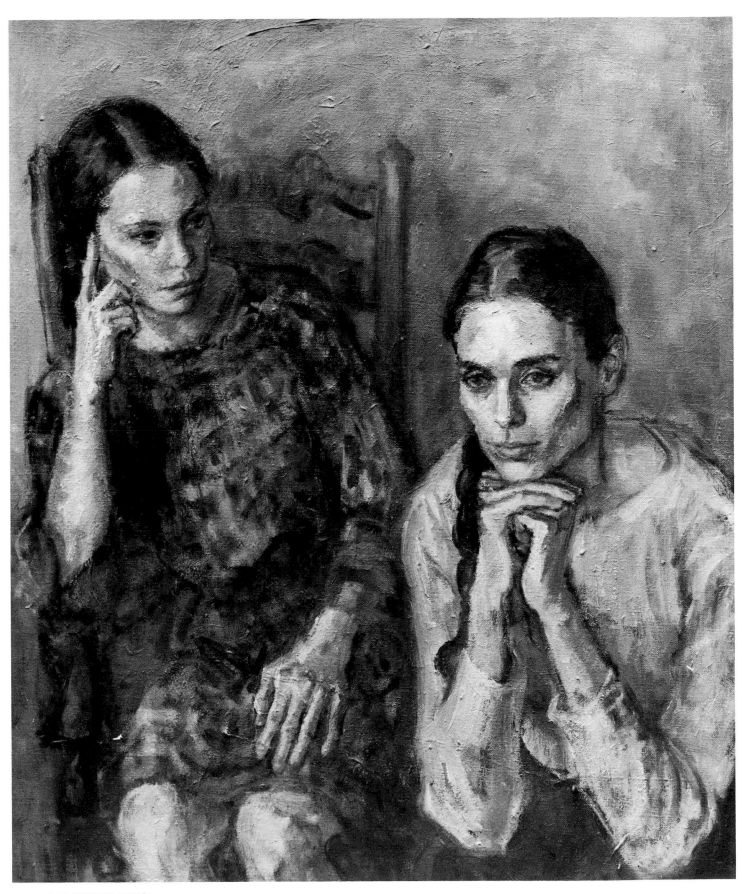

41. CONFIDENCES

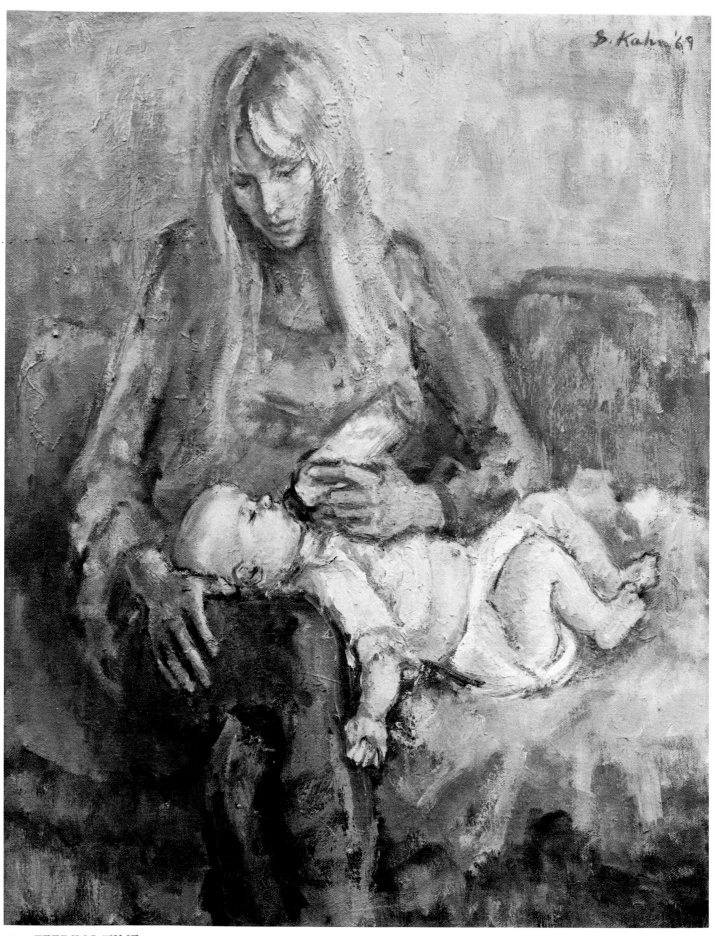

42. FEEDING TIME

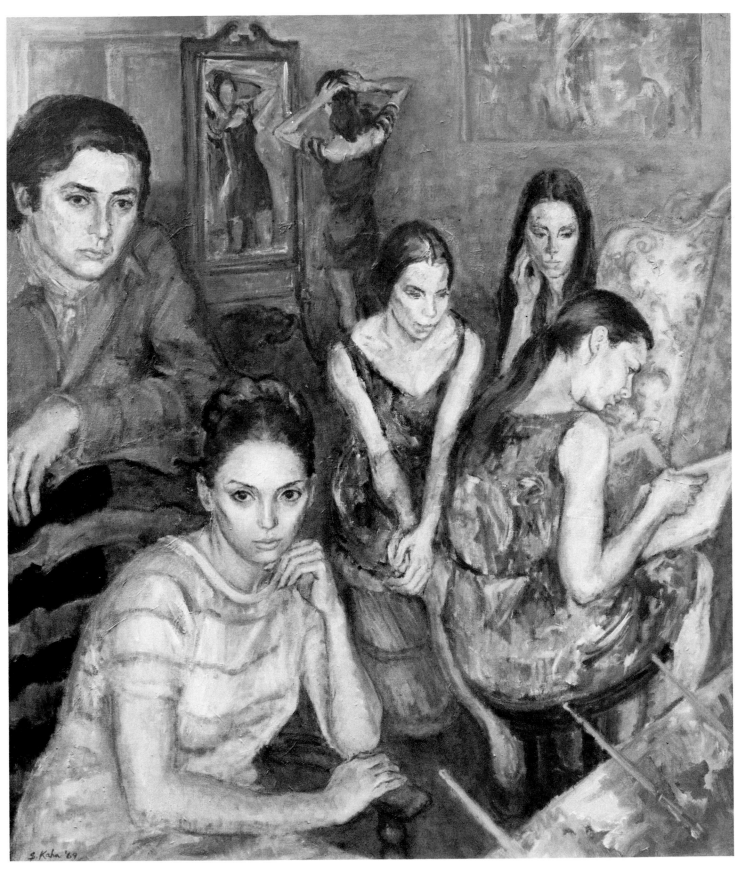

43. EAST END STUDIO

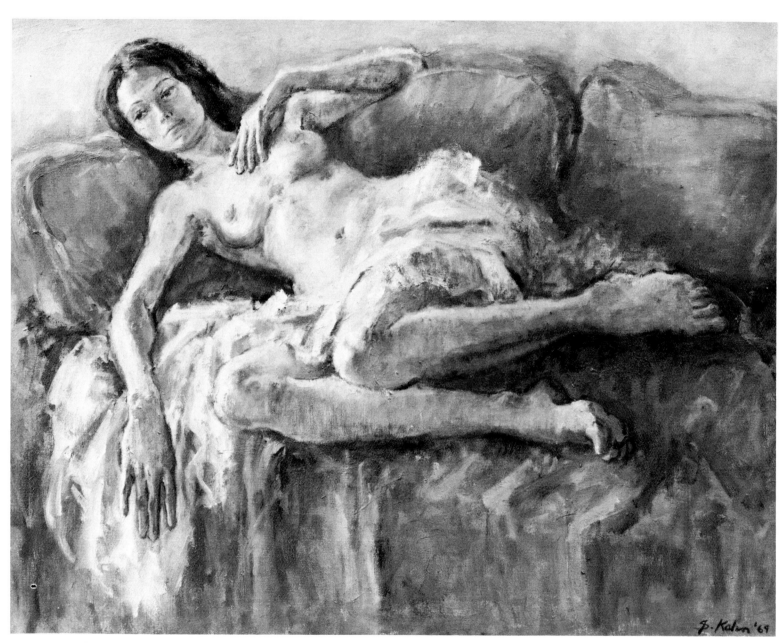

44. DRAPED NUDE

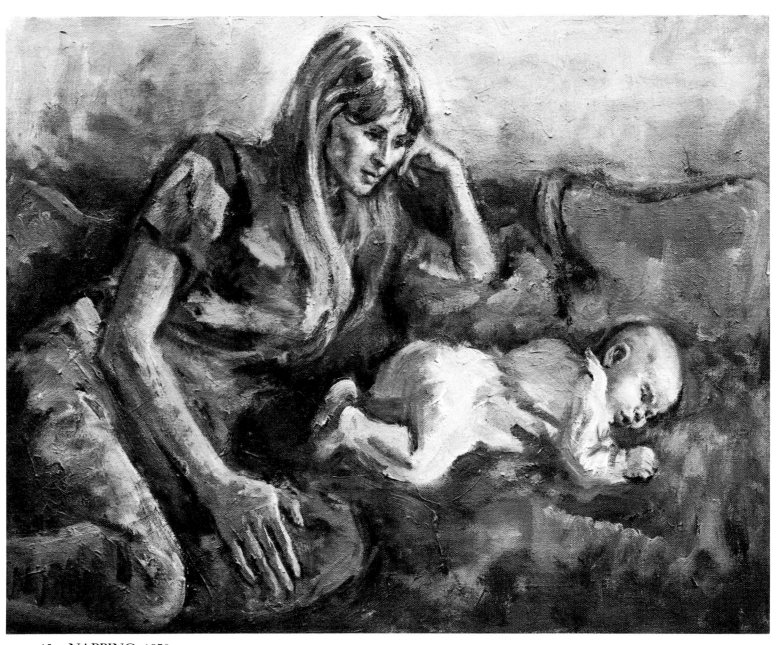

45. NAPPING, 1970.

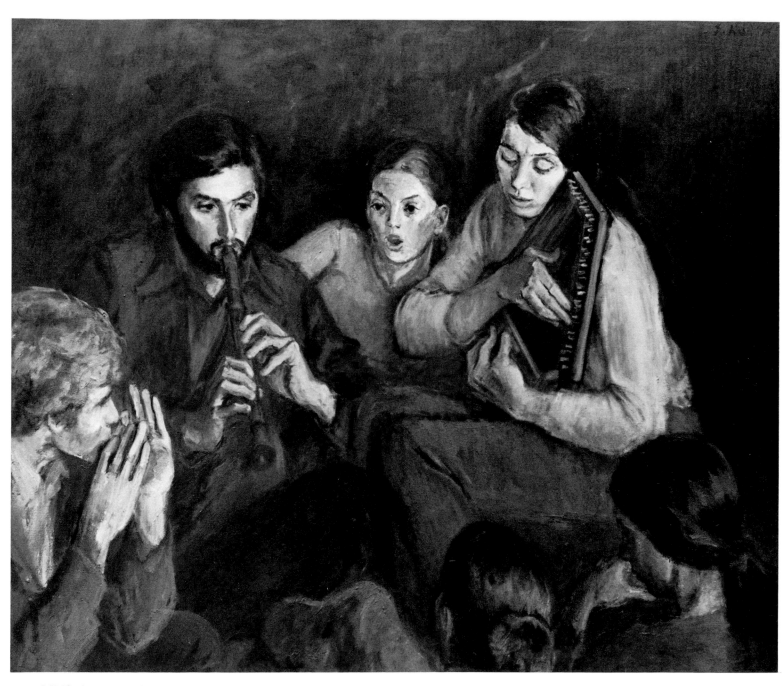

46. MUSICAL GATHERING

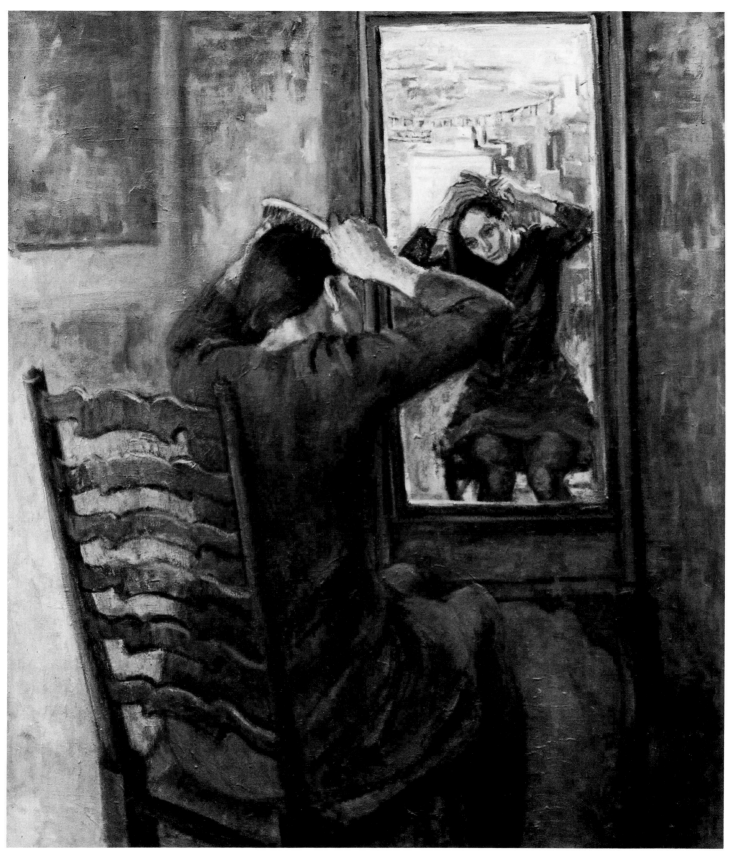

47. REFLECTION

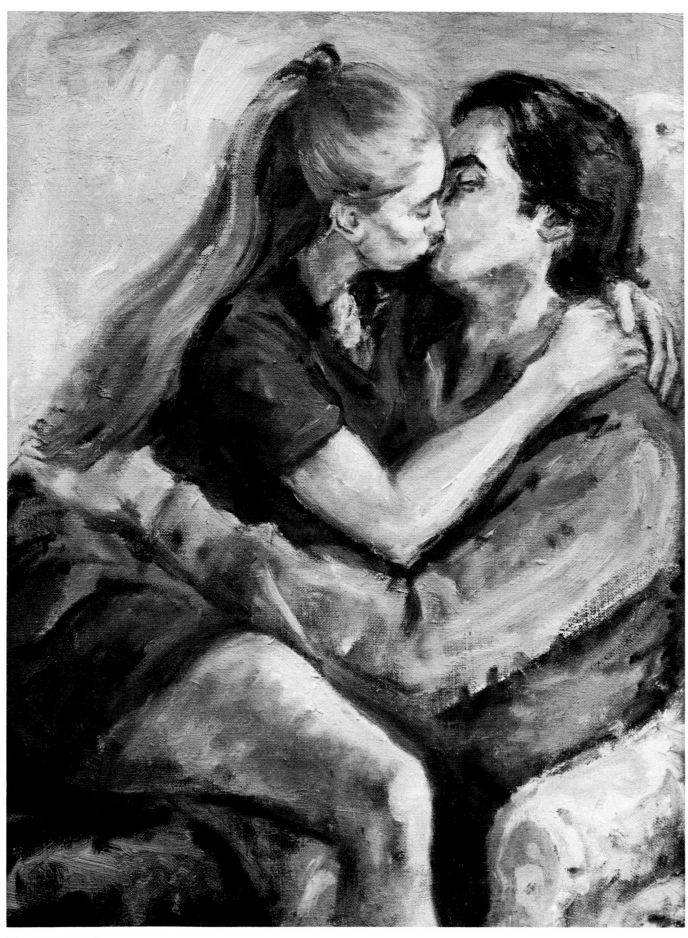

48. THE KISS

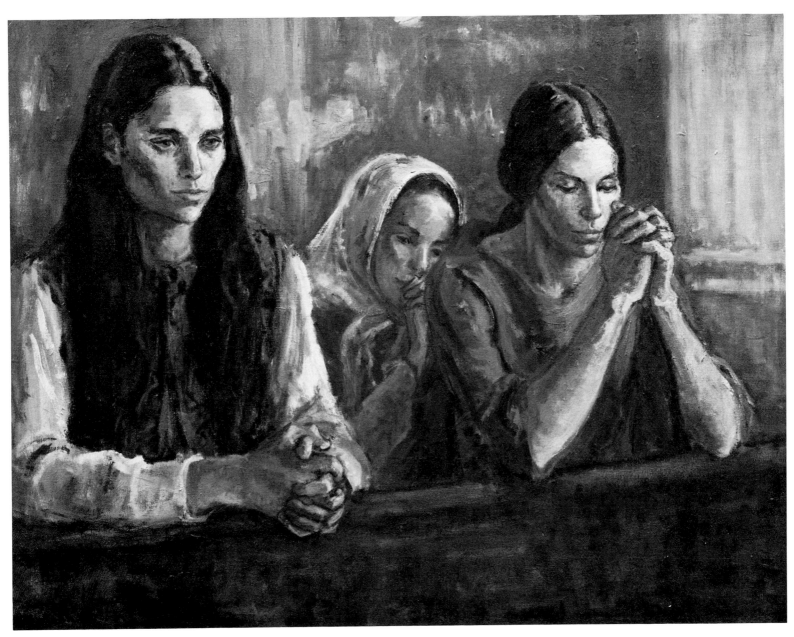

49. REVERENCE

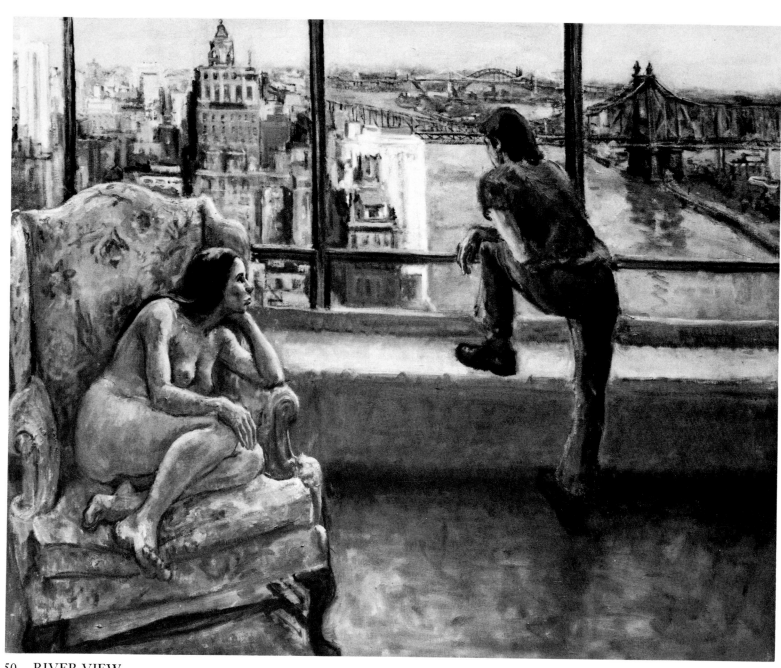

50. RIVER VIEW

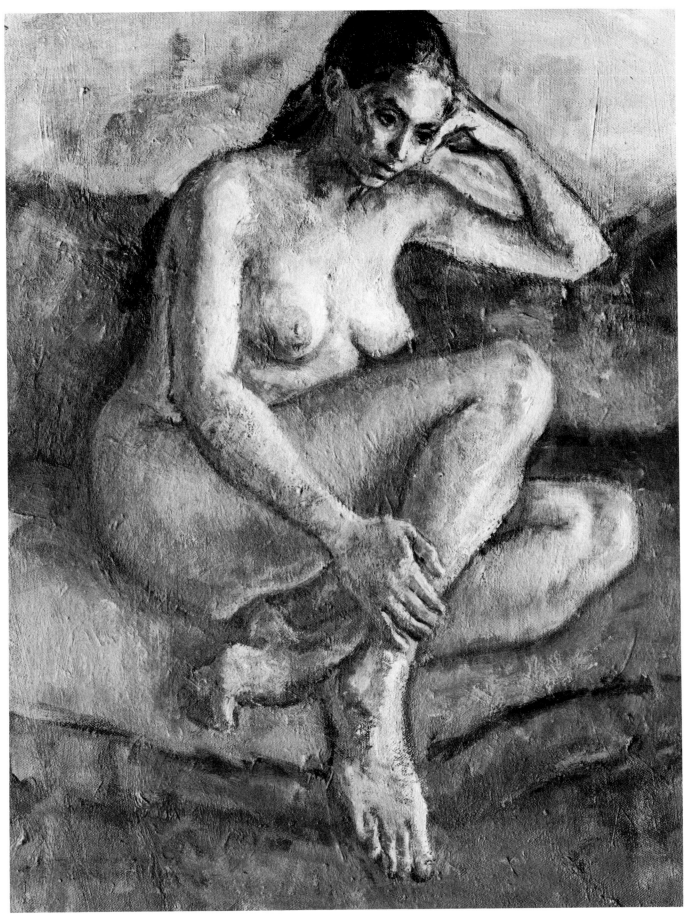

51. SEATED NUDE

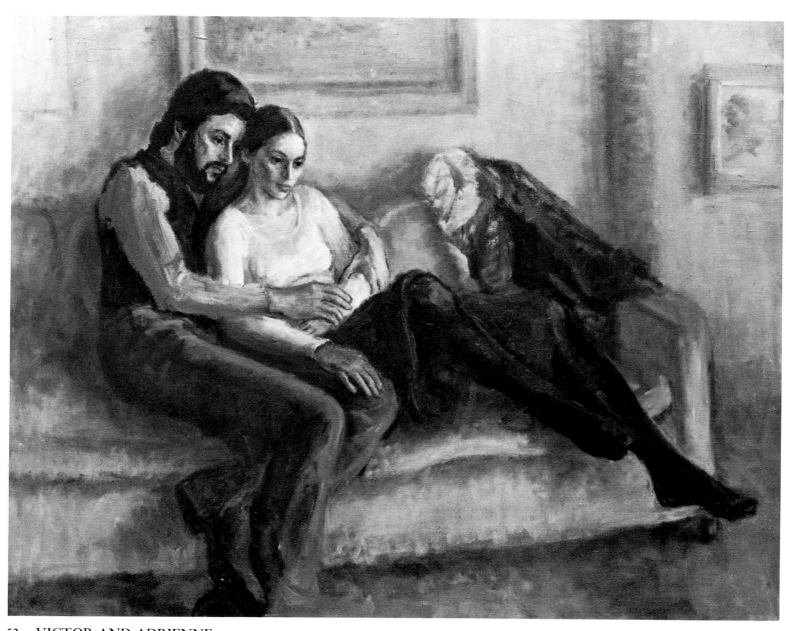

52. VICTOR AND ADRIENNE

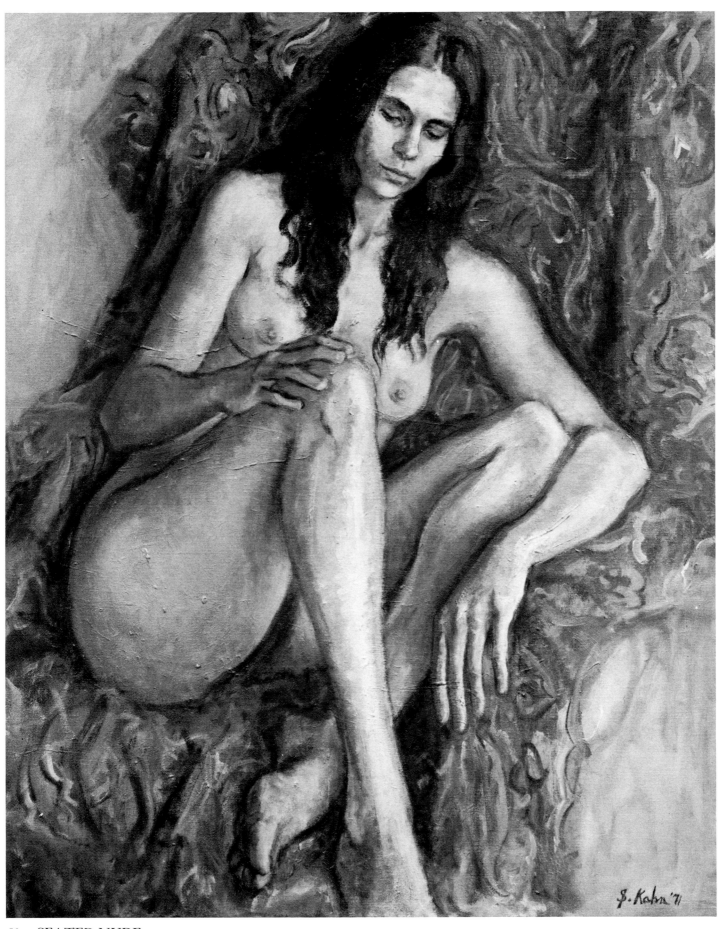

53. SEATED NUDE

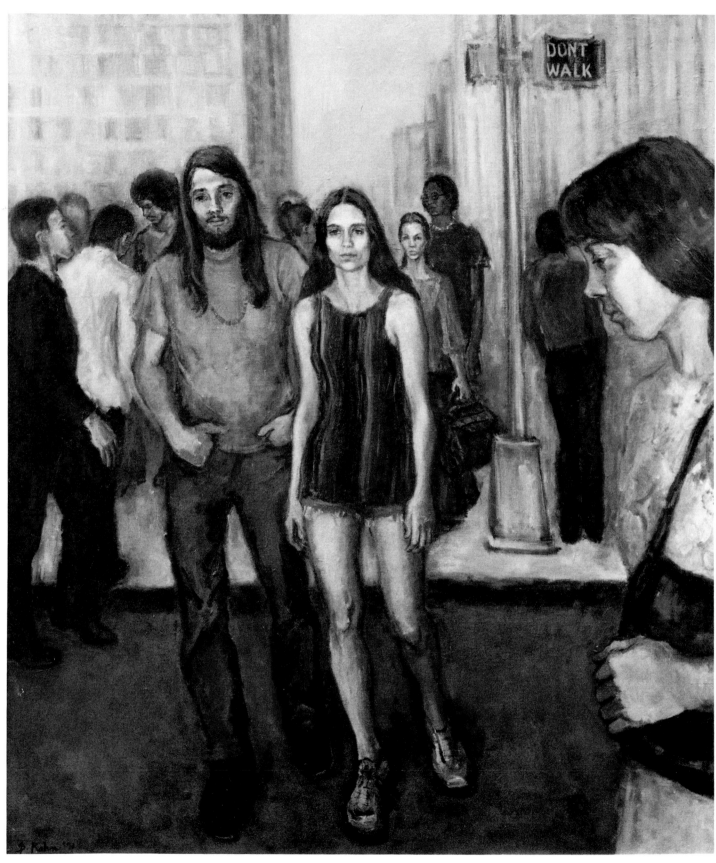

54. DON'T WALK

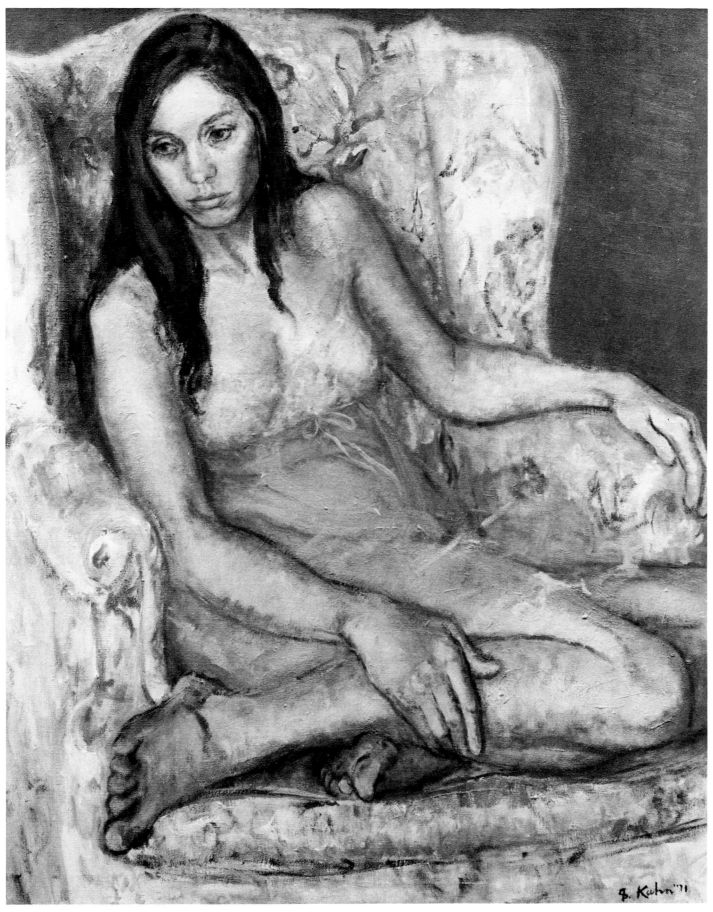

55. RED NIGHTGOWN

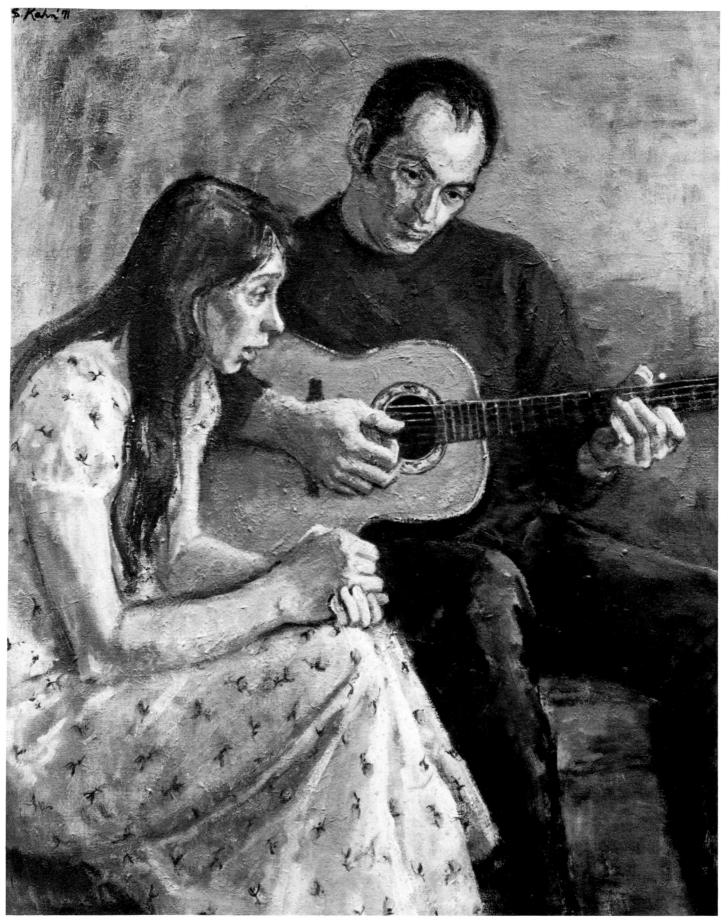

56. DUET

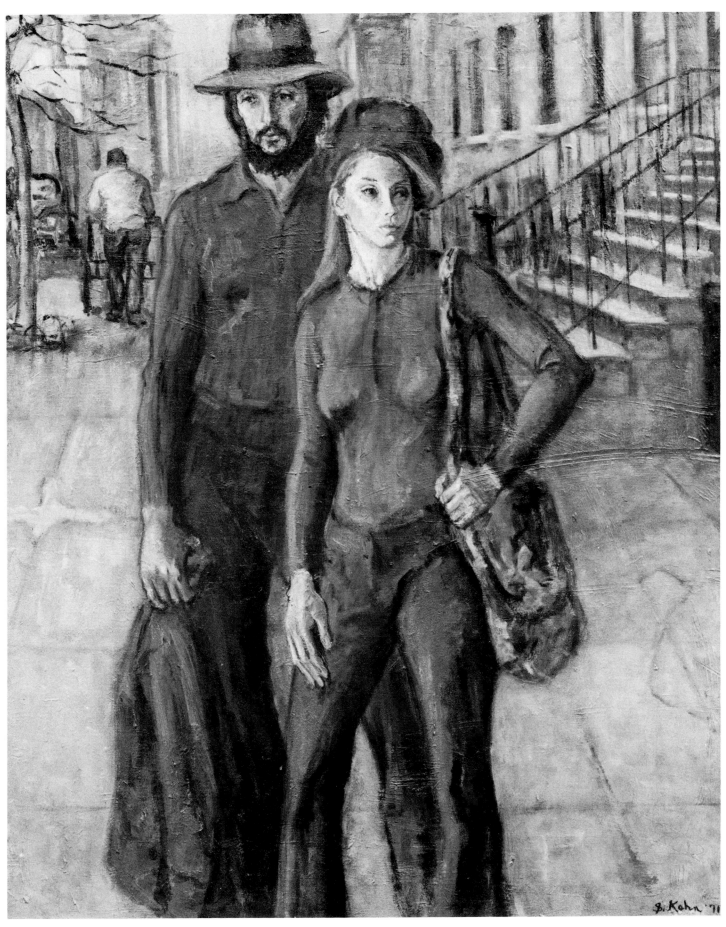

57. STREET SCENE II

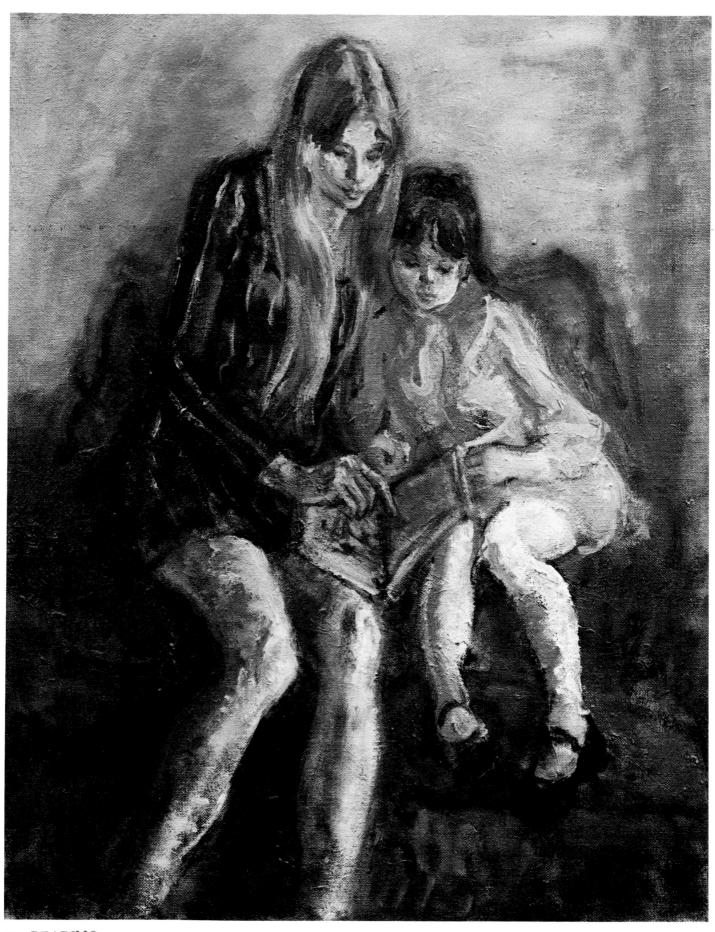

58. READING

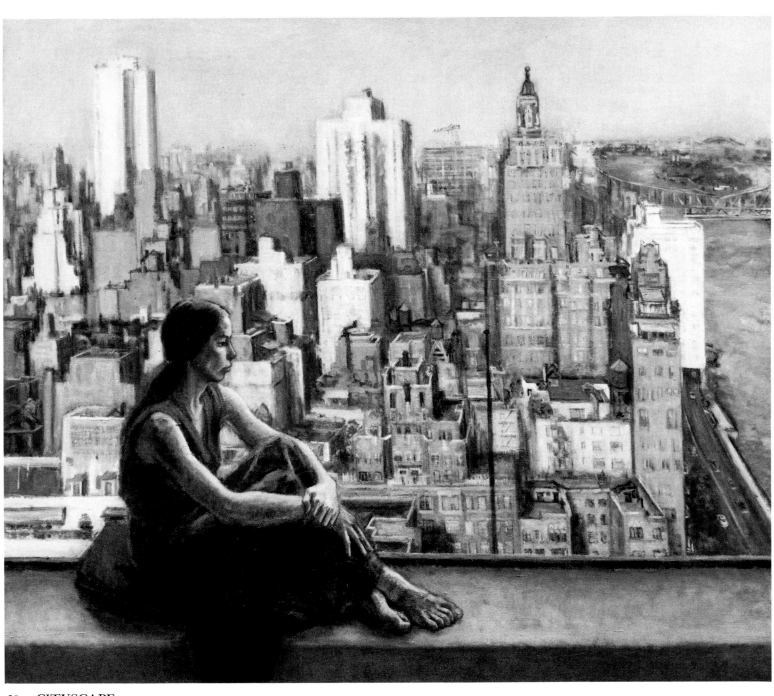

59. CITYSCAPE

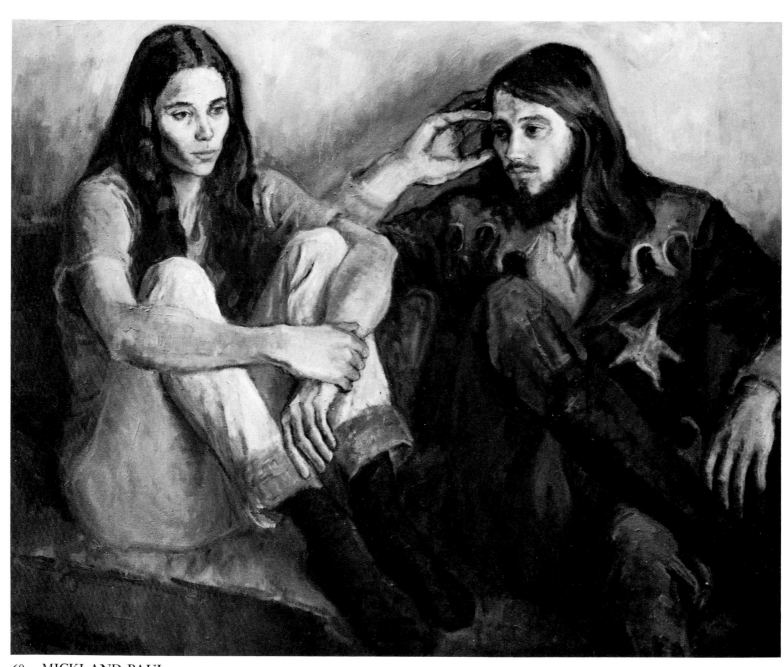

60. MICKI AND PAUL

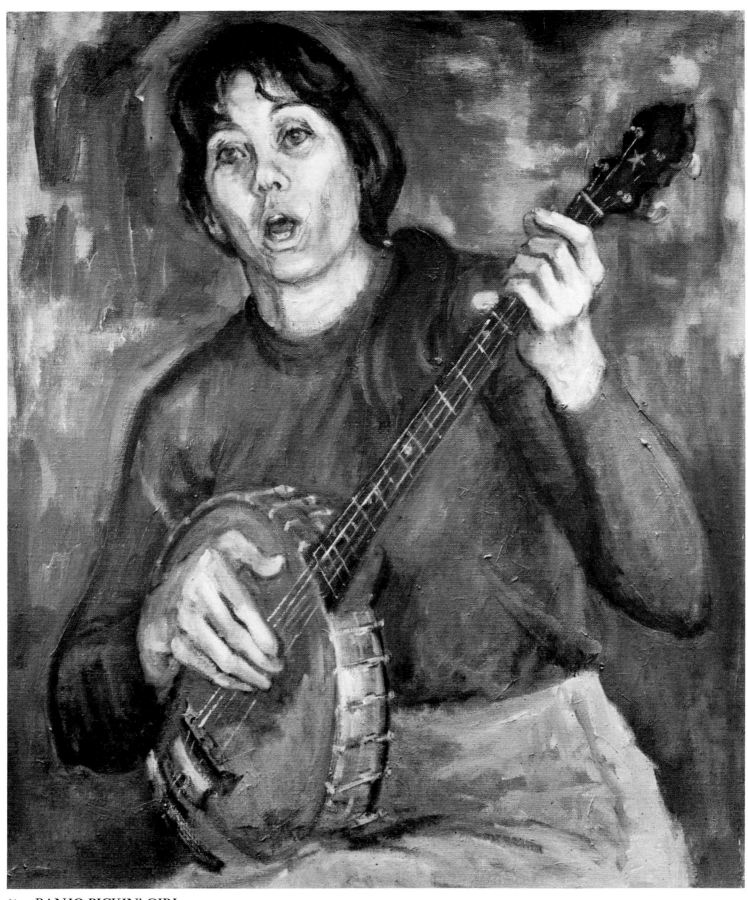

61. BANJO PICKIN' GIRL

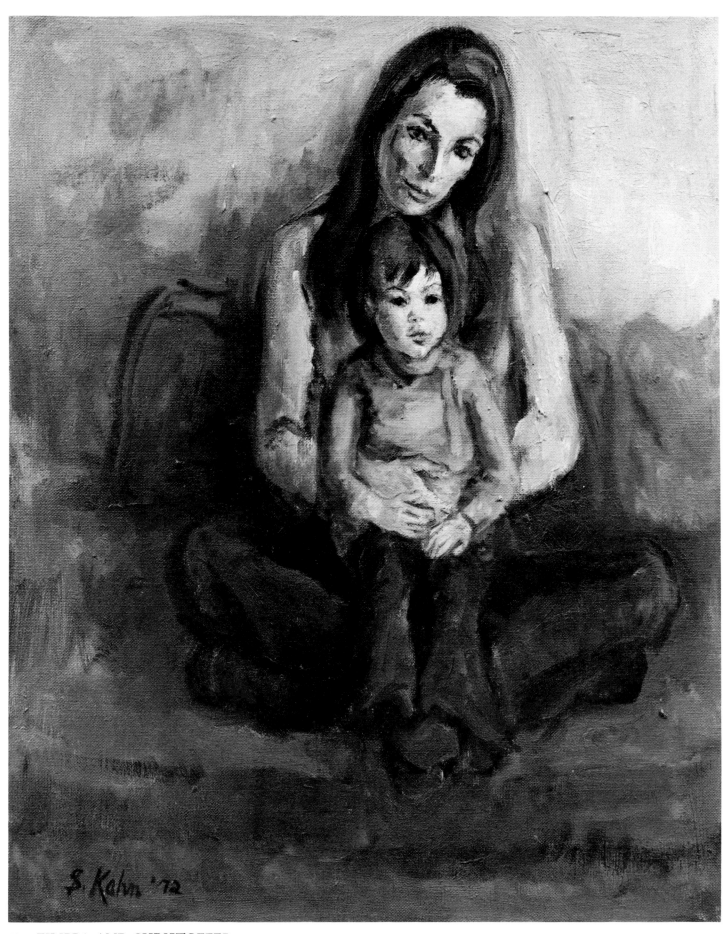

62. FILIPPA AND CHRISTOFFER

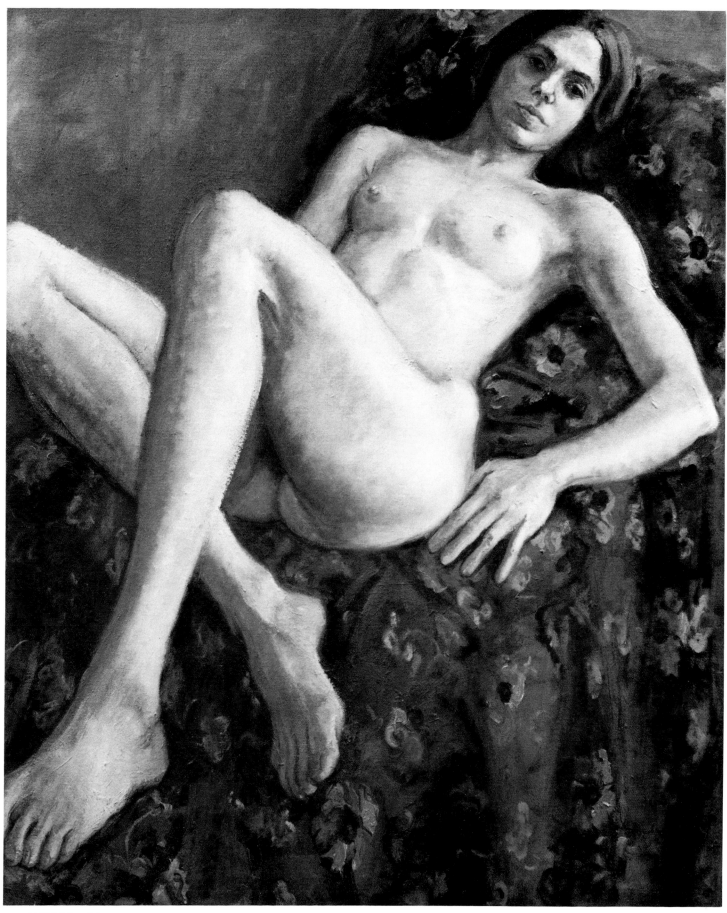

63. RECLINING NUDE

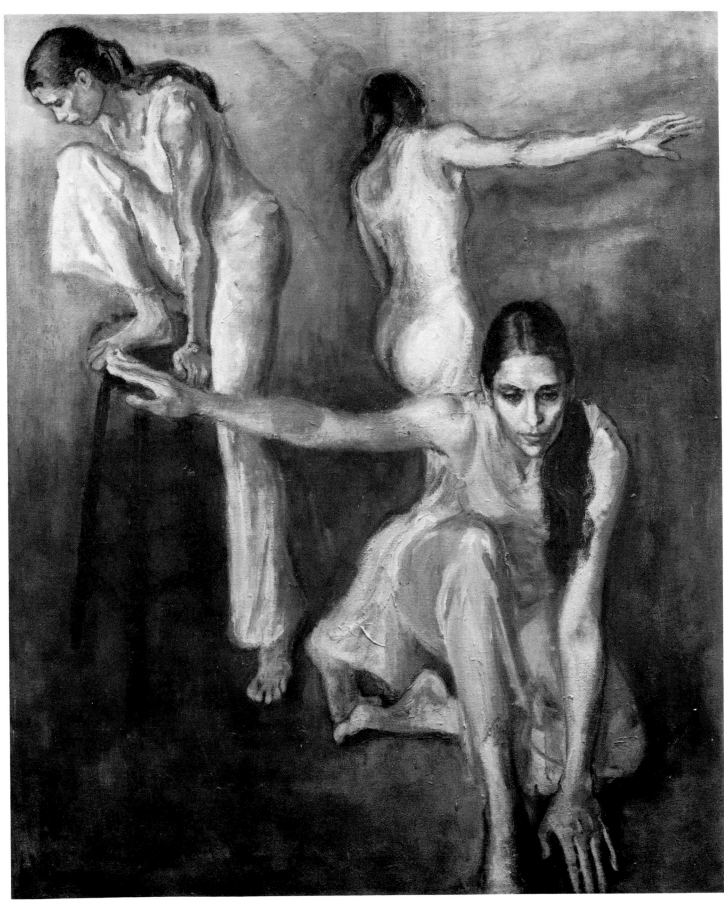

64. MICKI DANCING

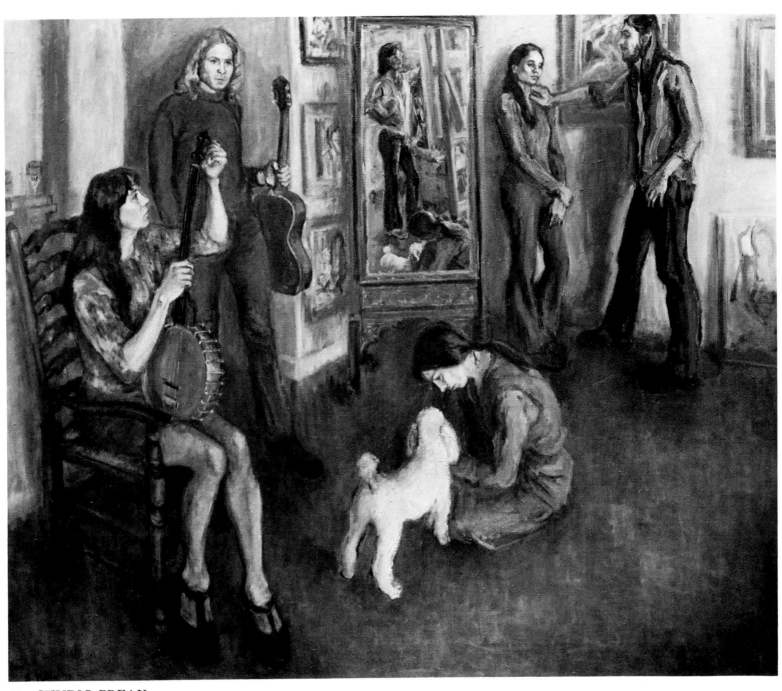

65. STUDIO BREAK

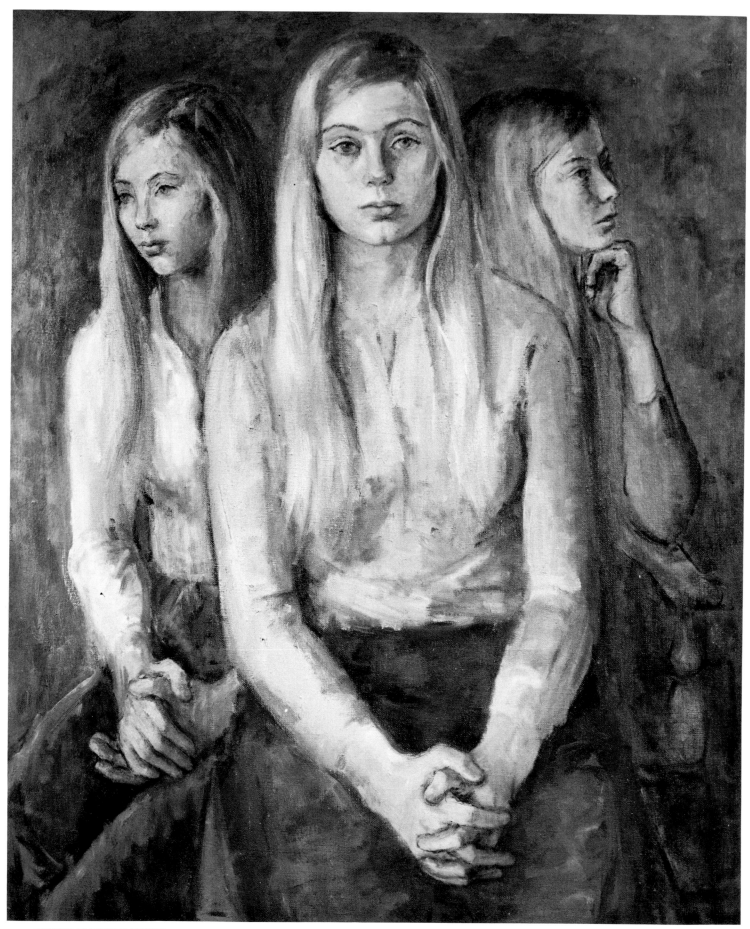

66. TRIPLE EXPOSURE

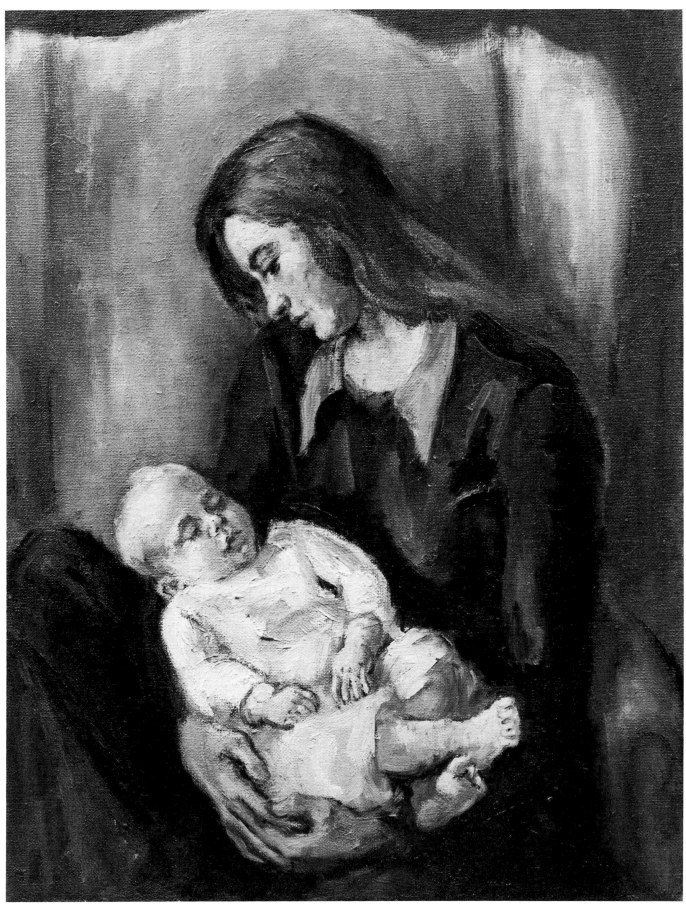

67. MOTHER AND CHILD

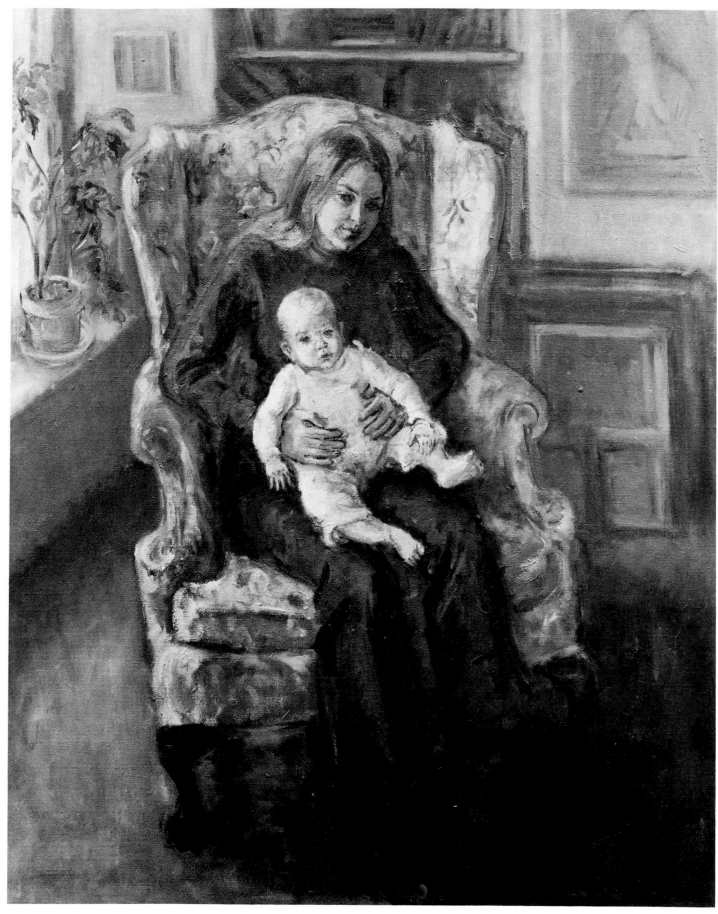

68. YOUNG MOTHER

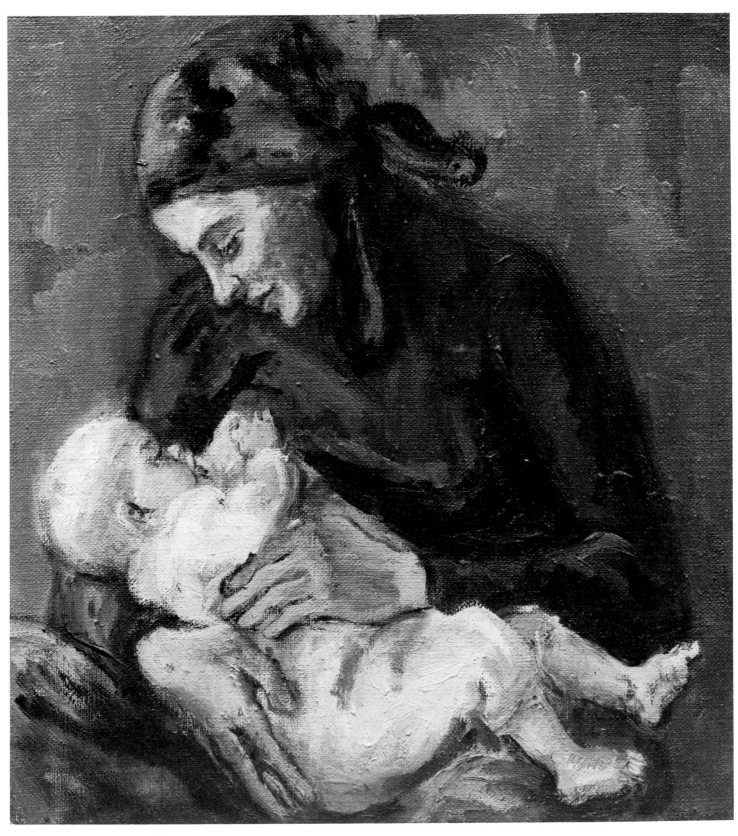

69. MODERN MADONNA

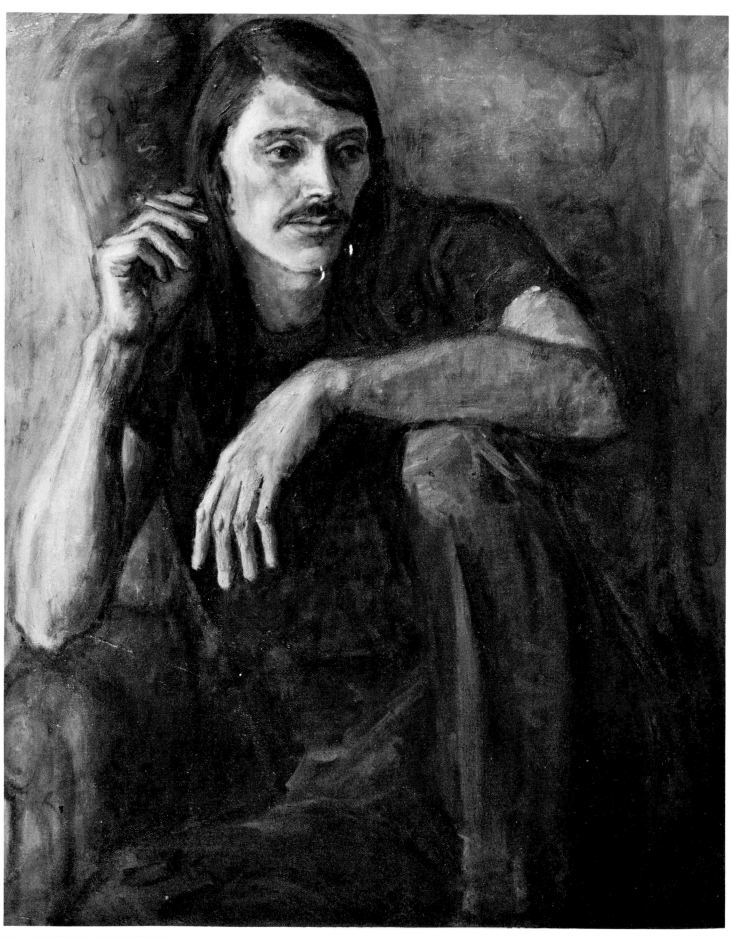

70. YOUNG SCULPTOR

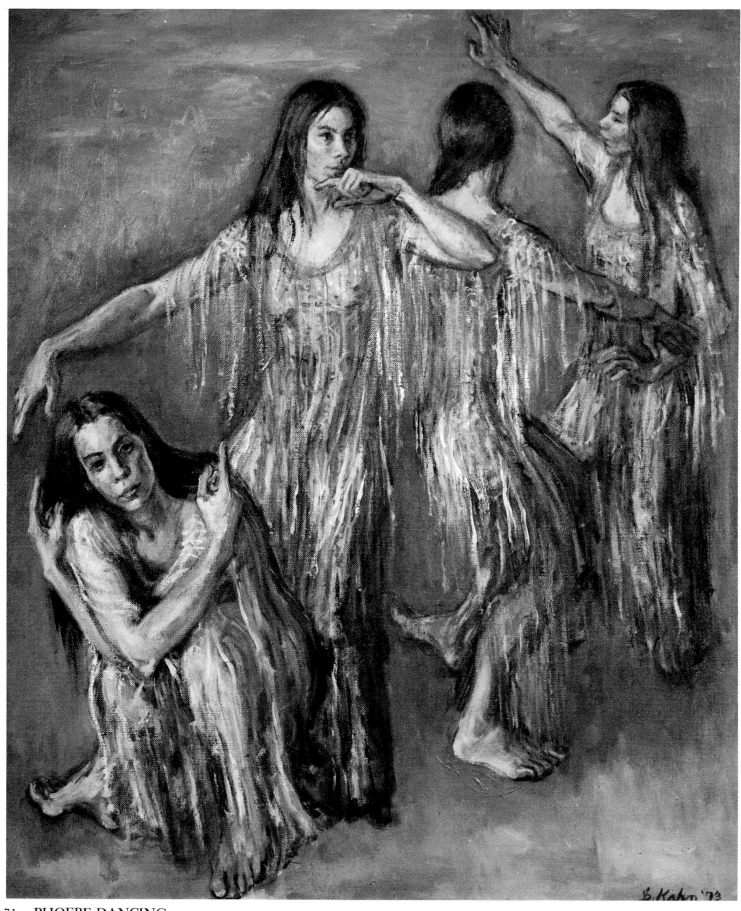

71. PHOEBE DANCING

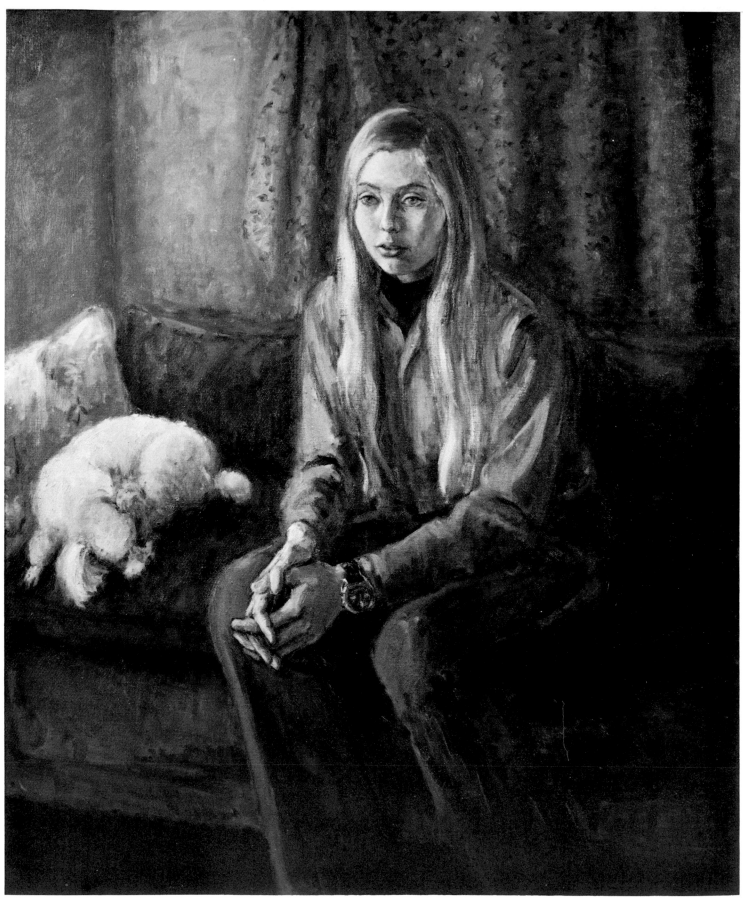

72. LINDA

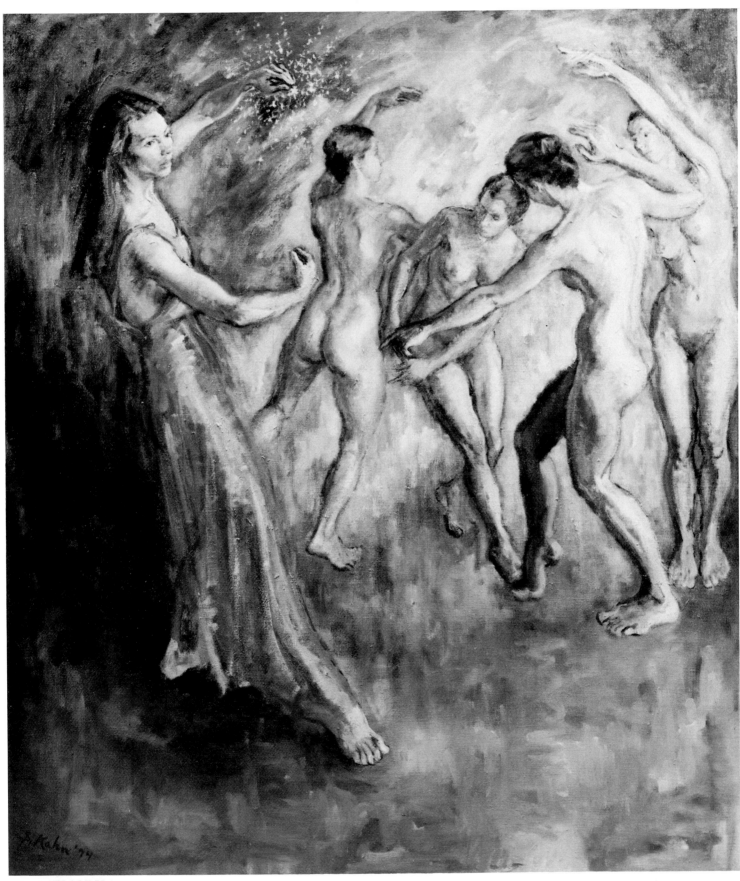

73. MEMORY

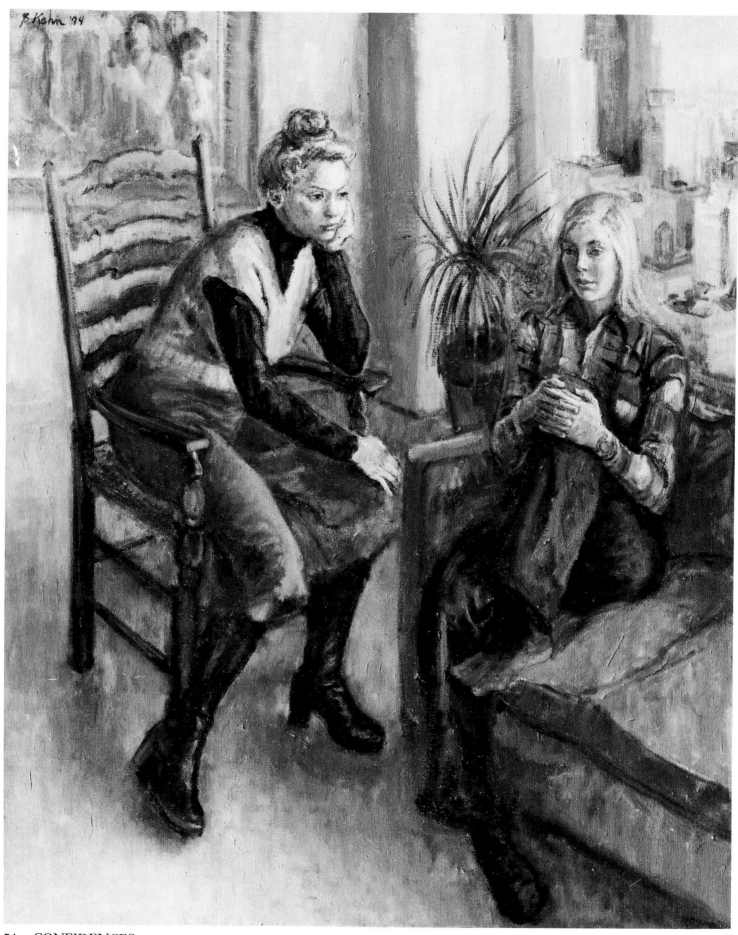

74. CONFIDENCES

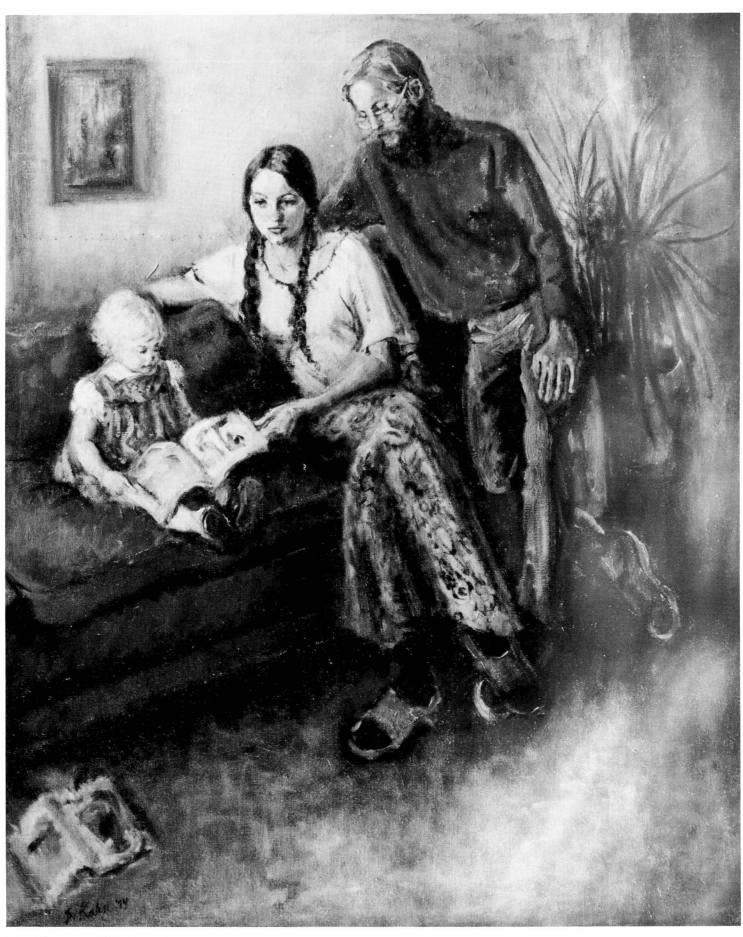

75. THE ANTON FAMILY

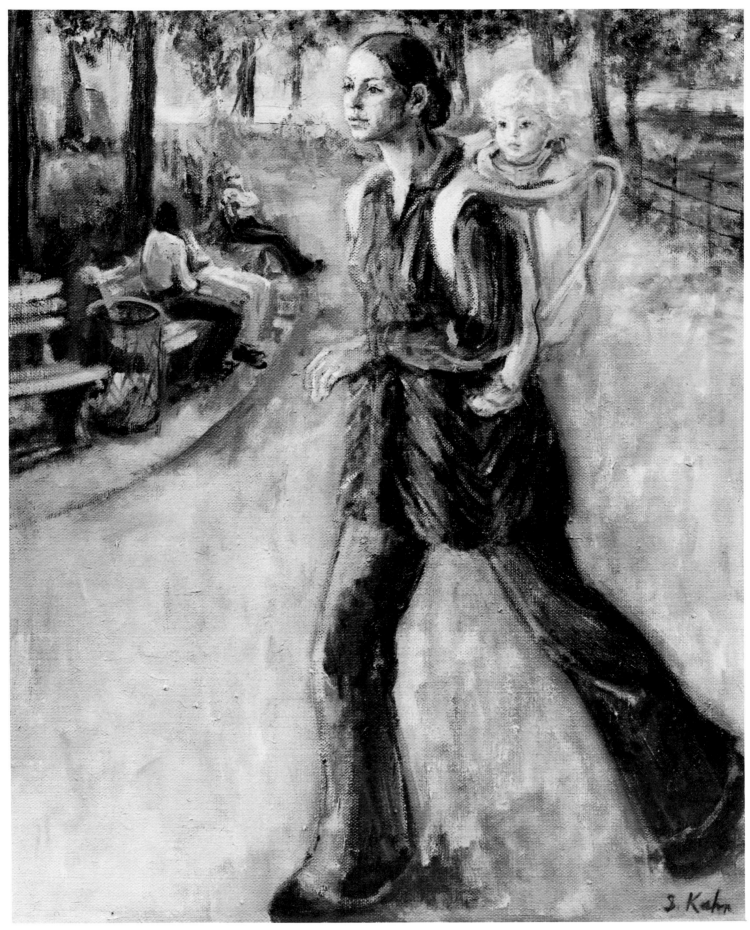

76. BACK PACK

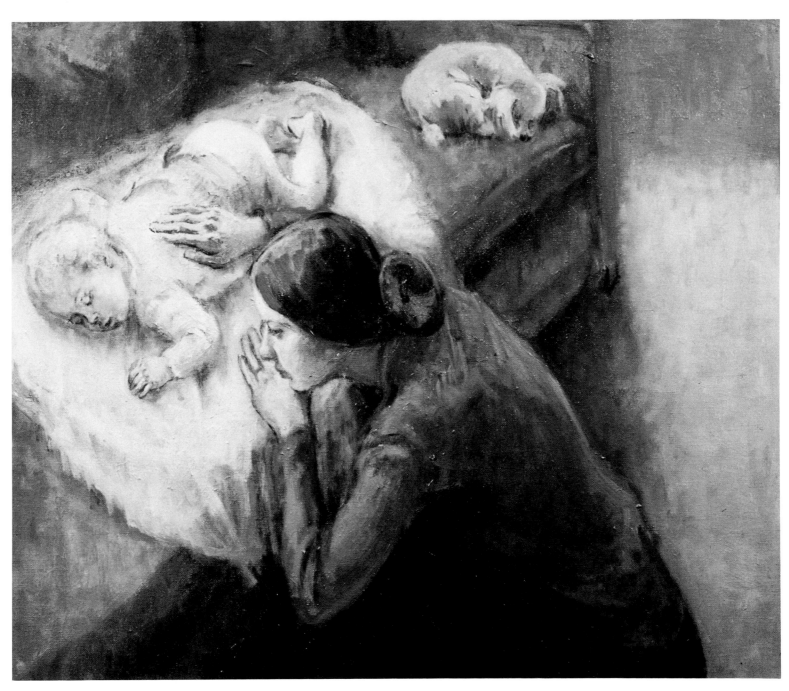

77. SLEEPING BABY

78. THE RAUSNITZ GIRLS

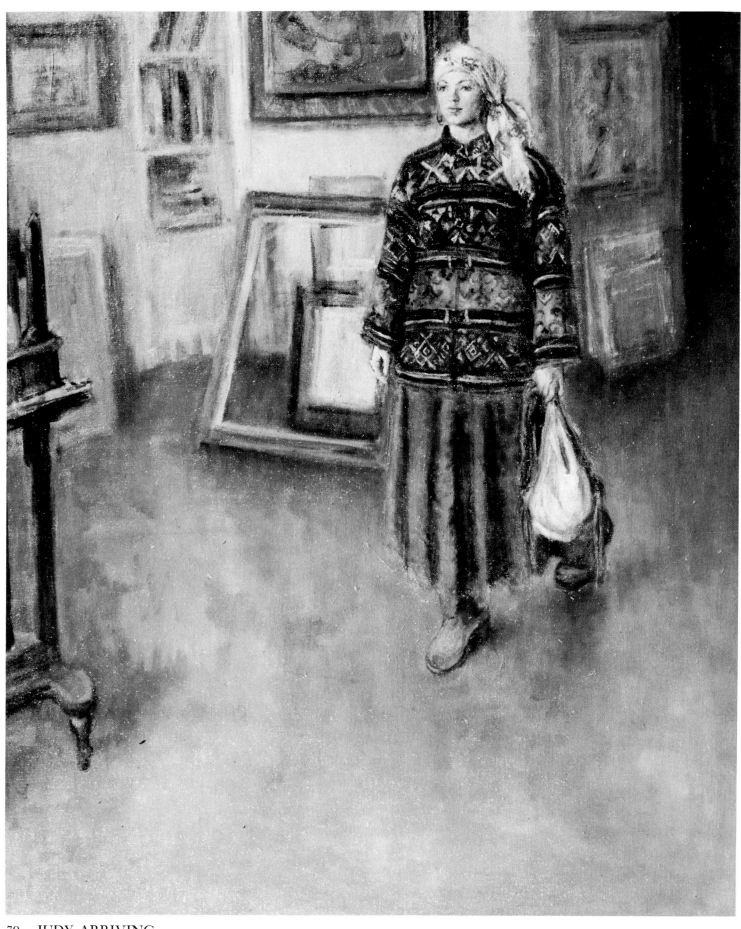

79. JUDY ARRIVING

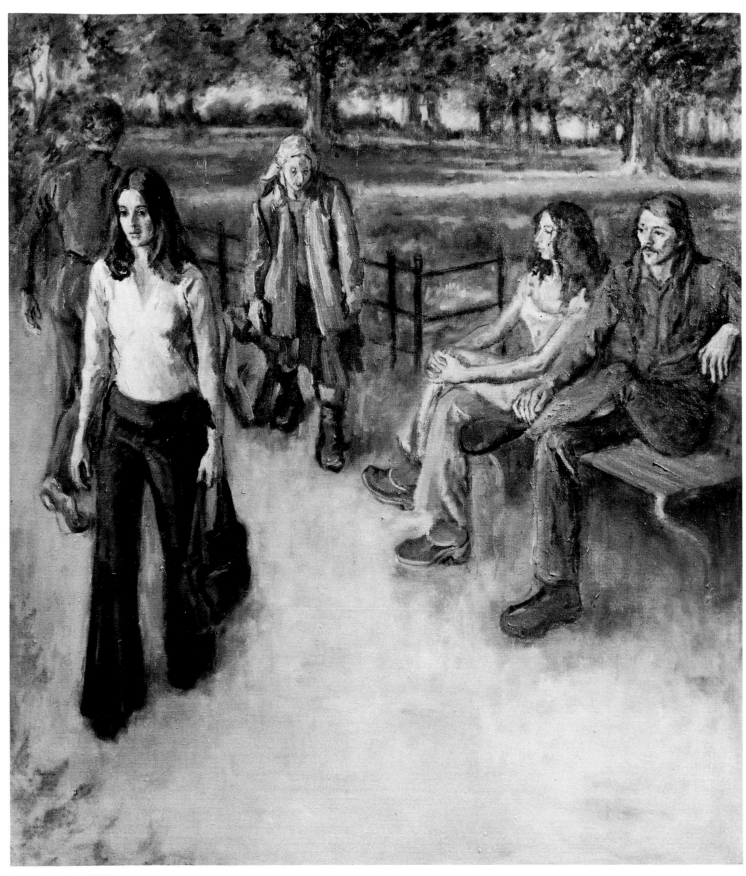

80. **THE PARK**

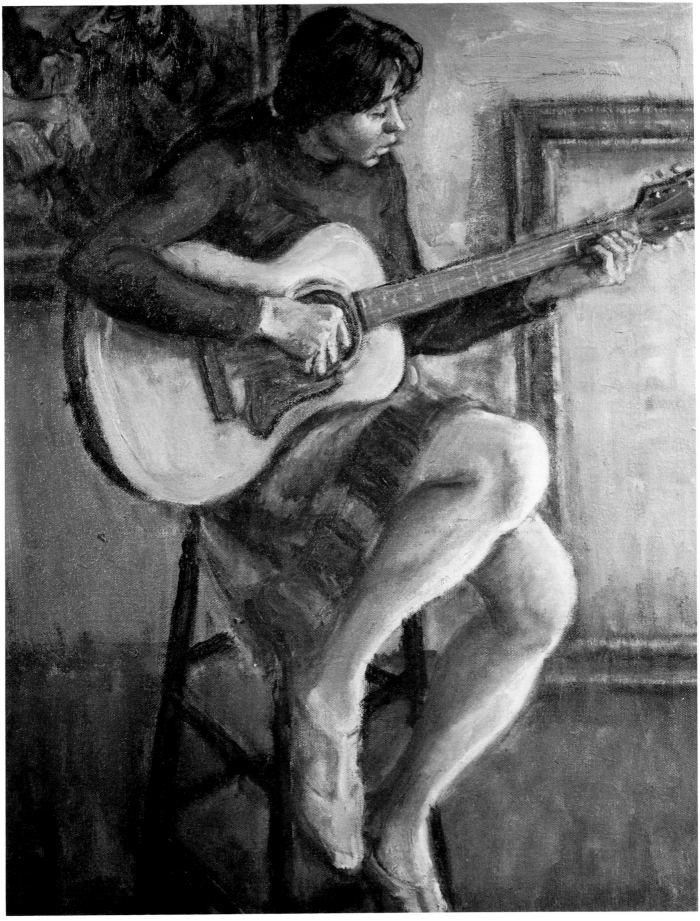

81. SONG

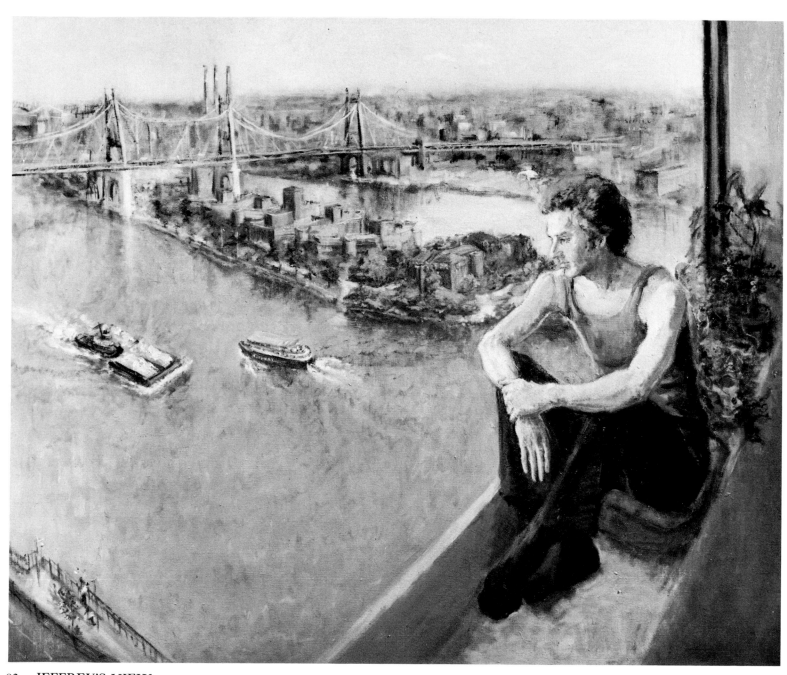

82. JEFFREY'S VIEW

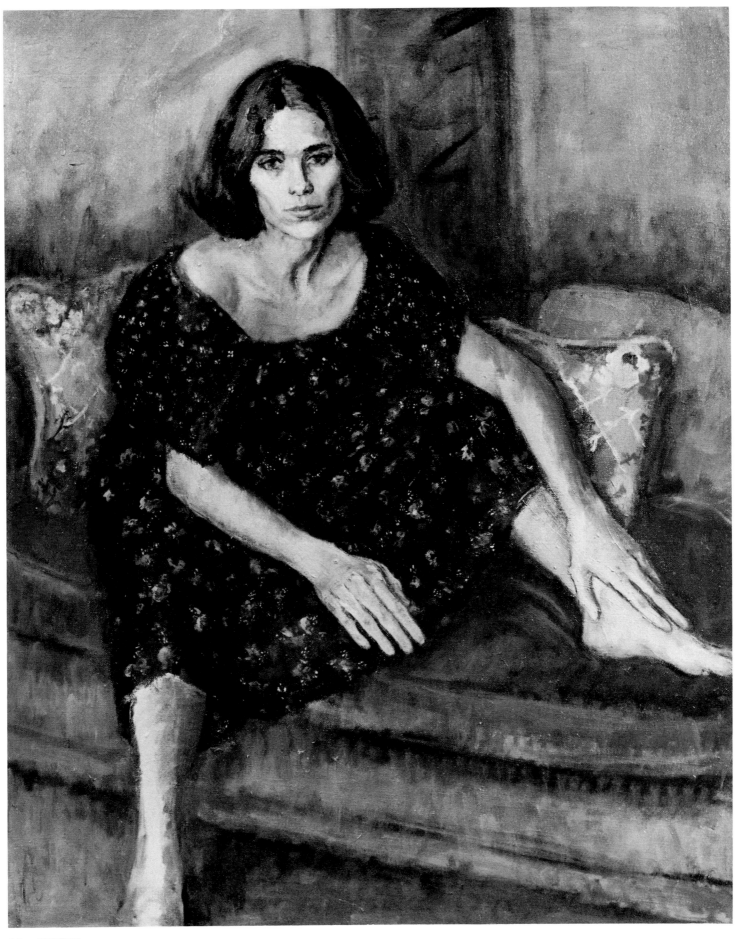

83. MICKI

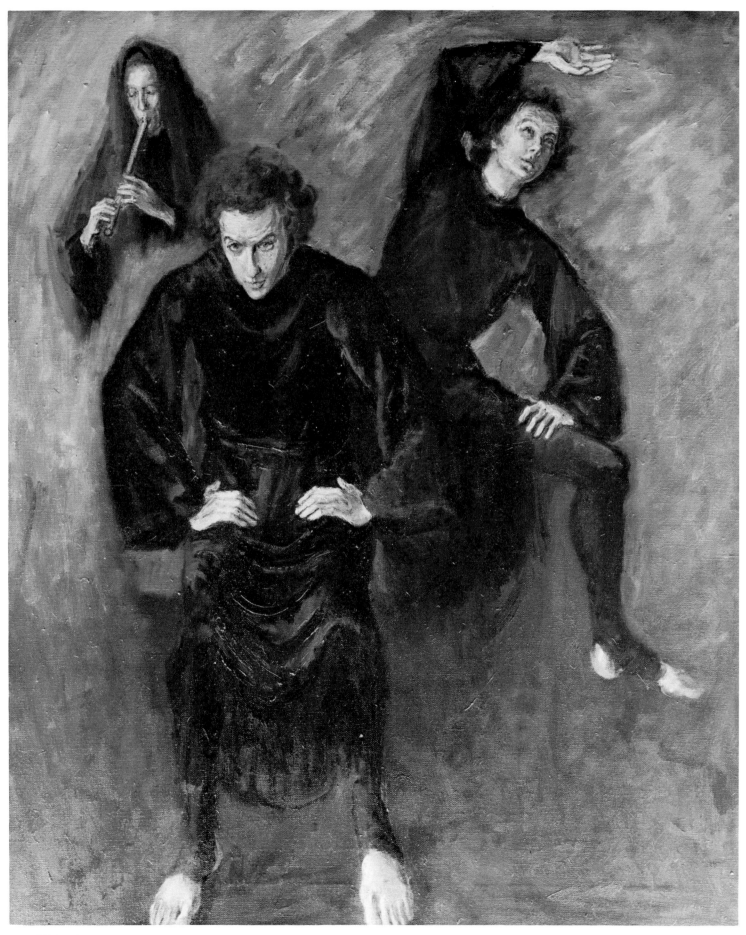

84. FANTASY

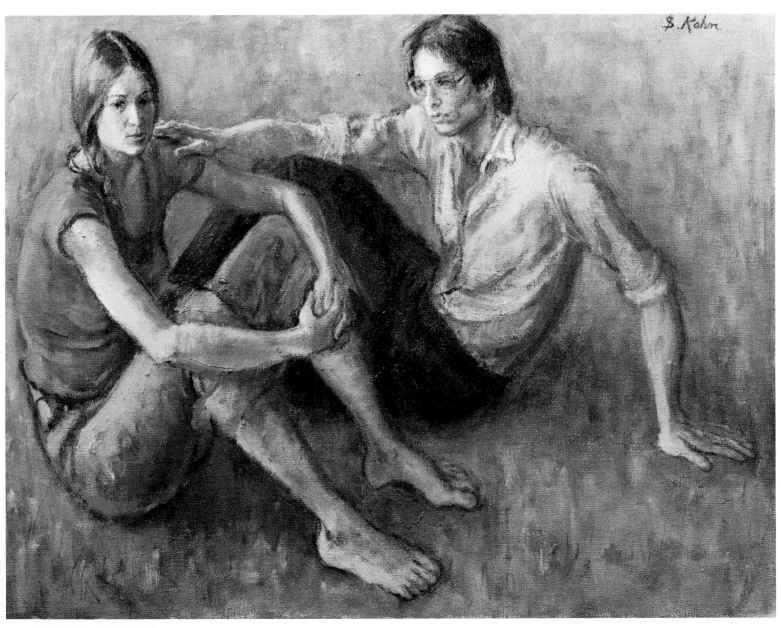

85. YOUNG COUPLE

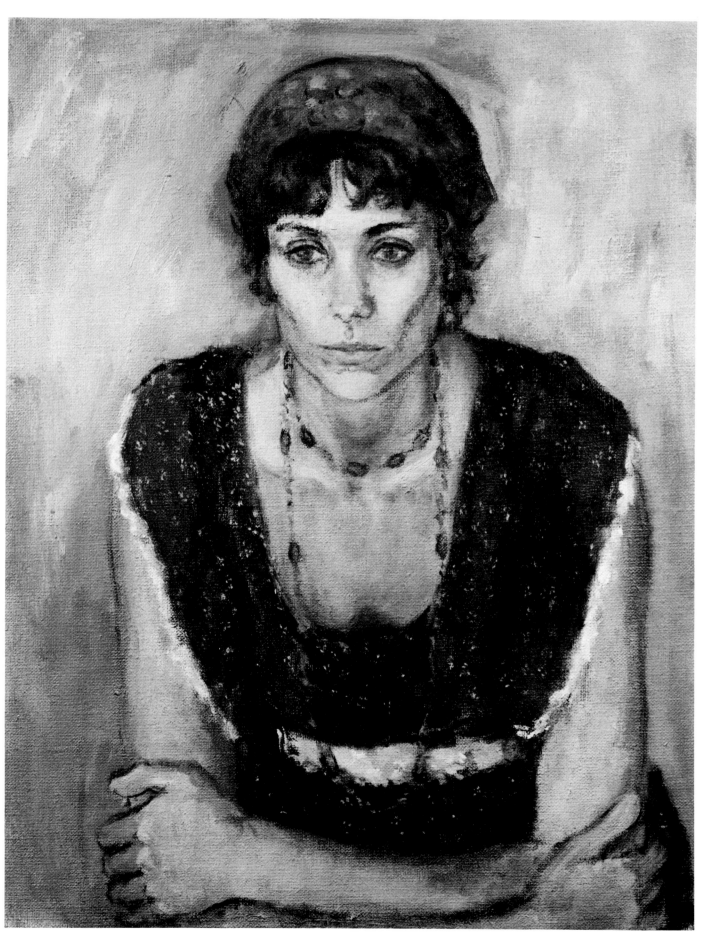

86. THE GREEN SCARF

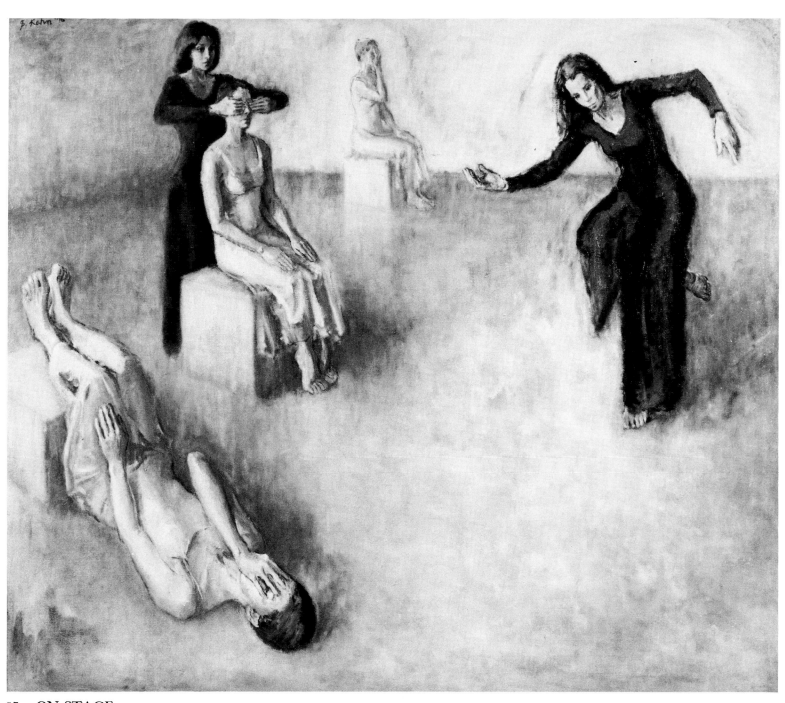

87. ON STAGE

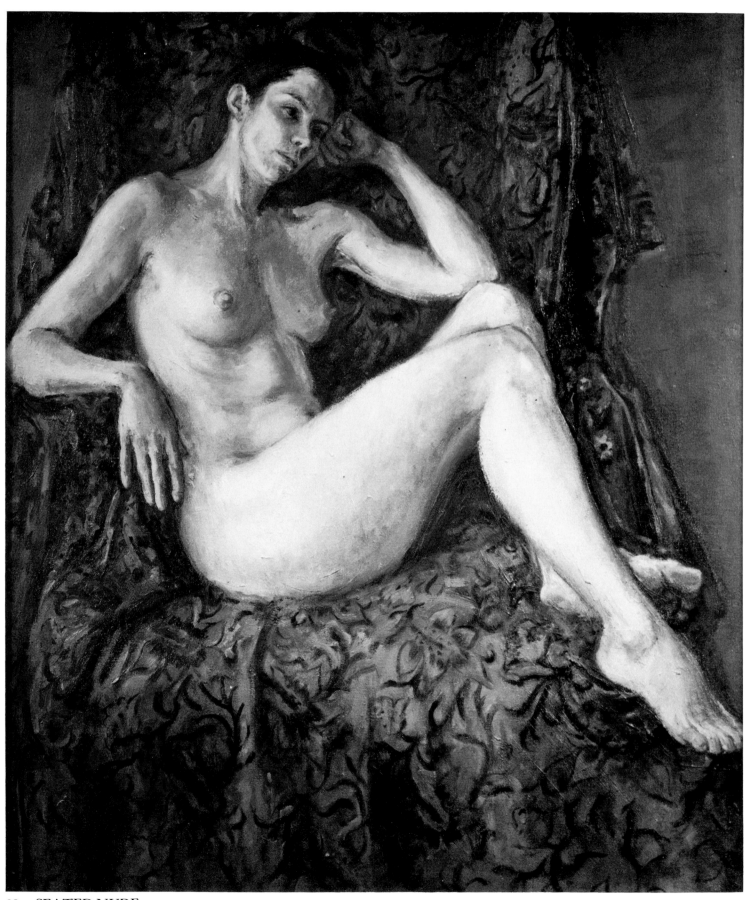

88. SEATED NUDE

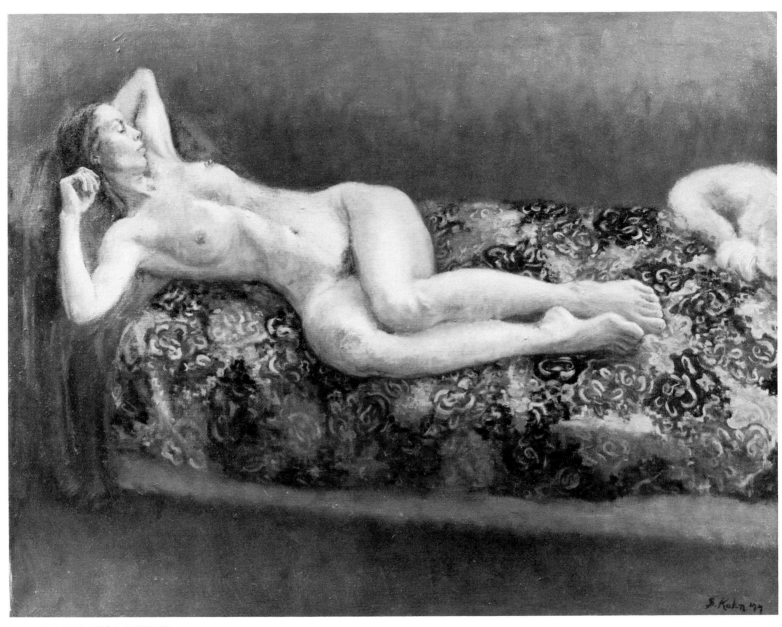

89. RECLINING NUDE

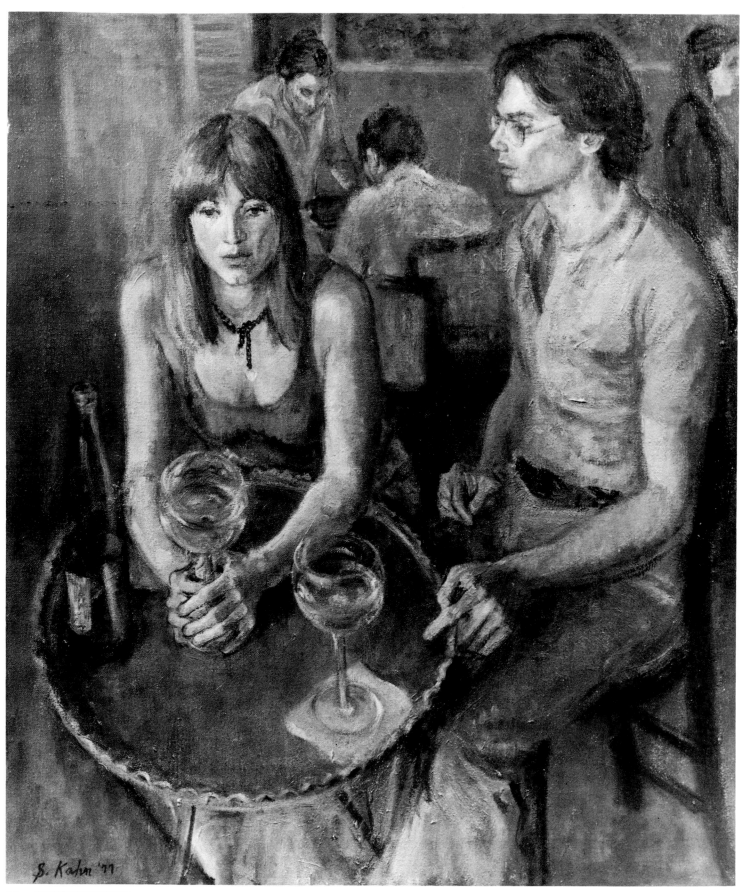

90. WHITE WINE

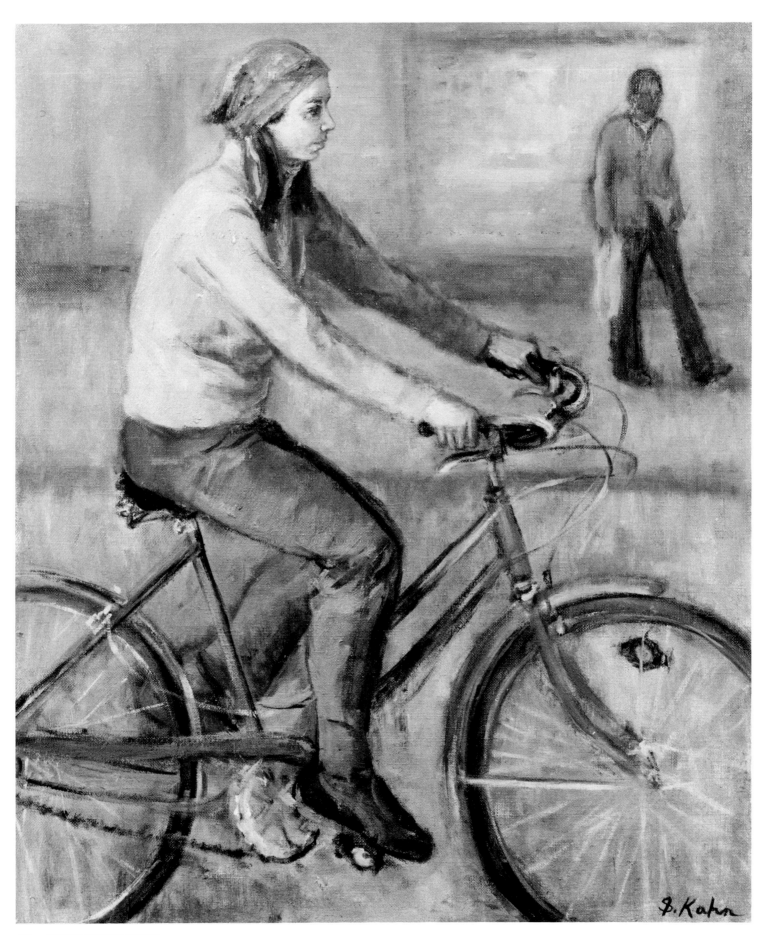

91. THE BLUE BIKE

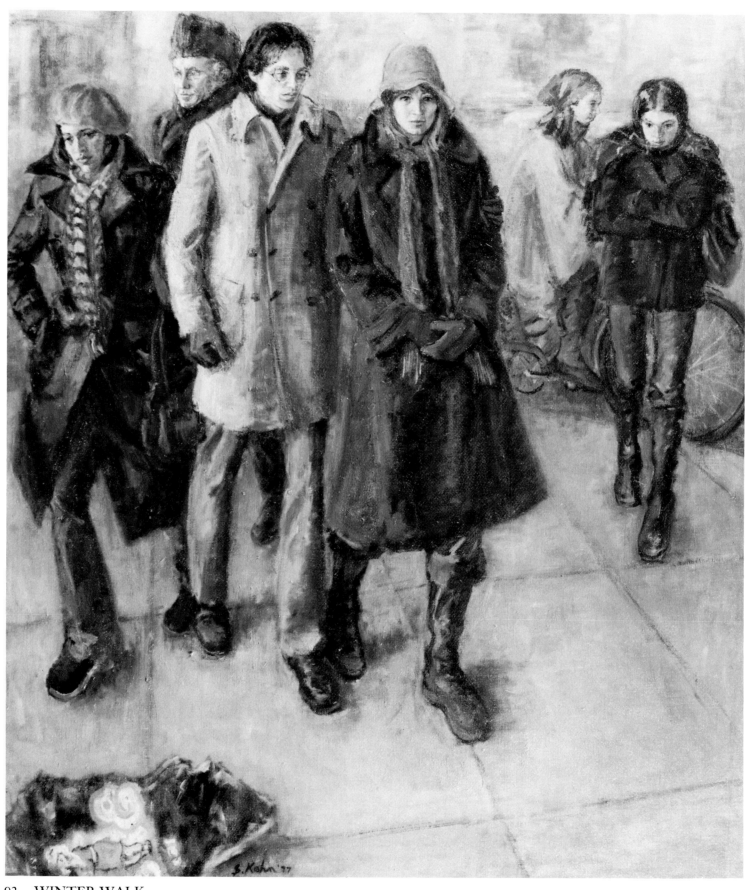

92. WINTER WALK

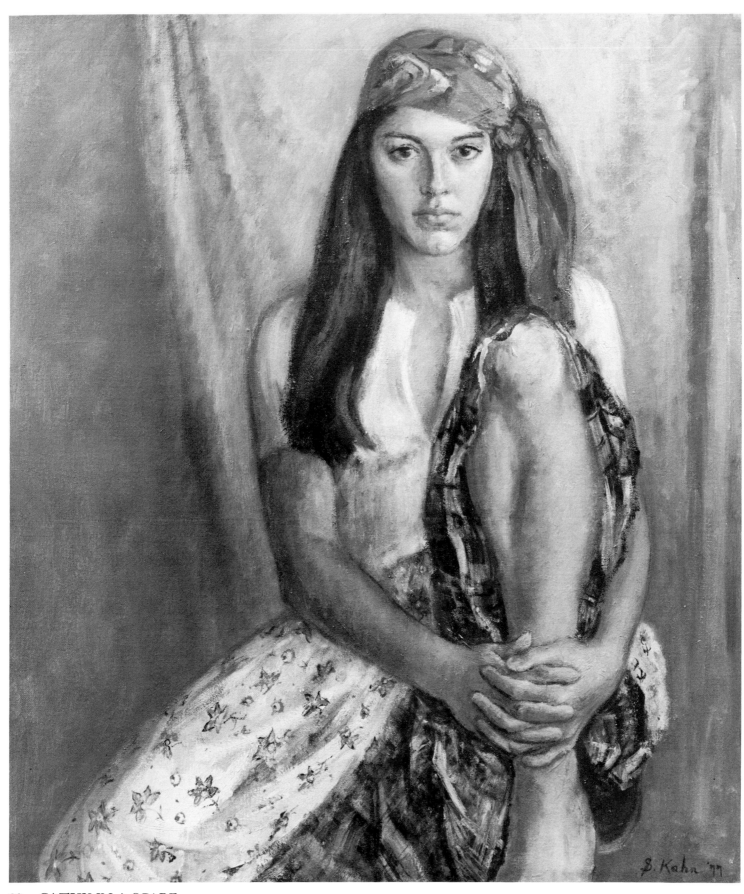

93. CATHY IN A SCARF

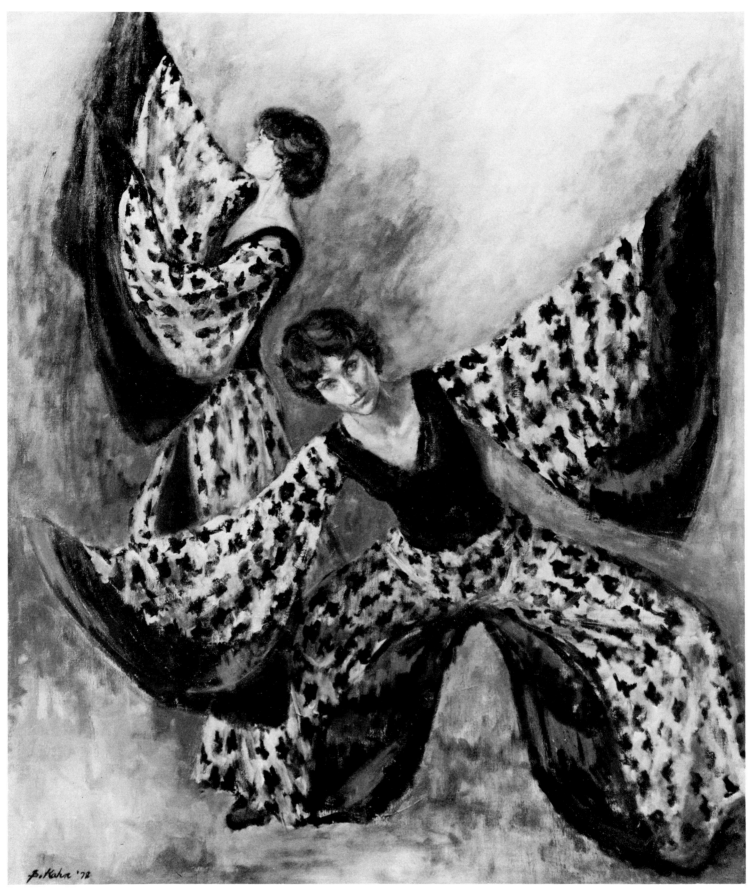

94. MONARCH

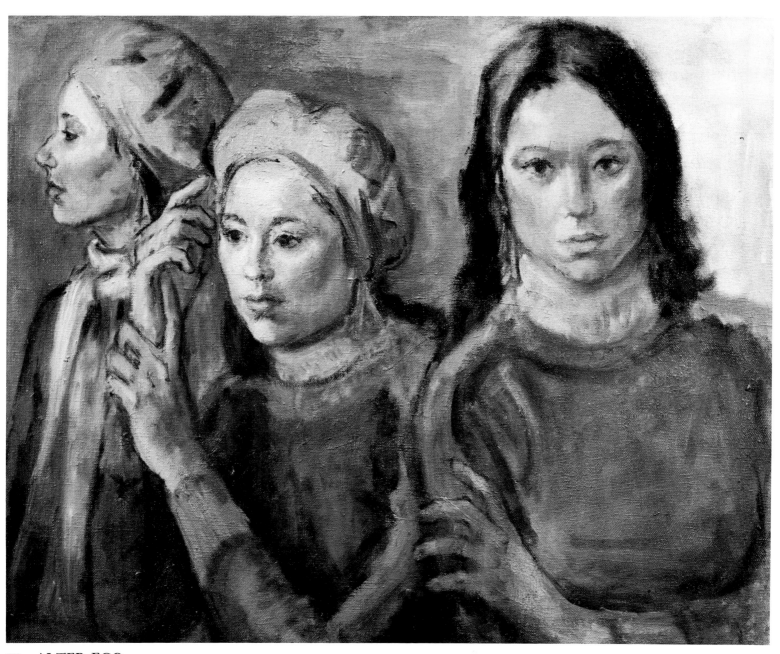

95. ALTER EGO

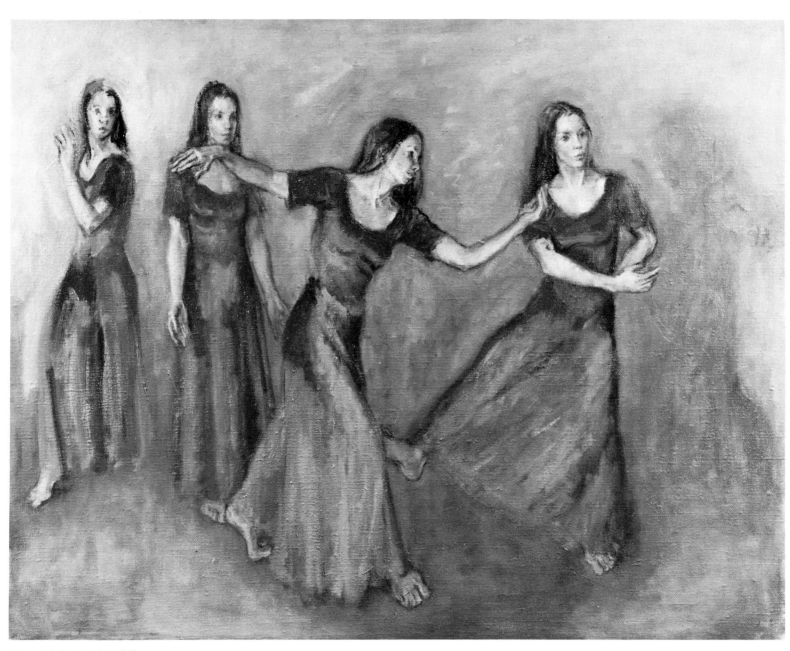

96. LADY DANCE.